AN ILLUSTRATED BRIEF HISTORY *of*
CHINESE DECORATIVE ARTS

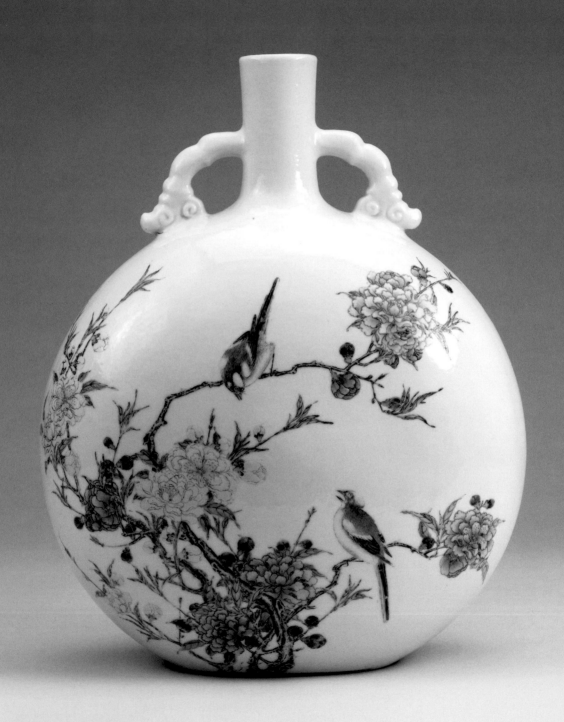

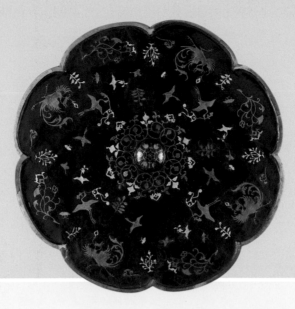

History · Aesthetics · Invention
AN ILLUSTRATED BRIEF HISTORY *of*
CHINESE DECORATIVE ARTS

By Shang Gang
Translated by Liu Haiming

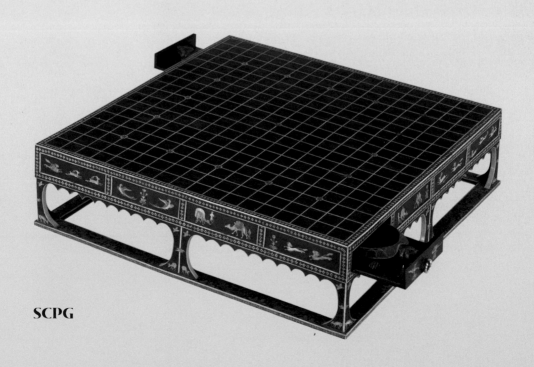

SCPG

On page 1

Fig. 1 Lacquer "Ear" Cup Painted with Phoenix Pattern

Mid-Western Han dynasty (202 BC–AD 8)
Height 4.2 cm, rim length 14.6 cm
Jingzhou Museum, Hubei

Unearthed from Tomb No. 28 at the raised burial site at Jiangling, Hubei in 1992. The phoenix pattern, a potent symbol, is painted vividly in a simplistic style. The concentric circles on the handles to the sides were likely created by impression method.

On page 2

Fig. 2 Famille Rose Flattened Vase with Floral and Bird Motifs

Yongzheng reign (1722–1735) of Qing dynasty (1644–1911)
Height 29.4 cm
The British Museum, London, U.K.

This piece is the most representative of famille rose porcelain produced during the reign of Emperor Yongzheng (1678–1735). Prior to the British Museum, it was in the collection of Percival David Foundation of Chinese Art that has some of the finest Chinese ancient porcelain wares.

On page 3, top

Fig. 3 Lobed Bronze Mirror Decorated on the Back with Gold and Silver Inlay on Lacquer

Ca. 650–755 of Tang dynasty (618–907)
Diameter 28.5 cm, rim band width 0.6 cm, weight 2,935 g
The Shosoin Repository (North Section), Nara, Japan

This Tang era mirror is in the Shosoin Repository of the Japanese royal house, which has a large collection of artifacts dated to the mid-8th century, well-preserved to this day according to strict conservation rules.

This book is edited and designed by the Editorial Committee of *Cultural China* series.

Text and Image by Shang Gang
Translation by Liu Haiming
Cover Design by Wang Wei
Interior Design by Li Jing and Hu Bin (Yuan Yinchang Design Studio)

Editor: Wu Yuezhou
Editorial Director: Zhang Yicong

ISBN: 978-1-93836-855-4

Address any comments about *An Illustrated Brief History of Chinese Decorative Arts: History · Aesthetic · Invention* to:

SCPG
401 Broadway, Ste. 1000
New York, NY 10013
USA

or

Shanghai Press and Publishing Development Co., Ltd.
390 Fuzhou Road, Shanghai, China (200001)
Email: sppdbook@163.com

Printed in China by Shanghai Donnelley Printing Co., Ltd.

1 3 5 7 9 10 8 6 4 2

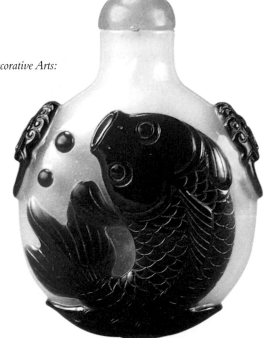

CONTENTS

On page 3, below

Fig. 4 *Zitan* (Purple Sandalwood) *Weiqi* Game
Board with Marquetry
Ca. 650–755 of Tang dynasty
Length 49 cm, width 48 cm, overall height 12.6 cm
The Shosoin Repository (North Section), Nara, Japan

Inside each of the two drawers is a tortoise-shaped
bowl holding *weiqi* pieces. The game board is similar
to that of the modern design, with some variations.

Fig. 6 Please refer to fig. 231 on page 143.

On facing page

Fig. 5 Glass Snuff Bottle with Overlay Fish Pattern
Mid-Qing dynasty
Height 6.5 cm, width 5.3 cm
The Palace Museum, Beijing

Fish has been an auspicious symbol since ancient
times, as the word for fish is homophonic in Chinese
with "abundance and wealth." The fish overlaid on
the bottle is pleasingly plump; joyous and propitious
in effect.

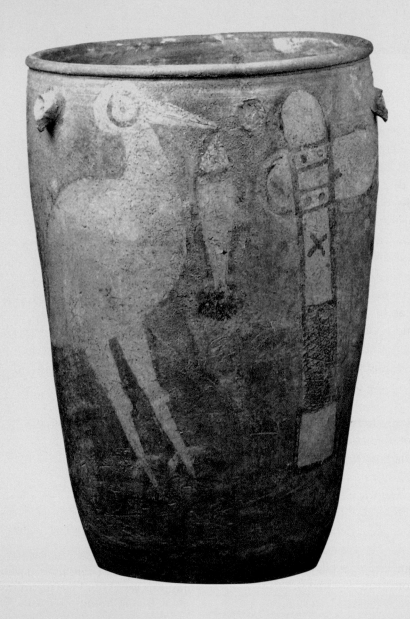

Fig. 7 Pottery Jar Painted with Crane, Fish and Stone Axe

Miaodigou phase, Yangshao Culture (ca. 5000–
ca. 3000 BC)
Height 47 cm, rim diameter 32.7 cm, base diameter
19.5 cm
National Museum of China, Beijing

Dating back about 6,000 years, it was unearthed
at a burial site near Yan Village, Linru, Henan in
1978. It has the largest painted surface among
extant ancient pottery in China. The crane image
is the oldest known example of a technique called
mogu painting ("boneless," without the usual strong
brush outline).

FOREWORD

ANCIENT CHINESE DECORATING ART AND ITS UNIQUE CHARACTERISTICS

The term decorative art refers to any of the plastic arts created by handcraft means. The origins of Chinese decorative art date back eight millennia, if discounting ornamental objects found from even earlier times, representing the earliest of artistic achievements at the dawn of China's Neolithic Age spanning four millennia. The early media mastered included pottery and textile, in addition to stone tools crafted by grinding and polishing. While textile materials were perishable and extant items rare, stone, jade, and pottery artifacts that have survived to this day in abundance bear witness to the artistic creativity of our ancient forebears. Throughout Chinese primitive societies, decorative arts showed a greater maturity and had more glorious achievements than fine arts. Painting (fig. 7) and sculpting (fig. 8) were often means of decoration for handcrafted utilitarian items.

What then is decorative art? If defined by its media—textile, ceramics, jade, metals, lacquered wood and miscellaneous (bamboo, animal tusks or horns and glass), rather than by any other debatable terms, objects of decorative art are chiefly prized for their utility and secondly decorative appeal. Yet, the line between function and beauty is often hard to draw. Items for everyday use can be visually pleasing, while those for admiration may also serve a practical purpose, except

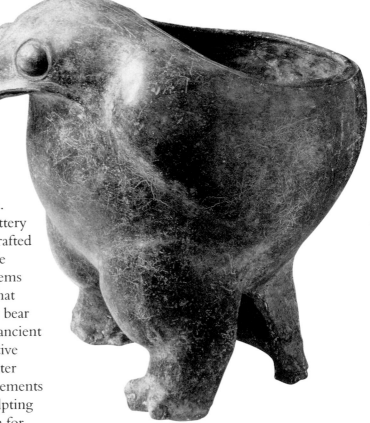

Fig. 8 Black Pottery *Zun* in Hawk Shape
Miaodigou phase, Yangshao Culture
Height 36 cm
National Museum of China, Beijing

Predated slightly by the painted pottery jar in fig. 7, this wine vessel (*zun*) was unearthed from a burial site at Taipingzhuang in Huaxian, Shaanxi in 1975. Fashioned into the shape of a hawk, the ample and masculine form, emblematic of its owner's noble status, shows amazing sculpting prowess.

that the latter may use better materials and be more exquisitely crafted.

1. The Utility Principle

With rare exceptions, usefulness is central to objects of decorative art, with their shape and decorative design serving functional needs. China in ancient times remained primarily agrarian. Specimens of decorative art from antiquity are thus solid and sturdy, made for easy storage or display, in keeping with the settled agrarian life. In periods under nomadic rulers' reign, portable items designed for the nomads' way of life became more widely available. As the conquering nomads settled down, the design and style of their everyday-use objects evolved, as shown in the pottery pilgrim flasks dated to the Liao dynasty (916–1125) (figs. 9 and 10).

Other design features were related to

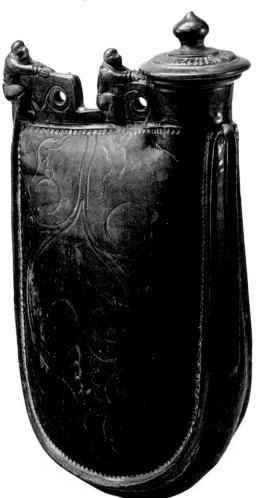

functionality, too. A wine pot, for example, could have a matching warming bowl (fig. 11), but never a teapot. For tea was always brewed in hot water while wine could be cold out of the container and require warming up for drinking. Larger wine vessels were always for libation of a mild nature, while smaller ones that of higher alcohol content. Decoration, on the other hand, was not as closely related to functionality. Yet the shift towards painted decoration, as opposed to engraving or

Fig. 9 Green-Glazed Pilgrim Flask
Liao dynasty
Height 34.5 cm

A later variant of the stoneware pilgrim flask, it was designed for a more settled lifestyle, with a loop handle at the top for carrying and a round body for easy storage.

Fig. 10 Green-Glazed Pilgrim Flask
Liao dynasty
Height 31.7 cm
Museum of Fine Arts, Boston, U.S.

This is an early form of the stoneware pilgrim flask fashioned in the shape of a leather satchel-like container, designed to be portable and for a nomadic lifestyle. It has a flattened body, with holes at the top for attachment of a carrying strap.

On facing page

Fig. 11 *Qingbai* (Shadowy Blue) Wine Pot in Warming Bowl with Carved Patterns
Northern Song dynasty (960–1127)
Overall height 20.2 cm, waist diameter 12 cm
Anhui Provincial Museum

The set was excavated from a Song dynasty (960–1279) tomb in Anhui (dated to 1087). The lobed warming bowl, with the wine pot in, can be filled with hot water to warm up the wine; a common design at the time.

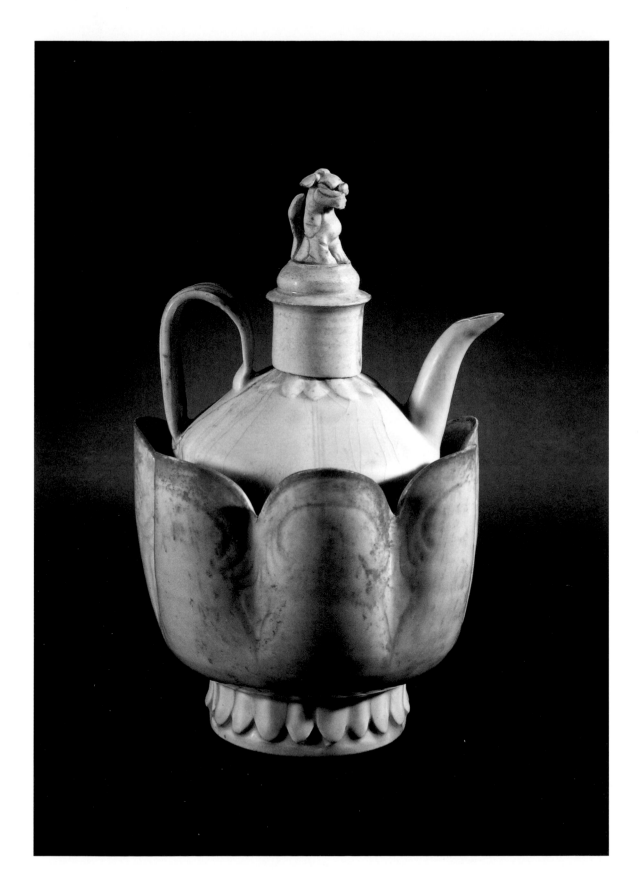

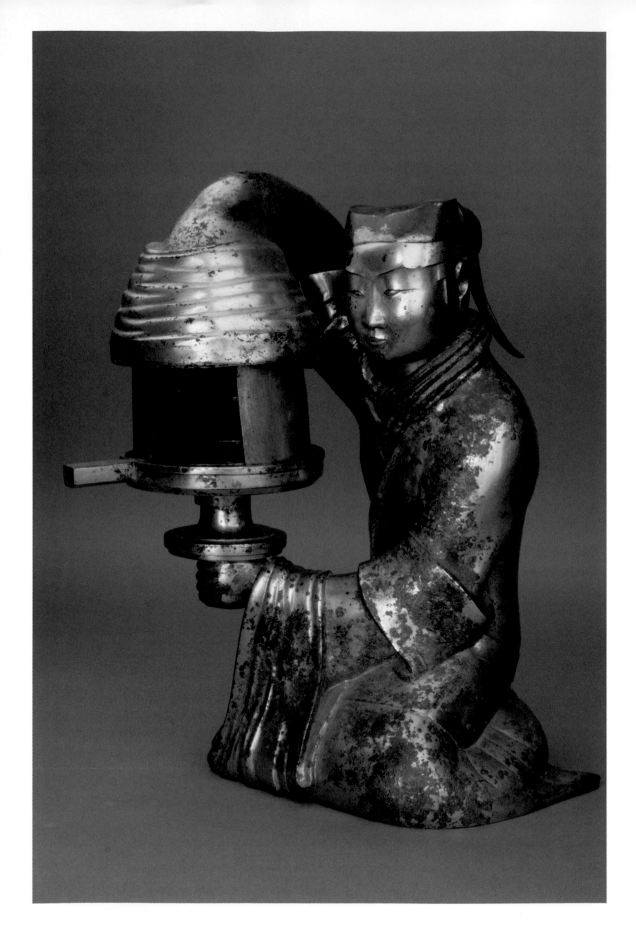

sculpting, had something to do with its ease of cleaning. Thus, underglaze painting on ceramics became prevalent in and after the Yuan dynasty (1271–1368).

The utility principle dictates that form and decoration should be fitting and not outlandish or disproportionate. Decoration not getting in the way of function is the minimum requirement. It is even better if it can enhance functionality. Thus, decorative art is always subject to certain constraints, akin to dancing in chains. However, while mediocrity abounds, constraints may also provoke more imaginative art, creating ingenious masters. Many extant artifacts, their creators' names long fallen into oblivion, attest to such creativity and genius, such as the Han dynasty bronze lamp (fig. 12) (Tip 1) and the Tang dynasty (618–907) incense burner (fig. 13) (Tip 2). These superlatively designed and exquisitely crafted objects embody both beauty and functionality; their design being an inspiring benchmark to this day.

On facing page

Fig. 12 Changxin Palace Lamp
Mid-Western Han dynasty
Height 48 cm
Hebei Provincial Museum

This bronze lamp was excavated from the tomb of Dou Wan (consort of Prince Liu Sheng of Zhongshan), at Mancheng, Hebei in 1968. It has a single point of ingress and a hollow body with a hole at the bottom. The design for this lamp, though very well known, was not as effective as others with two ingresses (for collecting smoke into the hollow body that usually holds water).

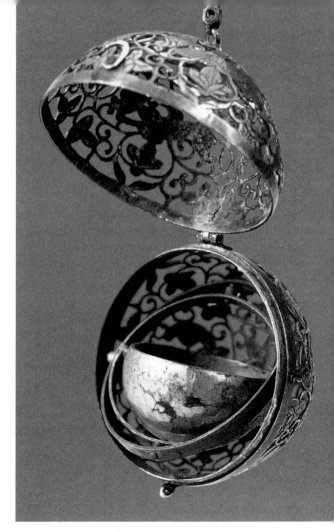

Fig. 13 Silver Incense Burner with Pierced Grape, Floral and Bird Motif
Tang dynasty
Diameter 4.6 cm, weight 36 g
Shaanxi History Museum

This silver incense burner was excavated from the site of an ancient treasure hoard at Hejia Village, near Xi'an, Shaanxi in 1970. Used both as an incense burner and hand-warmer, it was popular with the nobility during the Tang dynasty. Its openwork design allows dispersion of aroma, with a hook and chain for carrying.

Fig. 14 *Cong*-Shaped Celadon Vase from Guan (Official) Kilns

Southern Song dynasty (1127–1279)
Height 19.7 cm, rim diameter 13.5 cm, base diameter 12.6 cm
Tokyo National Museum, Japan

The vase shape was in imitation of the *cong* (square jade tube) of antiquity. Revival of archaic styles became popular during the Song dynasty and *cong*-shaped celadon vases were often made by both imperial and Longquan kilns.

2. Limitation of the Medium and Technology

Materials used to create objects of decorative art also determine their varying attributes. In ancient China, the media of decorative art were primarily pottery, metals and lacquered wood. While ceramics being mostly rounded with a limited range of suitable sizes, metals and lacquered wood allowed a higher degree of flexibility in shape and size. All this reflects the limitation of the medium. Ceramics are fashioned out of clay, which does not

Fig. 16 Blue-and-White Dish with Pine, Bamboo and Plum Motifs

Yuan dynasty
Height 1.72 cm, rim diameter 16.4 cm
The Capital Museum, Beijing

This dish was excavated from the Houyingfang site in Beijing. Dated to the late Yuan (as the jar in fig. 15), its underglaze blue is of a lighter tone. It has a delicate shape, with the pine, bamboo and plum motifs denoting attributes of a noble character.

Fig. 15 Blue-and-White Jar of "Guiguzi Descending the Mountain" Motif

Yuan dynasty
Waist diameter 33 cm

The blue-and-white wares from the Yuan times have been highly valued in recent years. This jar fetched a record price, equivalent to about 230 million yuan (RMB), at an auction in the UK in 2005. Its underglaze blue has a darker tone.

easily allow sizes that are too large or too small. When fired in the kiln, the clay body undergoes shrinkage; the larger the size, the greater the distortion. Humans are averse to irregularity in square forms and straight lines, but less so to that in curved lines or forms. Thus, ancient pottery tended to be round and of moderate sizes, while unusually large or small, or square-shaped (fig. 14) vessels were exceptions, produced according to a high standard and at greater costs.

The inventive use of materials yielded finer features. Cobalt, for example, was used to create the distinctive blue glaze of blue-and-white porcelain. However, different recipes determined varying shades of blue: heavy (fig. 15) vs. pale and elegant (fig. 16), rich and vibrant vs. dull and leaden. Even supplementary ingredients used for mixing cobalt can cause variations. Oil, which was popular with potters in the Qing dynasty (1644–1911) for blending glaze ingredients,

Fig. 18 "Eggshell" Black Pottery Stem Cup
Longshan Culture (ca. 2800–2300 BC)
Height 26.5 cm
Shandong Provincial Museum

Excavated from a site in Rizhao, Shandong. The long-stemmed wine cup, with a thickness of less than 1 mm, was exquisitely crafted, though its small foot makes it less stable. Other examples of such eggshell goblets feature a larger foot.

allowed finer, more intricate polychromatic patterns (fig. 2 on page 2), in contrast to the glue used widely in the earlier Ming dynasty (1368–1644) which tended to make the paint less wieldy, resulting in less intricate patterns (fig. 17). Such being the case, the history of decorative art is to some extent also a history of materials.

Likewise, it can further be viewed as a history of technology; technology that enabled not only the use of different materials, but also the creation of various striking features. Earthenware was first hand-molded in the Neolithic period. The invention of the potter's wheel then allowed the creation of thin-walled vessels. Without the fast-spinning potter's wheel, the "eggshell" ware (fig. 18) would have been inconceivable. For bronze casting, either the

Fig. 17 Famille Verte Jar with Cover, with Fish and Hornwort Motifs
Ming dynasty (Jiajing reign, 1522–1566)
Overall height 46 cm
National Museum of China, Beijing

Excavated from a site in Chaoyang District, Beijing, this splendid jar is a masterpiece of famille verte porcelain produced during Emperor Jiajing's reign. Its densely arranged auspicious images were cheerful and gaudy—the style of courtly wares at the time.

section molds (Tip 3) or the lost-wax process (Tip 4) was used, with only the latter being capable of producing finely detailed pieces (fig. 19). Silk produced in and after the Tang dynasty (fig. 20) had much more intricate and elaborate patterns than that of the Han dynasty and Kingdom of Wei (220–265), which only became possible with the adoption of the weft-facing weave technique.

Fig. 19 Bronze Wine Vessel, *Zun*, and Basin, *Pan*
Early Warring States period (475–221 BC)
Wine vessel height 30.1 cm, rim diameter 25 cm; basin height 23.5 cm, diameter 58 cm
Hubei Provincial Museum

The set was excavated from the tomb of Zenghouyi at Suizhou, Hubei in 1978. The wine vessel can be removed from the basin that serves to hold water for warming or cooling wine. The set has an intricate, yet somewhat cumbersome, design, with 72 cast components that were assembled by soldering.

Tip 3: Section-Mold Casting

This is a method commonly used in bronze casting at the time. A clay core with carved patterns is first encased with clay molding, with the patterns now impressed on the inner surface of the mold. The molding is then sliced into sections and removed. A thin layer, the thickness of the casting, is trimmed off the core, before the mold pieces are reassembled around the core, with a pouring gate left in place. After molten bronze is poured and cooled, the mold is broken up and the core removed. The casting with a hollow section is polished for finishing.

Fig. 20 Brocade with Hunter and Lion Motifs in Circular Dots (detail)
Tang dynasty
Full fabric length 250 cm, width 134 cm
Tokyo National Museum, Japan

Claimed to be the finest extant brocade fabric dated to the Tang dynasty, it was woven with rather exotic motifs of western-looking hunters, winged horses, outlandish flowering trees, and lions not native to China. Prior to Tokyo National Museum, it was in the collection of Horyuji Temple in Nara Prefecture, Japan.

3. Form, Decoration and Their Determinants

Both form and decoration are key to decorative design, with the exception of the two-dimensional, such as textile design. While both changed over time, form tended to vary less than decoration. Take the pottery bowl for example. While its shape remained largely unchanged, decorative patterns found on specimens from different eras are markedly different. *Meiping* vase ("prunus vase") showed little variation in shape from the Song (960–1279) through the Qing, whereas its decorative pattern changed greatly. The reason is simple: the way of living, which drove functionality and shape design, changed slowly in ancient times, while aesthetic taste, which determined decoration, was fickle and varied greatly from person to person. Thus, changes in decoration were frequent while primary forms remained rather stable.

Of objects of decorating art, vessels featured prominently. They were made from materials vastly different in value and prestige. Tea or wine vessels of jade, gold and silver, being the most precious and expensive, were the preserve of the noble, in keeping with rigid social hierarchy. Lacquered wood and ceramics, on the other hand, were crafted from less expensive and more accessible materials, usually with no restriction on their use. Catering to vanity and the obsession with luxury, ceramic and lacquer designs often copied those of gold and silver wares. While the reverse may also be true, it is the exception rather than the rule (fig. 21

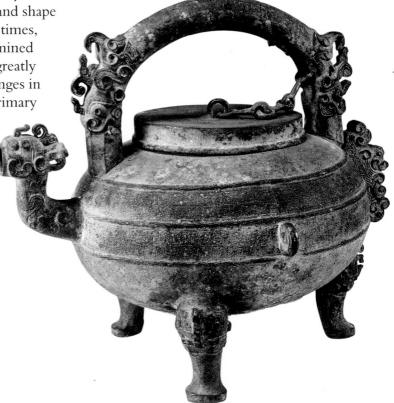

Fig. 21 Bronze Wine Vessel, *He*, with Loop Handle

Mid- to late-Spring and Autumn period (770–476 BC)
Overall height 26 cm, rim diameter 11.1 cm, weight 4.5 kg
Henan Provincial Institute of Cultural Heritage and Archaeology

This bronze vessel was excavated from a tomb at Xiasi, Xichuan County, Henan Province. Bronzes of a similar design were found at the burial sites in Shaoxing, Zhejiang, dated to the early Warring States period, an indication of its popularity at the time.

Tip 4: The Lost-Wax Method

This is a precision casting method for bronze and other metal objects still in use to this day. In ancient China, it first appeared during the Spring and Autumn period (770–476 BC). It involves first making a model out of beeswax, which is then surrounded in a clay jacket. The clay is fired to burn out the wax, drained through a hole left in the mold. After the bronze is poured and cooled, the mould will be broken up. The casting will be an exact replica of the wax model.

and fig. 23). Jade commanded the highest prestige. However, being rare to begin with and prone to damage, its use and influence was much less extensive than gold and silver. Silk, its prescribed decoration and colors signifying class, status, and changing fashion and aesthetics, had the widest and most profound influence on Chinese decorative art. Being the most visible, silk encapsulates the finest of decorative art, disseminating new styles, and inspiring emulation by artisans working in other media.

4. Aesthetic Sense and Appreciation

Beginning in the Xia (2070–1600 BC) and Shang (1600–1046 BC) dynasties, objects of decorative art were made either under imperial auspices or by private artisans. The courtly wares (fig. 22) were designed and made to serve mandated functions

according to imperial regulation, with little leeway for creative flexibility. Private artisans' output (fig. 24) were mostly for the marketplace and catered to patrons of like taste and means, on whom their livelihood depended, barring occasional custom-made items. Thus, products of both imperial workshops and private artisans were made

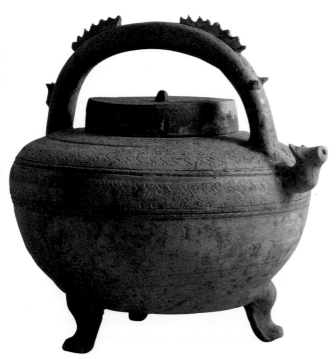

Fig. 22 Dragon Robe Embroidered with Peacock Feather

Qing dynasty
Height 145 cm, yoke and sleeves length 230 cm
Inner Mongolia Autonomous Region Museum

This official robe, originally belonging to Prince of Wuzhumuqinyouqi in the Qing dynasty, was embroidered with nine golden dragons over a band of peacock feather that turns the bronze-colored satin ground into a dark green. It was a gift from the court to the Mongolian lord.

Fig. 23 Stoneware Wine Vessel, *He*, with Loop Handle

Warring States period
Height 21.3 cm, rim diameter 8.4 cm
Shaoxing County Cultural Relics Protection Center, Zhejiang

Excavated from a site at Shaoxing, Zhejiang, this stoneware vessel has a shape and decoration that were apparently copied from bronzes. Given the physical attributes of the material, the decorative patterns were not nearly as fine as those of bronzes.

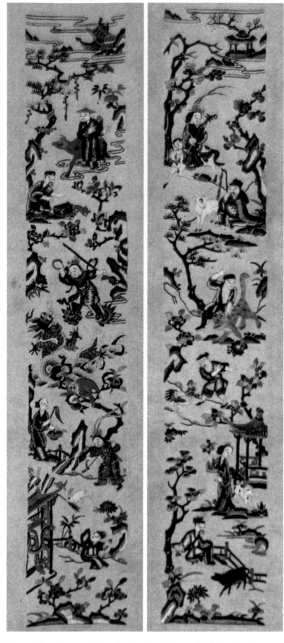

Fig. 24 Sleeve Bands Embroidered with Zodiac Motifs

Qing dynasty
Length 53 cm, width 12 cm
Suzhou Embroidery Research Center, Jiangsu

The sleeve bands were used as decoration on women's garment. The twelve embroidered animals were taken from twelve historical tales, which adds meaning to the otherwise mere zodiac symbols[1].

1 The Horse, for example, is taken from the story of Princess Zhao Jun of the Han dynasty who helped secure peace on the northern border by marrying the leader of Xiongnu, a powerful nomadic tribe. The sheep, on the other hand, is taken from the story of Su Wu (ca. 140–60 BC), who as an emissary was held by the Xiongnu chief, forced to live there as a shepherd, but refused to surrender and betray his emperor.

for certain classes of customers with their respective preferences. They show far more homogeneity than idiosyncrasies found in poetry and painting. The latter being either expressions of inner landscape or self-indulgence. Therefore, by studying decorative art, we can have a holistic and deep understanding of the aesthetic taste and changing fashion of a certain era, much more than other forms of art.

In addition to their usefulness, objects of decorative art, though not intended to be spiritually uplifting or morally instructive, have no less influence on the human mind than pure art. For one may live without appreciating art, but not without objects made by artisans and craftsmen, when one goes about the business of living. Even the plainest has a finished form and a certain color (fig. 25). One needs no extra effort to be charmed by their visual and formal language, which subtly cultivates one's sense of beauty and ultimately aesthetic judgment. Such unique influence is more powerful and enduring than that of other forms of art.

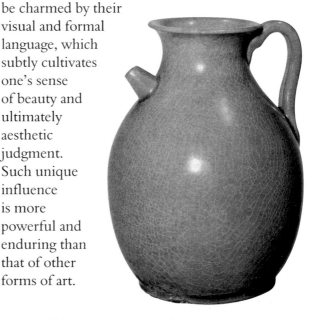

Fig. 25 Celadon Ewer from Yue Kilns

Tang dynasty
Height 14.3 cm, rim diameter 6.1 cm
The Palace Museum, Beijing

This celadon ewer was excavated from the tomb of the wife (d. 810) of Wang Shuwen, a Tang court official, in Shaoxing, Zhejiang Province in 1936. A product of the late Tang, its glaze has a warm luster, with a fine allover crackle, which was very popular at the time.

5. Cultural Mainstay and Mode of Production

Imperial workshops were well funded and supplied, with capable craftsmen employed at the state's service to produce superlative items for the ruling elite. Output under imperial auspices represented the cultural mainstay of the era, given dominance of the ruling class. Objects produced for the marketplace or personal use by private artisans, who were nowhere near their counterparts in the imperial employ in resources and technical prowess, were somewhat coarse by comparison. In hierarchical ancient societies, decorative art was a statement of status, following strict codes for the use of material, medium, decoration, and color. The humbler the user's station is, the greater the restrictions. However, private artisans often borrowed formal and stylistic elements of imperial masterworks, as long as they stopped short of breaking any mandated rules. This also created a homogenizing tendency in spite of hierarchical restrictions. Some private artisans' creations even closely resembled those of imperial workshops (fig. 26), risking code violation.

Design and stylistic uniformity often dominated the output of imperial workshops,

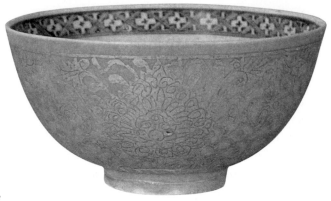

Fig. 26 Bowl with Intertwined Floral Pattern Painted in Gold over Green Glaze
Ming dynasty (Jiajing reign)
Rim diameter 11.5 cm
Japanese private collection

This splendid Jingdezhen ware is most lavishly decorated, probably of the kind described by a contemporary as "a dish or jar painted with gold may well fetch ten taels of gold; the worth of a well-to-do household."

Fig. 27 *Huanghuali* (Fragrant Rosewood) Lowback Luohan Bed
Ming dynasty
Height 75.6 cm, length 210.8 cm, width 75.6 cm
The Nelson-Atkins Museum of Art, Kansas City, U.S.

The shape of the bed, and the feel and texture of the rosewood, are most remarkable. The back railing was more beautiful than the sides. Using the choicest material for the most visible part was a common practice in Ming furniture production.

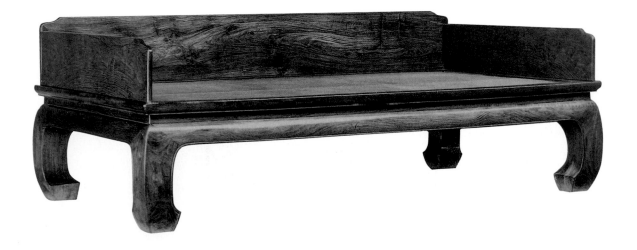

with variations intended for the court and the hierarchy of officialdom. Rare exceptions of superior craftsmanship were sometimes found in private artisans' creations for literati patrons. They show timeless charm and elegance (fig. 27), emblematic of scholarly sophistication and aesthetic aspiration of the *shi* (literati) class, which stood apart from the run of the mill. Such objects first appeared in the Song, and were highly sought after in the Ming and Qing dynasties.

With the exception of pottery kilns, workshops producing handcrafted items were mostly located in and around towns, forming clusters of artisanal excellence. Trading of goods and commerce took place in towns, which not only allowed the sale of artisans' products, but also encouraged competition, boosting innovation in form, decoration and technique. Pottery kilns, barring those under imperial auspices that tended to be small in size, had to be situated away from towns, their production requiring massive extraction of clay and minerals, and the collection and burning of wood fuel, causing inevitable dust and smoke.

6. Stylistic Elegance and Diffusion of Civilization

Chinese art is characterized by subtle, understated elegance, in contrast to Western art. Such elegance can be extensively seen in Chinese decorative art. Even the finer courtly wares made in and after the Song show beauty in form, material and color (fig. 28 and see fig. 29 on page 20), let alone items made for the literati. Many of them are plain, unadorned, and of classical elegance, with prized noble, exquisite craftsmanship. This is in sharp contrast to the lavishly colored and elaborately pierced objects with gold inlay

Fig. 28 Celadon Bowl from Ru Kilns
Northern Song dynasty
Height 6.8 cm, rim diameter 16.8 cm, foot diameter 7.5 cm
The British Museum, London, U.K.

Believed to be a Northern Song courtly ware made by Ru kilns, it is an extremely elegant piece. According to Song reports, agate was used as a glaze ingredient at Ru kilns, which has been confirmed by scientific testing. Prior to the British Museum, it was in the collection of Percival David Foundation of Chinese Art.

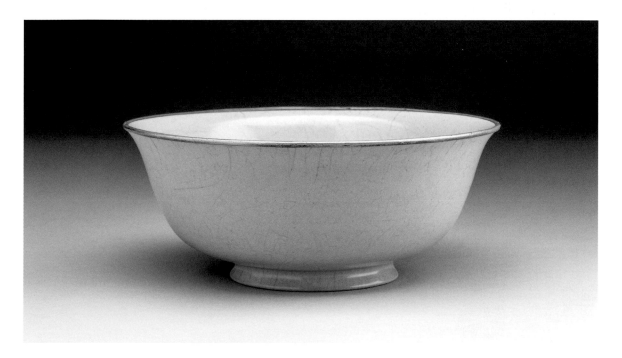

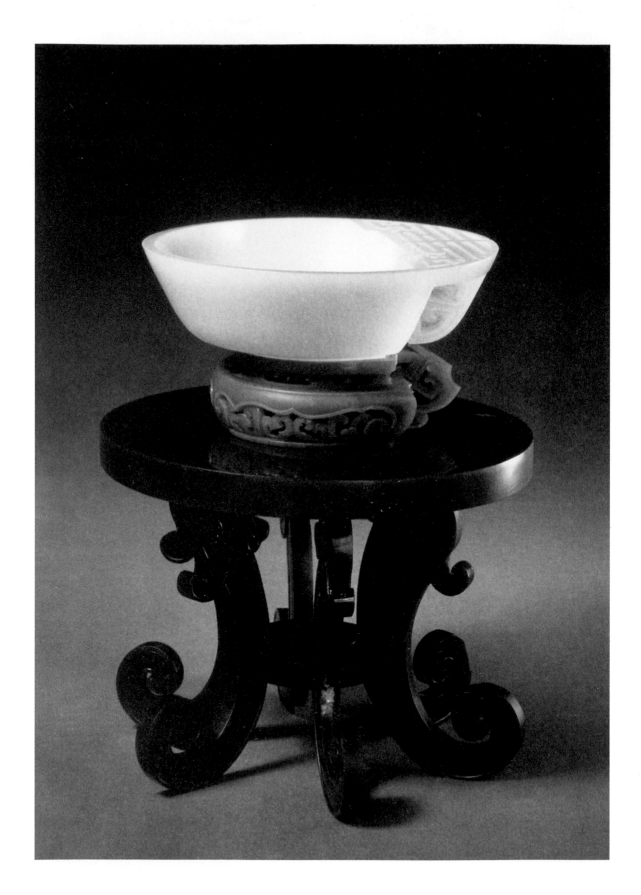

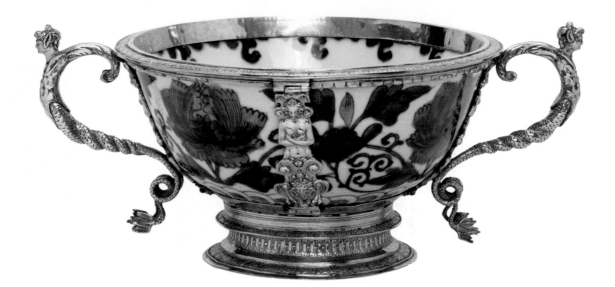

made in the West. Chinese decorative art values understated elegance, while allowing formal and pictorial exaggeration quite removed from reality; eliciting the inner quality, rather than mere mimicry, of what is represented. Subtle hints and evocative power that lingers were preferred, while the explicit and artless shunned. An object of such understated and enduring beauty is something to behold, inspiring contemplation. Superbly created by the Chinese artisan, the graceful, understated elegance is what sets Chinese decorative art apart.

Ancient Chinese decorative art has been widely celebrated. Silk and porcelain that were invented in China remained for a long time at the pinnacle of their respective medium. Chinese decorative art represented the only uninterrupted tradition of timeless artistry in the world. Decorative art occurred

On facing page

Fig. 29 Jade Brush Washer with Carved Character for "Longevity"

Qing dynasty (Qianlong reign, 1736–1795)
Overall height 22 cm, rim diameter of the washer 13.5 cm
The Palace Museum, Beijing

A splendid work from the imperial workshop, the jade washer, finely ground and polished, shows a transition in tone, lighter at the top and darker at the base, giving an enhanced sense of stability. Its apparent simplicity is underscored by great aesthetic sophistication.

Fig. 30 Gilt Silver Mounted Blue-and-White Bowl

Bowl, Jiajing reign of Ming dynasty; silver mount, England, 1599
Height 16.6 cm
Victoria and Albert Museum, London, U.K.

The blue-and-white bowl was produced by a private kiln in China sometime in the early 16th century, but was mounted with precious metals for a British noble in 1599; indicative of the great value placed on Chinese porcelain.

in other parts of the world, too, some having origins earlier than China's, and products more splendid than contemporary Chinese equivalents. Yet none of those traditions survived, or remained unaltered by, foreign military and cultural conquests. Chinese decorative art, part of the millennia-old Chinese cultural tradition, continued uninterruptedly, despite brutal intrusions of the West, whose influences were quickly assimilated.

Chinese civilization also spread with its decorative art, which for a long time was the chief conduit of its diffusion. Language and intellectual barriers made Chinese art, literature, and thought inaccessible to people of distant lands. However, Chinese silk and ceramics enjoyed worldwide repute; objects of beauty and utility to behold and be cherished (fig. 30). Through their use, people in distant lands came to know and appreciate the glorious achievements of the Chinese civilization.

THE PRIMITIVE SOCIETY

(Prehistory–2000 BC)

Archaeologists have dated the earliest human presence in China to 1.8 million years ago. Decorative arts appeared sometime in the evolution of the early humans. The rich finds at the "Upper Cave Man" site at Fangshan, Beijing were 30,000 years old. Many objects made from stone, animal bones, teeth and shells and decorated with incised lines, pierced holes and traces of coloring, were found at the site. Apart from serving ritual purposes, they also reflect an appreciation of objects of beauty by the early humans.

Origins of art has long been a subject of debate in the academe, thanks to the scarcity of evidence and profusion of rivaling ideas, theories, and methodologies. However, what is certain is that the first inkling of art, and that for decorative art, too, did not arise from pure aesthetic needs of the primitive man with budding intelligence struggling for subsistence. There was at least a close link with nature worship or totemic

Fig. 31 Stone Adze with Shank
Dawenkou Culture (ca. 4500–ca. 2500 BC)
Length 14 cm, width 4.3 cm, height 3.4 cm
Shandong Provincial Museum

Excavated from a burial site at Dawenkou ruins in Tai'an, Shandong in 1959. Fashioned out of siliceous limestone, it is finely finished and regular in form, showing beautiful texture; technically daunting even for the craftsman today. The projection in the middle is for attachment of handle.

Tip 5: Totem

Totem, derived from an Ojibwa word, refers to emblems and symbols representing various native tribes and clans. Existing in matriarchy societies and onward, they represented ancestors and guardian spirits believed to exist in animal, plant or other natural forms. They also became significant motifs in early decorative arts.

beliefs (Tip 5). The painted pottery objects found at the Dahe Village site dated to the Yangshao Culture (ca. 5000–ca. 3000 BC), for example, had recurrent patterns of the sun and the moon, which should indicate nature worship. Scholars pointed to the fish patterns on painted pottery from the Banpo site and bird patterns from the Miaodigou site, both belonging to the Yangshao Culture, as representing totemic symbols worshipped by the primitive tribes.

Different regions of China entered the Neolithic Age around 6000 BC. Stone tools (fig. 31) were extensively shaped by grinding and polishing; resulting in more sophisticated forms and polished surfaces. Drilling and

piercing reached maturity. Stones were carefully selected for suitable hardness, color and texture. Many of the crafted stone objects were no longer mere tools, for they show such attributes as desirable texture, touch, proportion and symmetry that are peculiar to decorative art. The techniques and some of the materials used in this period were later used in making early jade objects.

According to definitions by the Society of Chinese Mineralogy, jade stone is of either tremolite or augite. This would not have made any sense to the early humans who simply thought jade as a beautiful stone. The term in ancient China covered a variety of jade-like stones, some of which are not regarded as jade proper today, such as agate, rock crystal, and lapis lazuli. This was particularly true in prehistoric times, when rocks handily available were used for creating decorated items.

Even though jade stone was difficult to cut, carve and polish with rudimentary tools due to its hardness, the jade craft (Tip 6) had become well developed by the late Neolithic Age. Special attention was given to color and texture when selecting stones. Finished jade objects were well polished with a warm luster and intricately carved patterns. Some were fashioned in the shape of stone axe or scraper, showing a link to tools of the Neolithic period. More common were decorative and ritual items, which set jade apart from other

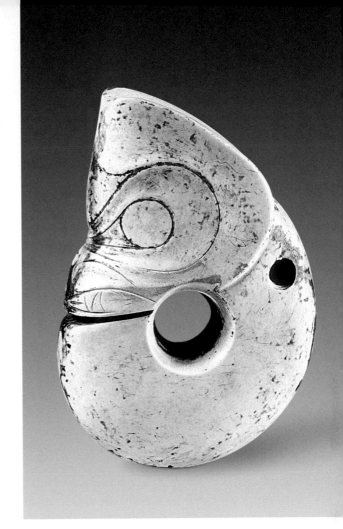

Fig. 32 Jade Beast-Form Pendant, *Jue*
Hongshan Culture
Height 15 cm, max width 10 cm, max thickness 4 cm
Liaoning Provincial Museum
Excavated from a site at Jianping, Liaoning. Having no textual references, scholars have given various names to such stylized beast forms of antiquity. This particular type has also been called "hog-dragon" jade pendant.

Tip 6: Jade Art

Of extreme hardness, jade had to be drilled and ground on rotational machinery with an abrasive paste of diamond sand, to become objects of sophisticated forms with intricate carving. Later, the spinning disk was invented. It had a sharp edge, mounted on a handle pulled back and forth by using a coiled rope, or was later powered by the foot-treadle, before they were succeeded by advanced modern jade-working machinery.

decorated implements. Examples of such primitive jade objects were found extensively in China, including at sites of the Hongshan and Liangzhu cultures, which are most representative of Chinese jade of the period.

Decorative objects found at the Hongshan Culture (ca. 4500–3000 BC) sites, in present eastern Inner Mongolia, western Liaoning, and northern Hebei, were often fashioned as pedants in stylized animal forms, with drilled suspension holes (fig. 32). Some small jade hawks were carved in a charming

form that was nearly square (fig. 33). However, the most extraordinary is the relatively large C-shaped dragon pendant (fig. 34), with incised details, true to the Chinese tradition of dragon iconography. It has such a graceful, delicate, and vivid form that, when vertically placed, it looks as if it were poised to leap and take flight.

The Liangzhu Culture (ca. 3300–ca. 2200 BC) sites, where a large number of the most beautiful jade artifacts were found, are scattered around the Taihu Lake. The most representative

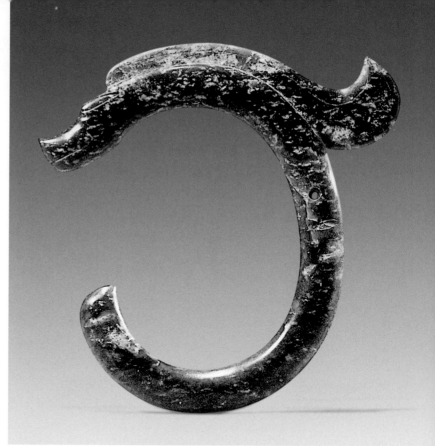

Fig. 34 Jade "Dragon" Pendant
Hongshan Culture
Height 26 cm, cross-section diameter 2.3–2.9 cm
National Museum of China, Beijing

Unearthed from a site at Sanxingtala Village, Wengniute Prefecture, Inner Mongolia in 1971. The photo shows how it is usually displayed in the museum or catalogue. However, if it were hung from a lace looping through the hole in the middle, the head of the dragon would droop and the tail curl downward; rather uninspiring in effect.

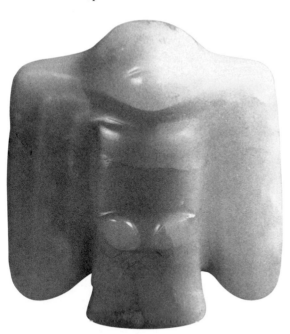

Fig. 33 Jade Hawk Plaque
Hongshan Culture
Height 5.7 cm, width 5.2 cm
Tianjin Art Museum

Artifacts of Hongshan Culture, erstwhile deemed merely as archaic, had been collected long before scientific dating was possible. Advances in archaeology helped to correctly date them.

are the objects for imperial ceremonies and ritual purposes, such as *cong* (square tube with cylindrical interior) and *bi* (disk with central orifice), and *yue* (axe, fig. 35), an icon of imperial authority. *Cong* is the largest of all Liangzhu Culture jade artifacts, with either a slender and tall form, or a solid and sturdy design. The largest *cong* (fig. 36) weighs as much as 6,500 grams. Decoration of the *cong*, with varying complexity, was usually more elaborate than other jade objects. Frieze or incised patterns of strict symmetry, and human or animal masks were principal motifs

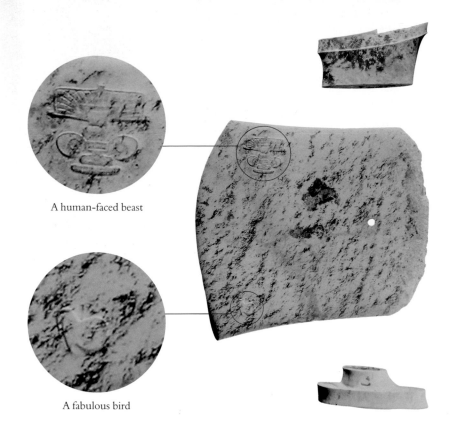

A human-faced beast

A fabulous bird

Fig. 35 Jade *Yue* (Axe)
Liangzhu Culture
Length 17.9 cm, upper end width 14.4 cm, blade width 16.8 cm, thickness 0.8 cm
Zhejiang Institute of Cultural Heritage and Archaeology

Excavated from Tomb No. 12 at Fanshan site, Yuhang, Zhejiang in 1986. The axe-like *yue* was a soldier's weapon. The two smaller pieces (above and below) are ornaments for both ends of the handle. Both sides of the blade are incised with a human-faced beast above a fabulous bird, though jade axes from Liangzhu Culture sites are mostly undecorated.

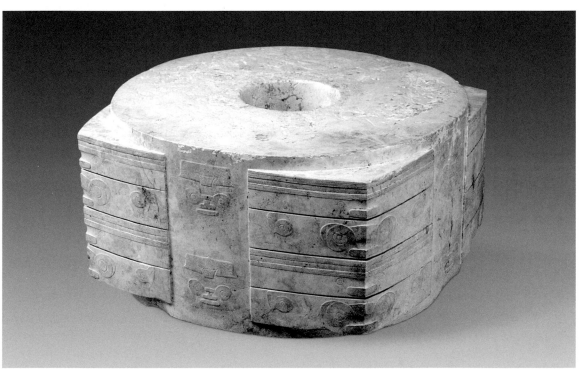

Fig. 36 "The King of *Cong*"
Liangzhu Culture
Height 8.8 cm, square border 17.1 by 17.6 cm, weight 6,500 g
Zhejiang Institute of Cultural Heritage and Archaeology

Excavated from Tomb No. 12 at Fanshan site, Yuhang, Zhejiang in 1986. Named the "king of *cong*" for its massive size and highly intricate decoration, it is incised with 16 animal masks of varying complexity in design.

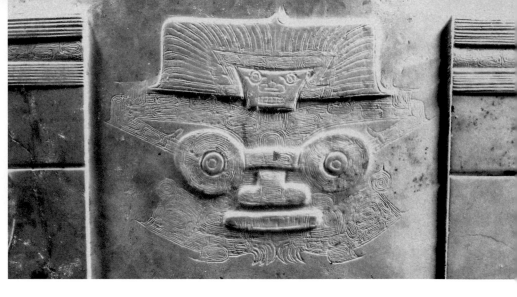

Fig. 37 Animal Mask Pattern

Detail of carved pattern in fig. 36 on page 25. It features a crouching spirit-being with a large feathered crown and curved arms holding an enormous animal mask. The pattern is only 3–4 cm in width.

(fig. 37). Researchers believe that the use of animal-faced figures marks the beginning of a ritual practice focused on such spirit-beings. The incised lines, of dazzling craftsmanship, were so intricate as to match today's microscopic carving. The green jade *bi* was said to be used in ritual ceremonies in honor of the celestial god while the cream-white *cong* for its earthly counterpart. However, the jade *bi* from the Liangzhu Culture sites, typically not as refined, was probably not so nobly intended at the time.

Pottery-making indicated the advent of the Neolithic Age. Pottery of considerable hardness, made from soft, loose clay, was an ingenious invention of the early humans. The early types included red, grey, black and white pottery. Potting techniques included pinching by hand (Tip 7), coiling (Tip 8) and the potter's wheel (Tip 9) that appeared successively. The molded clay body was smoothed and polished, or applied with engobe. Painting and paddle decoration, and appliqué pieces were added. Other methods of decoration included incision (fig. 38) and perforation. Firing temperatures ranged from 800 to 1,000°C (Tip 10). The best known is the ancient painted pottery.

Tip 7: Pinching by Hand

Pinching by hand, a clay-molding method, is used for making small ceramic objects with usually irregular forms.

Tip 8: Clay Coiling

This method involves first rolling the clay into long coils, layering them, one at a time, and then brushing on a slurry or slip and welding the layers together to create a solid form. It is often used for building pottery jars of larger sizes and thick walls.

Tip 9: Potter's Wheel

Throwing a pot on the potter's wheel involves centering the clay on the wheel and using both hands to push the clay up and down, into the desired form, with the wheel rotating at speed. First in use around the middle of the Neolithic period, the wheel allowed the creation of cylindrical forms and walls of even thickness. Wheels rotating at slower speeds preceded faster ones that made extremely thin-walled pots possible.

Tip 10: Firing

Pit-firing, albeit at lower temperatures, is the oldest method of clay firing. Later, coal or wood-fired kilns appeared which could reach higher temperatures for firing vessels of greater hardness. By controlling the amount of oxygen in the kiln's atmosphere during firing, the color and texture of the clay can be altered. The oxidation atmosphere is used for firing red pottery, while the reduction process, when oxygen is leeched out of the kiln atmosphere, produces the grey ware.

Fig. 38 Black Pottery Jar with Hooked Thunder Scroll Pattern

Songze Culture (ca. 3900–3200 BC)
Overall height 26.3 cm, rim diameter 15.2 cm
Shanghai Museum

Unearthed from a burial site at Songze in Qingpu, Shanghai in 1974. The grey pottery urn is covered in a black slip on the outside and incised with a neat and vigorous pattern of hooked thunder scrolls; displaying great workmanship.

Patterns were painted in black, brown or white on the shaped clay body before being fired to produce red pottery. Such a technique produced patterns that would not flake off easily, unlike those painted later on fired body. The former was used mostly on pottery ware for everyday use while the latter served ritual and burial purposes.

Animal, plant, human motifs (fig. 39) and geometric patterns of curved or straight lines (fig. 40)—the most prevalent—were commonly found in decoration on painted pottery. Animal motifs such as fish and bird often became the subject of debate, with some pointing to their origins in totem worship, while others believing they were symbols of farming and nature. As for geometric patterns, most scholars believed that at least some were abstract representations of fish,

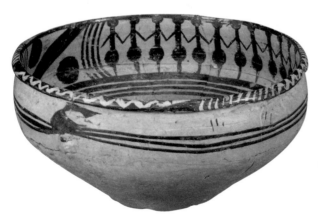

Fig. 39 Pottery Basin Painted with Dancing Figures

Majiayao Culture (ca. 3000–ca. 2000 BC)
Height 12.5 cm, rim diameter 22.8 cm
Qinghai Provincial Institute of Cultural Heritage and Archaeology

Unearthed at the Zongri ruins in Tongde County, Qinghai in 1995. The inside of the basin is painted with two groups of dancing figures, all hand-in-hand; one having 11 and the other 13 people. The dance should hold significant ritual meaning for the clan.

Fig. 40 Double-Handled Pottery Jar Painted with Lozenge Pattern

Banshan phase, Majiayao Culture
Height 15.3 cm, rim diameter 12.8 cm
Gansu Provincial Museum

Unearthed at Shajingyi near Lanzhou, Gansu. The lozenge pattern looks almost modern, akin to that of the chess board or checkered flooring.

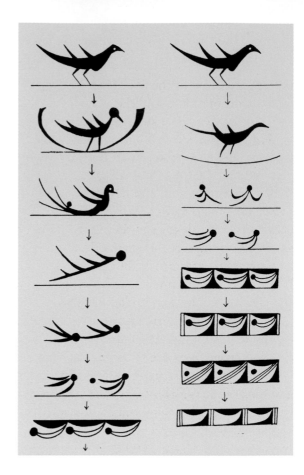

Fig. 41 Evolution of Bird-to-Geometric Patterns Found at Miaodigou Site

The chart illustrates the conjectured evolution from bird profile to abstract, geometric patterns found on the painted pottery of the Miaodigou phase. Courtesy of Zhang Pengchuan, *Patterns on Ancient Chinese Painted Pottery*.

bird or other animal forms (fig. 41), while others production tools. The netlike pattern, for example, could have been inspired by the fishnet and the eight-point star a weaving loom component. Although origins of most decorative patterns remain obscure, it can certainly be said that they reflect apparent utilitarian inclinations, with little consideration for pure aesthetics; a general tendency at the time.

The vessels were painted on the upper one third of the body, easily within the scope of vision of the user, while the rest, usually hidden from view, was left undecorated

Fig. 42 Ancient and Modern Man's Line of Sight and Angle of View

The areas decorated on the surface of an object have much to do with the usual line of sight and angle of view of the user. This chart and the illustration in fig. 43 are from *On Areas Decorated with Pictorial Patterns and Bands on Neolithic Painted Pottery* by Yang Hong.

Fig. 43 Perception of Zigzag Pattern on Pottery Jar of Banpo Phase

As the line of sight is elevated, the zigzag lines become flower petals. The rim, having no relation to the pattern in a frontal view, becomes the center of an eight-lobed flower design in a top view.

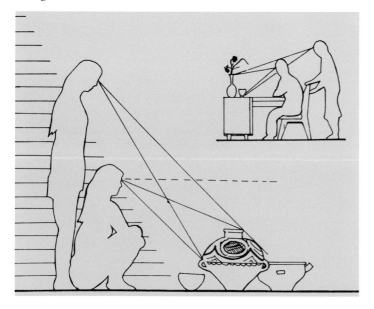

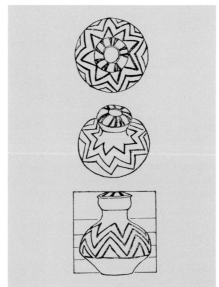

(fig. 42). Because of the curved surface, the effect of decoration could also change with the angle of view. The zigzag wave pattern viewed from the side, for example, would look like an eight-petal flower (fig. 43) when viewed from the top. Decorative styles varied from region to region, and traditions were passed down and carried on. Despite regional variations, most designs of the painted pottery showed a strong sense of spatial rhythm and increasing mastery of formal symmetry, balance, repetition, interval and contrast, manifesting timeless charm and artistry.

Primitive pottery artifacts were found extensively in China. Those from the Yellow River drainage basin are generally considered as having the highest artistic attainment, although pottery-making in other regions, such as the Yangtze River drainage basin, was also well developed. The Yangshao and Majiayao (ca. 3000–ca. 2000 BC) cultures in the upper and middle Yellow River regions are famed for their painted pottery, so are the Dawenkou (ca. 4500–ca. 2500 BC) and Longshan (ca. 2800–2300 BC) cultures of Shandong.

The Banpo (fig. 44) and Miaodigou (see figs. 7 and 8 on pages 6 and 7) sites of the Yangshao Culture, and the Majiayao (fig. 45 and see fig. 39 on page 27), Banshan (see fig. 40 on page 27) and Machang sites of the Majiayao Culture were all renowned for their finely painted pottery wares. The Majiayao Culture was most prominent for the abundance and varied decoration of its

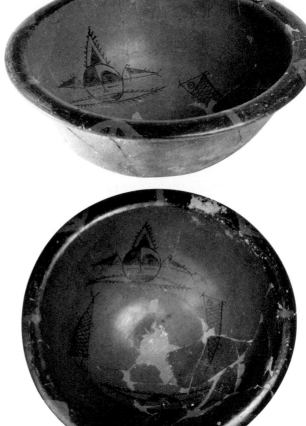

Fig. 44 Pottery Basin Painted with Mask and Fish Motifs

Banpo phase, Yangshao Culture
Height 16.5 cm, rim diameter 39.5 cm
National Museum of China, Beijing

Unearthed from the Banpo site near Xi'an, Shaanxi in 1955. The use of urns for child tombs was a burial practice in Yangshao Culture. The basin here was used as a burial urn cover.

Fig. 45 Swirl Pattern Painted Pottery Amphora

Majiayao site, Majiayao Culture
Height 25.5 cm, rim diameter 7 cm
Gansu Provincial Museum

Unearthed at Lujiaping site in Longxi, Gansu in 1971. The ovoid body tapering to narrow base is a rather efficient design for fetching water and being placed vertically in earth.

Fig. 46 Pottery Jar Painted with Petal Patterns
Dawenkou Culture
Height 19.5 cm, rim diameter 7 cm
Nanjing Museum, Jiangsu

Excavated from the Dadunzi site in Pixian, Jiangsu in 1966. The jar is finely potted in a slender form, typical of designs found in coastal regions. It is exquisitely decorated with patterns in brilliant colors that resemble painted pottery of Yangshao Culture.

painted pottery, unmatched by other cultures of the Neolithic China, reaching unsurpassed heights in pottery art.

The Dawenkou Culture, in addition to its exquisite painted pottery (fig. 46), also produced thinly potted black wares that are remarkably delicate and unique and rare white wares of increased hardness. Some vessels had complex forms or were molded in animal shapes. The Longshan Culture in Shandong succeeded the Dawenkou Culture, with exquisite white wares (fig. 47) and the more prominent black pottery. Mostly wheel-made, the finer ones had very thin and even walls of less than 0.5 mm in thickness. They were finely potted in delicate, tall or slender forms, with intricately incised or pierced decorations (see fig. 18 on page 13). The "eggshell" ware represented the highest achievement in pottery of the primitive age. Widely distributed in eastern China, such highly refined black

Fig. 47 White Pottery Cooking Vessel, *Gui*
Longshan Culture
Height 29.7 cm
Shandong Provincial Museum

Unearthed from a site in Weifang, Shandong in 1960. The pottery *gui* was used for cooking food. The bulbous feet could increase exposure to heat. The splendid design is in the form of chirping bird.

wares were found at sites of the Liangzhu (fig. 48) and the earlier Hemudu cultures in the south, in addition to those of the Longshan Culture in Shandong. The technique was used for not only black ware, but also painted pottery. Specimens were found at sites of the Daxi (ca. 4400–ca. 3300 BC) and Qujialing (ca. 5300–ca. 4600 BC) cultures in the Yangtze River drainage basin. However, their decoration did not match the level of sophistication of those found along the Yellow River.

The bulbous form of the ancient pottery was apparently inspired by that of the sphere, with most shapes being an expansion, compression or cutaway of the typical globe. Such a design allowed maximum volume with sparing use of clay. It also reduced distortion in firing and enhanced durability, all scientifically sound. Ancient craftsmen had a good sense of dimension and proportion. The rim of the pottery basin was usually around 30 centimeters in diameter, less than the typical shoulder-width, which made it easy to hold. The rim of the bowl was usually about 15 centimeters across, with roughly a 2:1:1 ratio for the rim, base and height, which offered best stability and is followed to this day.

Other decorative arts also evolved. Objects made from animal bones, horns or tusks often had decorative patterns. Lacquer ware, first invented in China, adopted more refined techniques of colored painting and jade inlay. Simple decorative patterns also appeared on fabrics of flax, kudzu, silk and wool that were soft to the touch, fitting, pleasing to the eye, and offering better insulation; their invention was a breakthrough of great significance in the history of civilization.

Great achievements in decorative arts by the primitive humans had influence on arts in later eras. The zoomorphic patterns on ancient jade were used as decorative motifs on bronze vessels in the Shang and Zhou (1600–256 BC) dynasties. Distinctive vase shapes

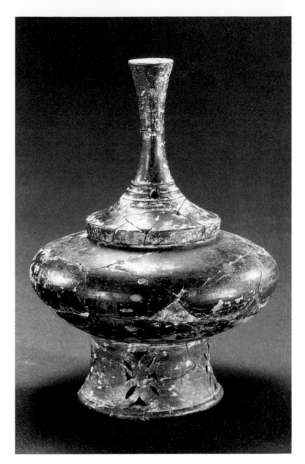

Fig. 48 Black Pottery Jar with Cover
Liangzhu Culture
Overall height 21.8 cm, rim diameter 7.6 cm
Shanghai Museum

Unearthed from Fuquanshan site in Qingpu, Shanghai in 1986. Its cover is designed with a tall, slender finial. The compressed round body tapers to a raised foot with three pierced patterns. Both the cover and body are painted with decorative bands in reddish brown.

of pottery antiquity were adopted in bronze casting. By the Song dynasty, jade *cong* became the most admired formal standard in ceramics (see fig. 14 on page 12). Silk, being the ideal fabric, dominated the development of Chinese decorative styles with its distinctive patterns. Pottery, as well as its successor porcelain, remained the favorite medium for everyday wares. Chinese silk and pottery, their invention during this period being of great significance, not only continued to advance in China with remarkable achievements, but was to have an enduring and far-reaching impact on decorative arts around the world.

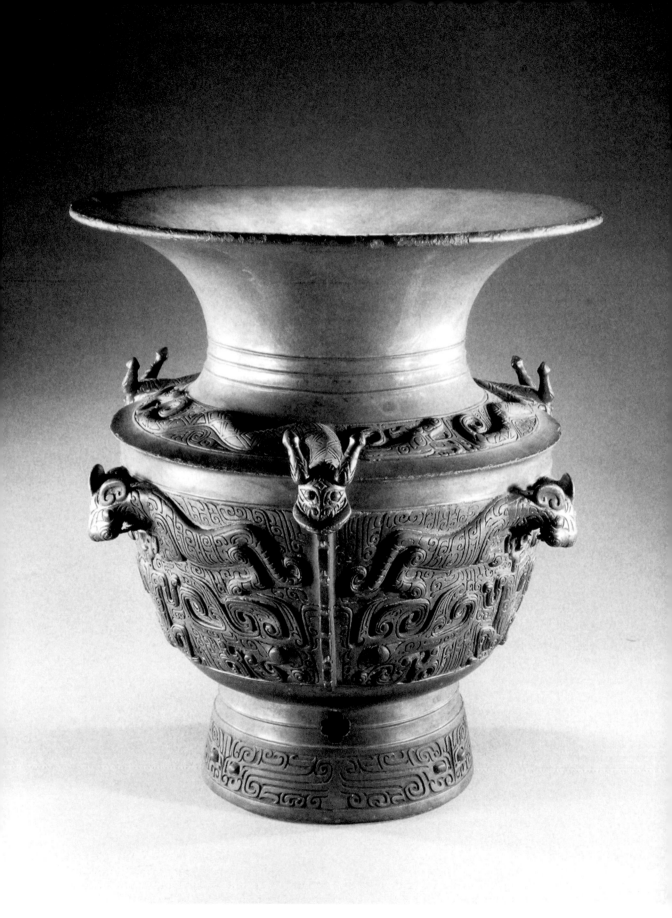

THE XIA, SHANG, AND WESTERN ZHOU DYNASTIES

The Xia Dynasty (2070–1600 BC)
The Shang Dynasty (1600–1046 BC)
The Western Zhou Dynasty (1046–771 BC)

Bronze Age is a phase in human history when bronze was used as an important material in creating utensils and vessels. In China, the Bronze Age began in the 21st century BC and continued well beyond the 5th century BC (or as late as the Warring States period, 475–221 BC). Bronze represented the most glorious of ancient Chinese art in the current period, reaching its first peak in the late Shang and early Western Zhou dynasties.

Xia, the first Chinese dynasty, was founded by Yu, the leader of his clan, in the area that covered the present southern Shanxi and western Henan provinces. Pottery making was thought to have been well developed during the Xia dynasty; so were bronze casting (fig. 50), and jade and bone carving on a significant scale. However, no artifacts have so far been found to demonstrate the extraordinary achievement of decorative crafts of the period, though the Xia tradition could be assumed to have been carried on by the later dynasty.

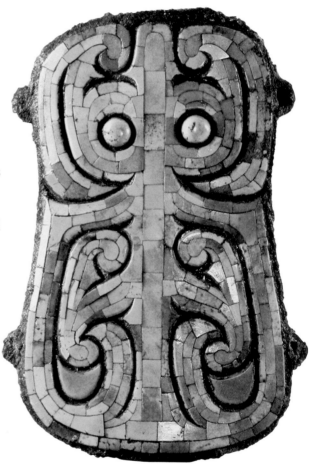

On facing page

Fig. 49 Bronze Wine Vessel, *Zun*, with Dragon and Tiger Motifs

Mid-Shang dynasty
Height 50.5 cm, rim diameter 45 cm, weight 16.6 kg
National Museum of China, Beijing

Unearthed at the Runhe site near Zhuzhai in Funan, Anhui in 1957. The rounded body is cast in relief with panels, between notched flanges, of double-tiger fiercely devouring human prey; a recurrent motif on Shang dynasty bronzes.

Fig. 50 Mask Motif Bronze Plaque with Turquoise Inlay

Late Xia dynasty
Height 14.2 cm, width 9.8 cm
Institute of Archaeology, Chinese Academy of Social Sciences

Excavated from the Erlitou site at Yanshi, Henan in 1981. It is the earliest known bronze with an animal mask motif. Turquoise had long been used as chief material for inlay decoration in various media.

The Shang people that defeated the Xia came from the east. They were fond of consulting the oracle bones, reverent of a supreme celestial deity and other spirit beings, and pleasure-seeking. In a system that relied heavily on penal punishment rather than code of conduct and moral dictates, the Shang kings, with assured ascendance to god-like status in afterlife, enjoyed absolute authority. Solemn, sacred rituals took place regularly, where myth and fear reigned. Various crafts developed and bronze casting flourished, which increasingly took on forms and decorations of haunting and awe-inspiring power (fig. 51). They reflected the dominance of the patriarchal clan system and were emblematic of its religious beliefs and prescribed mores.

The last tyrannical king of the Shang dynasty was defeated by the Zhou (1046–256 BC), a people who had come from the area between Fufeng and Qishan in modern Shaanxi. The animistic practices began to wane in the Western Zhou period

and rituals were reduced to those for the celestial and earth gods and ancestral spirits only. Hedonistic tendencies were suppressed and alcoholism prohibited. The patriarchal system was entrenched and the royal ruler exulted as the son of heaven. Elaborate rituals and music were at the center of a system governed by kinship and tribal rules, and the ubiquitous, formidable order of hierarchy. Bronze art in the early Western Zhou was essentially a continuation of the late Shang tradition, imparting a mysterious, haunting power. However, by the mid-Western Zhou, reserved, regular forms became prevalent

Fig. 51 "Fuhao" Bronze Square Container with Cover, *Yi*
Late Shang dynasty
Height 60 cm, rim length 88.2 cm, rim width 17.5 cm, weight 71 kg
National Museum of China, Beijing

Excavated from the tomb of Fuhao at Yin Ruins in Anyang, Henan in 1976. The double-chambered container is designed in the form of a miniature palace, which has been modeled on in reconstructing Shang dynasty buildings.

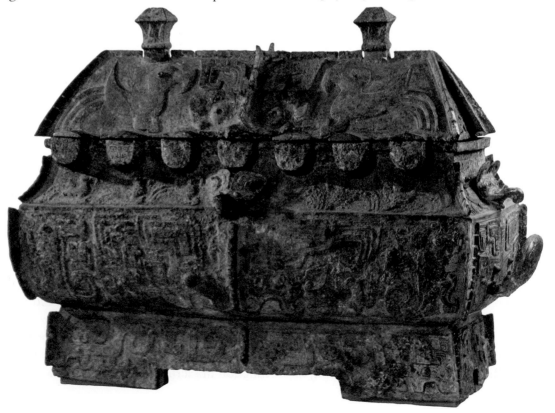

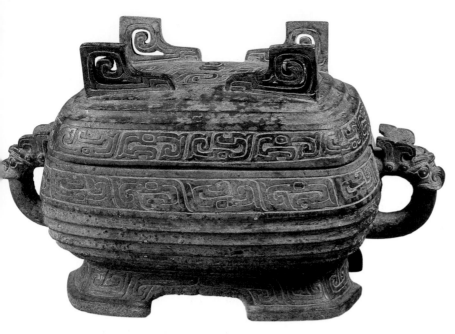

Fig. 52 "Boduofu" Bronze Food Container, *Xu*

Late Western Zhou dynasty
Overall height 21.5 cm, rim length 17 cm, rim width 25 cm
Zhouyuan Museum, Fufeng, Shaanxi

Excavated from the site of a treasure hoard in Fufeng, Shaanxi in 1971. The bronze container was named after Boduofu mentioned in the inscription on the vessel. The patterns include hooked "S" lines extending along the rim of the vessel and the edge of the cover, with fluting both above and under them. Some bronze vessels at the time were decorated with fluting only; rather coarse in appearance.

and decoration more modest (fig. 52). They denoted the patriarchal, hierarchical order, more than religious and mythical beliefs, though examples of the latter can still be seen in archaeological finds.

In the Xia, Shang, and Western Zhou dynasties, bronze represented the best of metalwork technology at the time. Bronze featured most prominently in the affairs of the state, indispensable to rituals and warfare, both paramount for primitive societies. In ceremonies staged for animistic gods and spirits of clan ancestors, the inexplicable, awe-inspiring iconography on ritual and musical instruments facilitated the praying for protection by the celestial deity, river and mountain gods and other spirit beings. Bronze weapons aided battles, conquests, and the maintenance of authority. Bronze objects were also symbols of patriarchal order and ruling hierarchy. This is particularly true with the Western Zhou, when ritual vessels served different ceremonies according to strict rules.

Bronze is an alloy of copper and tin, which gives it enhanced hardness and aesthetic appeal. The earliest examples of Chinese bronze were found at late Neolithic sites in the Yellow River drainage basin. According to ancient legends, the casting of *ding*, a round or square vessel on three or four solid legs, first appeared in the Xia dynasty. Bronze vessels, weapons of sophisticated designs, and plaques with intricate animal mask patterns and turquoise inlay (see fig. 50 on page 33) were found at the Erlitou site in Yanshi, Henan, though the precise dating of the Erlitou Culture, i.e. whether it represented the Xia dynasty proper or the late Xia and early Shang, is still a matter of scholarly debate. By the mid-Shang, the range of vessel types was largely complete, with many being of tremendous sizes (see fig. 49 on page 32), thin-walled and with broad, flat bands of simple decorations.

The art of Shang bronzes reached a glorious height towards the end of the period. It was represented by the great number and variety of bronzes found at a cluster of sites near Anyang in Henan known as Yinxu ("Yin Ruins"), once the seat of the Shang royal power. Most of the finds were bronze ritual objects, musical instruments, tools, and fittings for chariots and harnesses, with the ritual objects being of the greatest importance. They can be grouped according to their function in sacrificial rites: food cooking and

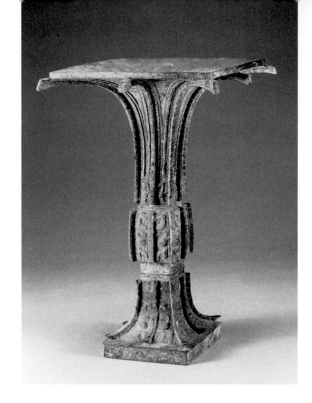

holding vessels of *ding*, *li*, *yan* and *gui*, vessels for ablution—*pan* and *yu*, and wine vessels of *jue*, *jia*, *gu* (fig. 53), *zhi*, *zun*, *you*, *hu*, *gong*, *he*, *lei*, *bu* and *yi*. The great variety of wine vessels reflects the bacchanalian propensities of the ruling houses. *Ding* denoted royal authority, potent in politico-religious meaning. The tomb of Fuhao, believed to be a consort of the Shang king Wu Ding (?–1192 BC), contained 468 bronze burial objects, an indication of the great wealth of bronzes owned by the Shang ruling house.

At the height of their monumentality, bronze vessels, the *ding* in particular, were cast in tremendous sizes in the late Shang, most of considerable thickness. The Houmuwu square

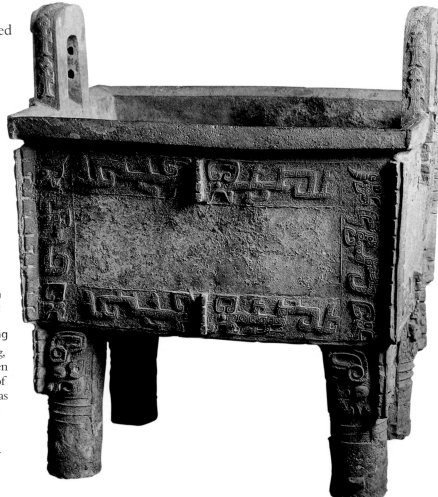

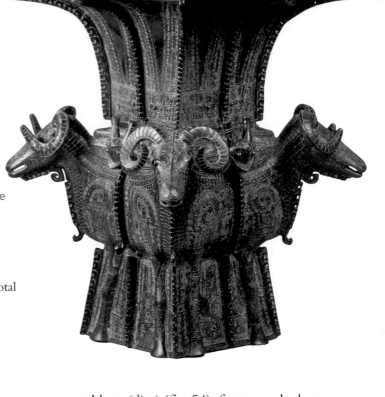

Right

Fig. 55 Bronze "Four-Goat" Square Wine Vessel, *Zun*

Late Shang dynasty
Height 58.3 cm, rim length 52.4 cm
National Museum of China, Beijing

Excavated from the Yueshanpu site in Ningxiang, Hunan in 1938. Goat motif was common in decoration of archaic objects, as the word for "goat" rhymes with "auspicious" in Chinese.

Below

Fig. 56 "Fuhao" Owl-Shaped Bronze Wine Vessel, *Zun*

Late Shang dynasty
Height 45.9 cm
National Museum of China, Beijing

Excavated from the tomb of Fuhao at Yin Ruins in Anyang, Henan in 1976. Out of a total of 210 bronze ritual objects unearthed from the tomb, three quarters were wine vessels; reflecting the Shang's love for drinking.

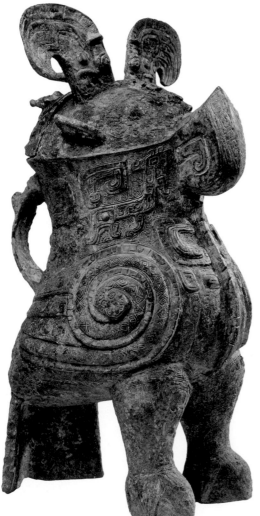

cauldron (*ding*) (fig. 54), for example, has a height of 1.33 meters and weighs 832.84 kilograms, with a majestic and awe-inspiring form. It required at least 70 crucibles (nicknamed "the general's helmets," each holding 12.5 kilograms of molten bronze) and several hundred founders working in unison to create such a casting. It is not difficult to imagine the scale of the royal foundry and the level of coordination at the time.

A remarkable technique of casting by sectional molds was invented. Parts that were cast separately could be assembled, freely movable, or detachable. The shapes were either square or bulbous, and their complex decoration consisted of raised bands and parts cast in the round (fig. 55), imparting awe-inspiring dignity and mythical charm. Wine vessels such as *zun*, *you* and *gong* were shaped in stylized animal forms (fig. 56), at once representational and hauntingly outlandish. Decoration showed a tendency towards a compact and sculptured effect, with raised animal forms below a band of patterns, set on dense ground of square spirals known as

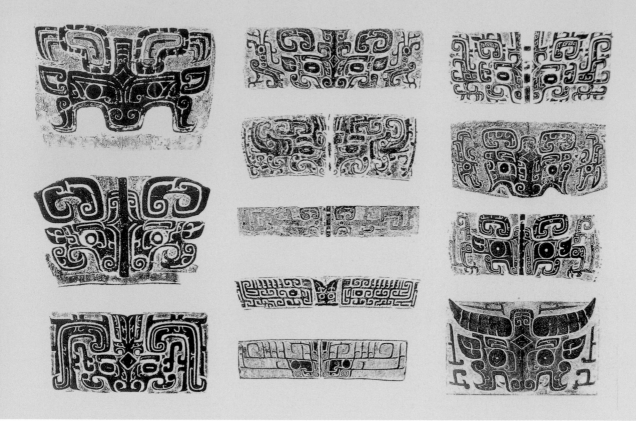

leiwen ("thunder pattern"), forming a three-tiered pattern. Zoomorphic motifs were prevalent, featuring such creatures as the elephant, bird and cicada, and more often the mythical *kui* (a dragon-like beast) and dragon. Two *kui* dragons in profile, juxtaposed face-to-face, form the *taotie* mask (fig. 57), most prominently positioned. This solemn and intriguing motif was apparently related to the Shang belief in shamanistic empowerment.

Even in regions far from the center of the Shang kingdom, bronze

Fig. 57 Zoomorphic Mask Patterns on Shang and Zhou Bronzes

A chart of zoomorphic mask patterns, respectively identified as bull, goat or tiger by scholars according to their features.

Fig. 58 Bronze Mask

Late Shang dynasty
Height 60 cm, width (between tips of ears) 134 cm
Sanxingdui Museum, Guanghan, Sichuan

Excavated from the Sanxingdui site in Guanghan, Sichuan in 1986. The mask with protruding eyes represented King Cancong of the ancient Shu Kingdom, according to scholars who cited a reference, in chronicles of the period, to "Cancong with bulging eyes."

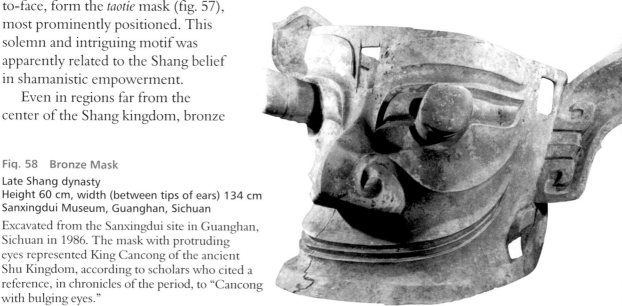

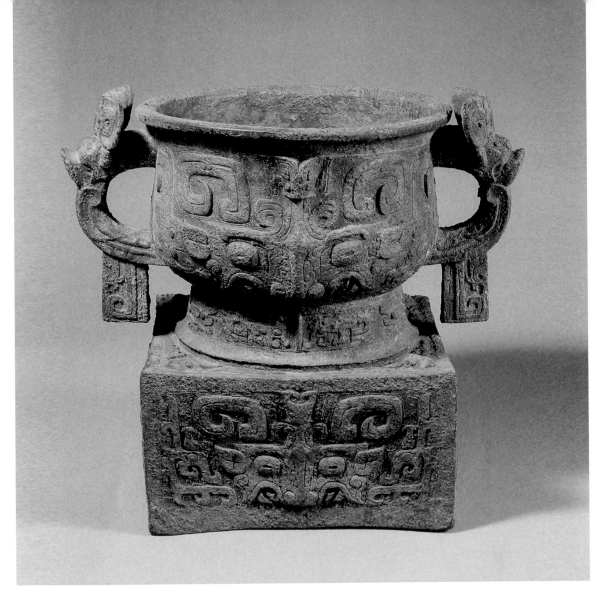

Fig. 59 "Li" Bronze Food Serving Vessel, *Gui*

Early Western Zhou dynasty
Overall height 28 cm, rim diameter 22 cm, weight 7.95 kg
National Museum of China, Beijing

Unearthed from a treasure hoard at Xiduan Village, Lintong, Shaanxi in 1976. Known to be the oldest of Western Zhou bronze vessels, it is cast with an inscription that describes awards being given on the seventh day after the defeat of King Zhou of the Shang by King Wu. Such bronze *gui* vessels with loop handles raised on a square base were extensively cast during the Western Zhou period.

casting was well developed. Remarkably well crafted wine vessels were found at sites to the southwest of Dongting Lake, with highly representational decorations covering partially (see fig. 55 on page 37) or all over (see fig. 56 on page 37) the surface. At Sanxingdui in Guanghan, Sichuan, two sacrificial pits that were dated to the ancient state of Shu, contemporaneous to the late Shang, were discovered. A bronze upright figure, various masks and a tall bronze tree unearthed at the

pits, enormous in size, show astonishingly advanced casting technology and modeling skills. The upright human figure is 2.62 meter-tall. One mask measures incredibly 1.34 meters in width (fig. 58), and the bronze tree 3.84 meters in height.

In the succeeding Western Zhou dynasty, the center of bronze technology shifted from Guanzhong (in Shaanxi) to Luoyang (in Henan), the seat of royal power. The ritual bronzes of the early Western Zhou (fig. 59)

Fig. 60 "Feng" Bronze Wine Vessel, *You*

Mid-Western Zhou dynasty
Overall height 21 cm, rim length 12.2 cm, rim width 8.8 cm, depth 12 cm, weight 2.6 kg
Zhouyuan Museum, Fufeng, Shaanxi

Unearthed from a treasure hoard at Zhuangbai Village, Fufeng, Shaanxi in 1976. Its domed cover is decorated with bird and snake patterns, and the bulbous body an elegant pattern of phoenix with upswept feather on its head and drooping tail.

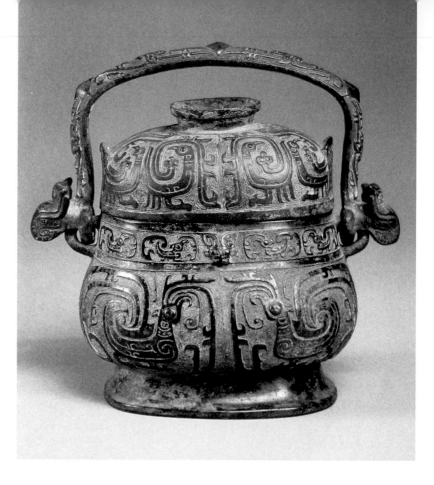

continued the late Shang tradition, with their form and décor still imparting mythical power and inspiring awe. Change occurred around the middle of the Western Zhou. Although wine vessels of exquisite form and decoration were still being made (fig. 60), albeit in smaller quantities and some old shapes disappearing altogether, new types of food vessels such as *fu* and *xu* (see fig. 52 on page 35) appeared, and the casting of *ding* and bronze bells resumed. There was an apparent tendency towards geometric patterns in decoration, with hooked "S" lines, interlacing whorls, and curvilinear wave

Fig. 61 "Ji Zibai of Guo" Bronze Basin, *Pan*

Late Western Zhou dynasty
Height 39.5 cm, rim length 137.2 cm, rim width 86.5 cm, weight 215.3 kg
National Museum of China, Beijing

Reputed to have been unearthed at Guochuansi, Baoji, Shaanxi in the Qing dynasty (Daoguang reign, 1821–1850). The largest known bronze basin, it is finely cast with elaborate decoration. Inscription on the bottom inside the basin contains 111 characters, describing a feast ordered by the emperor to celebrate the victory of Zibai of the Guo State.

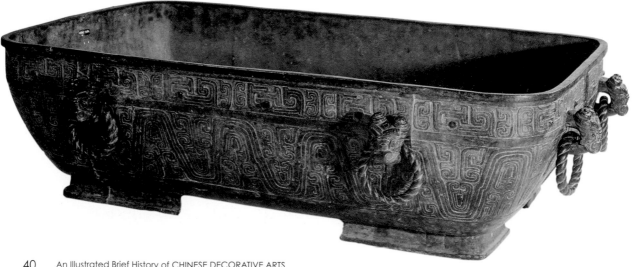

bands and horizontal grooves. The style of decoration became simpler, less compact, and uniform, increasingly with parallel bands (fig. 61). This indicates the Western Zhou's increased emphasis on ceremonial rituals vs. shamanistic empowerment. Inscriptions, which first appeared on Shang bronzes with maximum length of no more than forty characters, became more elaborate in the Western Zhou. The lengthiest example was found on *Maogong Ding*, the bronze tripod cauldron, having 499 characters in 32 lines (fig. 62). The inscriptions, being splendid specimens of calligraphy, were also helpful in dating the bronzes, in addition to recording historical events.

Utensils for everyday use by the masses were primarily pottery. Most of them were clay pottery for food serving and drinking, while a tougher variety, made by mixing clay with sand to enhance heat resistance, was made for cooking. Red and grey pottery were the commonest, usually unadorned or with simple paddled or incised patterns. Painted pottery had become rare by then. The finest

Fig. 62 Bronze "Maogong" *Ding*
Late Western Zhou dynasty
Height 54 cm, rim diameter 48 cm, weight 34.7 kg
Palace Museum, Taibei

Unearthed at a site in Qishan, Shaanxi in 1843. The inscription describes King Xuan of the Zhou dynasty giving appointment and mandate to Maogong (Duke Mao). The extensive account, cast in the official script of the Zhou dynasty, has significant historical value and is deemed "comparable to that of a chapter of *Shangshu* (*The Book of Documents* or *Classic of History*)."

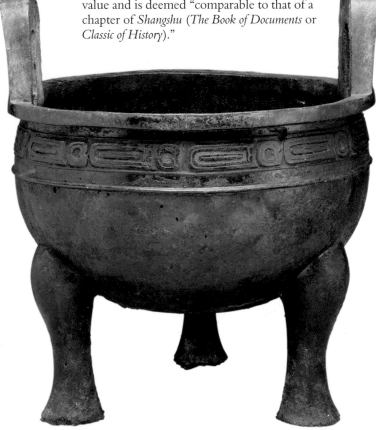

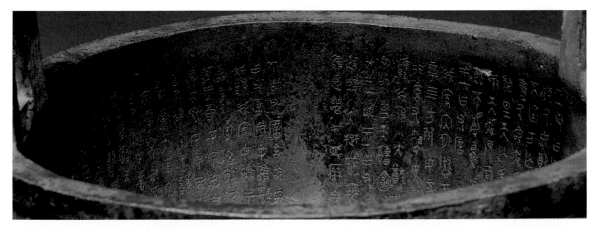

Fig. 63 White Pottery Jar, *Lei*, with Square Spirals

Late Shang dynasty
Height 33.2 cm, waist diameter 28.3 cm
The Freer Gallery of Art, Washington D.C.,
U.S.

Reputed to have been unearthed from the
Yin Ruins in Anyang, Henan. Far more
refined than other types of pottery at the
time, the white pottery has an appearance
similar to bronze and is believed to have been
used as its substitute.

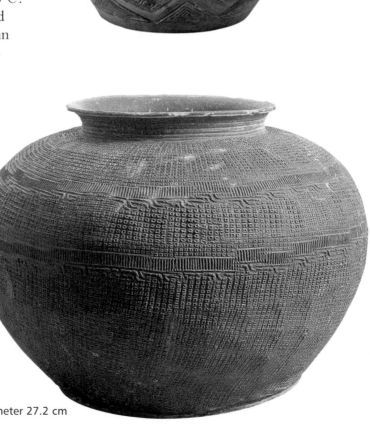

specimens of the white pottery (fig. 63),
of either fine and coarse types, appeared
briefly in the late Shang dynasty. They
often copied the shape and motifs of ritual
bronzes. In the lower Yangtze basin a hard
stoneware, with repeated geometric patterns
stamped over its surface (fig. 64), became
popular. Called "geometric patterned pottery,"
they were fired at temperatures around 1,150 ℃.
Such stoneware was to continue and found
in large numbers in the Spring and Autumn
period and even the Qin (221–206 BC)
and Han dynasties, before being gradually
succeeded by porcelaneous stoneware and
porcelain.

The porcelaneous stoneware (fig. 65),
which first appeared in the mid-Shang
dynasty, was widely produced in the
lower and middle Yangtze basin.
The clay body was made with
crushed china stone and fired at
a temperature around 1,200℃,
with a glaze (Tip 11) of brownish
green to olive, collectively called
"celadon." It had been the most
popular glaze up to the Sui
(581–618) and Tang dynasties. The hard-
bodied stoneware was durable, with a

Fig. 64 Stoneware Jar with Stamped Pattern

Western Zhou dynasty
Height 30.5 cm, rim diameter 21.2 cm, base diameter 27.2 cm
Quzhou Museum, Zhejiang

The bulbous jar is stamped with a dense lozenge pattern, rather ornate in effect.
It is considered to be a superior specimen of stamped stoneware.

lustrous glaze that was pleasing to the eye, easy to clean and impervious to water. Its invention laid a solid foundation for the later development of porcelain.

Advances in jade carving continued, most notably in the late Shang, as evidenced by the finds at the Yin Ruins. Although many "jade" ornaments were made from jade-like stones of various origins, nephrite from Hetian (Hotan) in Xinjiang was already used extensively. The varied sources of jade stones signified the tributes paid to the Shang ruling house by neighboring tributary states. Hetian jade, a beautiful nephrite, had become a preferred material for Chinese jade carving. The large number of jade objects (755 in total) unearthed from the Tomb of Fuhao at the Yin Ruins, which had never been broken

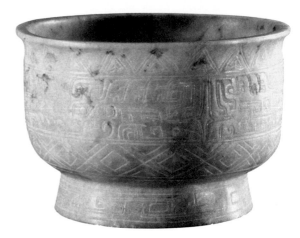

Fig. 66 Olive-Green Jade Bowl, *Gui*
Late Shang dynasty
Height 10.8 cm, rim diameter 16.8 cm, wall thickness 0.6 cm
Institute of Archaeology, Chinese Academy of Social Sciences
Excavated from the tomb of Fuhao at Yin Ruins in Anyang, Henan in 1976. The bowl is decorated with mask motif on the outside. In addition to olive-green jade bowl, a pale-green jade bowl was found at the same site, both being the earliest known jade vessels.

into at the time of excavation, give a glimpse of the ruling house's lavish infatuation with jade. They fall into seven categories— ritual offerings, ceremonial items, tools, utensils, ornaments, decorative objects, and miscellaneous implements. A small number of ritual objects were vessels (fig. 66), while ornamental objects and decorative items were mostly fashioned in the shapes of animals, and occasionally figurines carved in the

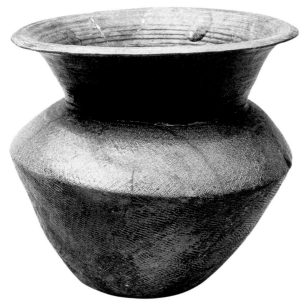

Fig. 65 Porcelaneous Stoneware Wine Vessel, *Zun*, with Out-Turned Rim
Shang dynasty
Height 28 cm, rim diameter 27 cm
Zhengzhou Museum, Henan
Unearthed from a tomb dated to the Shang, on Minggong Road in Zhengzhou, Henan. Porcelaneous stoneware is closely related to primitive stoneware with stamped patterns, which were found by researchers to have sometimes been produced by the same kilns.

Tip 11: Glaze

Glaze is a glass-like coating applied to a ceramic body. Ground limestone power is mixed with a suitable amount of clay to serve as chief ingredients for the glaze. The level of iron oxide determines the color, with more than 5% producing a black glaze, around 3% a green glaze, and less than 1% a white glaze. The kiln atmosphere also has an effect on coloring. The green glaze, for example, will take on a bluish green tint in reduction atmosphere, and yellowish green, gray, or yellowish brown and other colors in oxidization atmosphere.

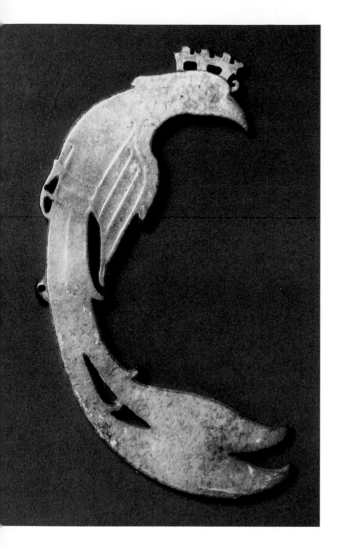

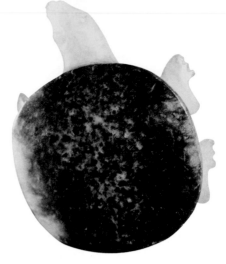

Fig. 68 Jade Turtle Ornament
Late Shang dynasty
Length 4 cm
Institute of Archaeology, Chinese Academy of Social
Sciences

Excavated from Yin Ruins in Anyang, Henan in 1975. The natural variations of ink-black and grey of the stone were used ingeniously for the carapace, neck, eyes and the underside of the turtle.

Tip 12: Clever Use of Color Streaking

A special artistic treatment in jade carving, it is seen as a mark of excellence in jade workmanship. Jade stones can be mottled and have streaks of coloring. Such coloring can be turned to advantage by matching the color streaks and the shape of the jade for a desired design effect.

Fig. 67 Jade Phoenix Pendant
Late Shang dynasty
Height 13.6 cm, thickness 0.7 cm
Institute of Archaeology, Chinese Academy of Social
Sciences

Excavated from the tomb of Fuhao at Yin Ruins in Anyang, Henan in 1976. The pendant is designed in the elegant, flowing form of a phoenix; the finest example of phoenix or bird ornaments of the Shang dynasty.

round, or were plaques (fig. 67). They had simple incised patterns, and vivid, exaggerated forms that captured essential characteristics of what was represented, with great decorative appeal. The techniques of drilling and grounding were highly sophisticated. The ingenious use of the stone's natural streaking of color or mottled pattern for design effect was the most notable (fig. 68) (Tip 12).

The jade finds dated to the Western Zhou seem to have a lower level of accomplishment than the Shang jades. Rather than a deterioration of technical prowess, this should be attributed to the fact that no royal burial sites of the Western Zhou have so far been found. A distinct character of jade art began to show by the middle of the Western Zhou, with representational forms of animals carved in simple, sparing lines, and increasingly on flat plaques (fig. 69). Jade stones used were of a greater hardness, with a warm luster and brilliance, evocative of the fine human

Fig. 69 Jade "Dragon, Phoenix and Figure" Pendant

Mid- to late-Western Zhou dynasty
Height 6.8 cm, width 2.4 cm, thickness 0.5 cm
Institute of Archaeology, Chinese Academy of Social Sciences

Excavated from Tomb No. 157 at Zhangjiapo Village, Chang'an, Shaanxi in 1984. The small ornament was densely decorated with incised and carved openwork patterns of three dragons, one phoenix and two human heads.

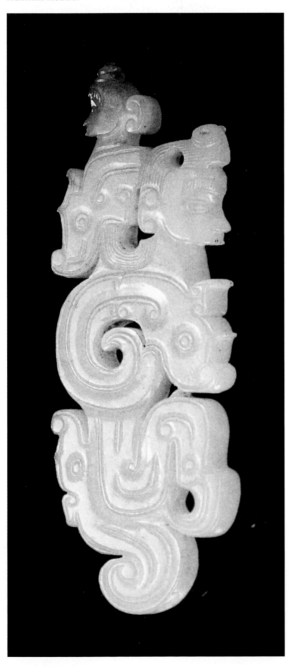

qualities they represented. Jade became more valued in the Western Zhou, and its beauty hallowed with lofty moral connotations. The "virtues of the upright character" were compared to those of jade and the notion that "a gentleman never goes about without having a piece of jade on him" became the norm for the upper class. Jade ornaments were used as lavish garment accessories, often in a set of several pieces, as was the fad at the time. They were assembled as necklace (see fig. 70 on page 46), pendant, bracelet or headdress. Yet, jade utensils were always few and far in between, even in later eras, owing to the scarcity of jade and its prescribed lofty status.

There was increasing sophistication in decorating lacquerware. Of the lacquered objects unearthed at the Erlitou site (of the Xia or early Shang period), the most beautiful was a carved red lacquer piece. By the late Shang, a variety of decorating methods had been developed, including color painting, engraving, turquoise and mother-of-pearl inlays, and gold appliqué, which further reached maturity by the Western Zhou. The range of materials used for constructing the base also expanded. In addition to wood, leather could now be lacquered. However, lacquer wares from archaeological excavations were extremely rare, and often severely damaged, with some only having impressed traces to prove they once existed.

Fabrics such as silk are even more difficult to preserve. The weaving of damask on tabby with patterns is known to have existed in the Shang dynasty, and brocade with colored patterns was produced in the Western Zhou, with archaeological evidence of embroidery being also available. An extremely fine woolen fabric with a checkered pattern was unearthed in Xinjiang.

There were abundant finds of objects carved out of ivory or animal bones, the most exquisite of which were three ivory cups from the tomb of Fuhao. They were large

and tall in size, two with turquoise inlay (fig. 71), and all had decorative patterns densely carved in a style similar to that of bronzes. Such was the influence of the Shang and Zhou bronze art, foreshadowing also the formal and decorative styles of ceramics in the succeeding dynasties.

Gold was first used ornamentally for its beauty and decorative appeal by the primitive people, though it was rarer and more difficult to obtain than silver. Among the rich archaeological finds dated to the Shang and Zhou dynasties, decorated gold plaques unearthed at Sanxingdui of Guanghan and at Jinsha Village near Chengdu, both in Sichuan, are the most outstanding. Some of the bronze heads were decorated with gold foil masks. The splendid gold sheath of a wooden staff has a height of 1.42 meters. A gold object with a thickness of only 0.02 cm (fig. 72), found at the Jinsha site that is related to Sanxingdui in many ways, was the most stunning. Its decorative motifs were determined to be the sun and immortal birds, believed to indicate the practice of sun god worship by the ancient Shu people.

To sum, the bronze art in Xia, Shang, and Western Zhou periods evolved from being plain and simply ornamented, to the elaborate and mythical, before becoming restrained and conforming to strict regulation. The advances of other

Fig. 70 Jade Necklace
Western Zhou dynasty
Length around 50 cm, width around 30 cm
Zhouyuan Museum, Fufeng, Shaanxi

Unearthed from a site at Qiangjia Village of Huangdui Township, Fufeng, Shaanxi in 1981. The necklace is composed of globular and tubular beads of jade and agate, in addition to arc-shaped pendants and mini-masks; in colors of light-yellow, pale-green, white, red and yellow.

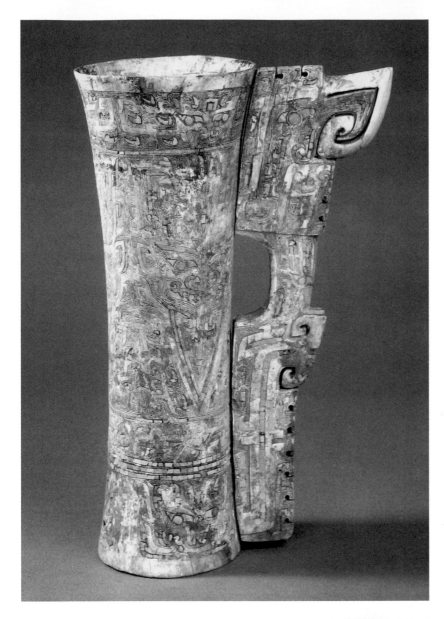

Late Shang dynasty
Height 30.5 cm, rim
diameter 11.2 cm, rim
thickness 0.1 cm
National Museum of China,
Beijing

Excavated from the tomb
of Fuhao at Yin Ruins in
Anyang, Henan in 1976.
Ivory carving has never
truly been a major medium
of decorative arts in China,
likely due to the scarcity
of the material and limited
practical use.

Fig. 72 Sun and Immortal
Bird Gold Ornament

Late Shang dynasty
Diameter (from outer rim)
12.5 cm, thickness 0.02 cm,
weight 20 g
Jinsha Site Museum,
Chengdu

Unearthed at the Jinsha
Village site near Chengdu,
Sichuan in 2001. A
splendid ornamental object
(of 94.2% gold), out of a
total of more than 90 gold
pieces found at the site, it
has since been designated
an emblem of Chinese
cultural heritage.

decorative arts followed a similar pattern.
Plain and simply ornamented decoration
marked Xia bronzes, in contrast to bronzes
of later eras, with the extraordinary bronze
plaque with intricate turquoise inlay being
an exception. Henceforth, the tendency
towards elaboration and mysticism became
increasingly apparent and reached a pinnacle
in the late Shang period. The new decorative
style became entrenched and continued into
the early Western Zhou dynasty. A more
restrained character and strict regulation
appeared around the mid- and late Western
Zhou times, before the eventual deterioration
of bronze art signified by crude workmanship.

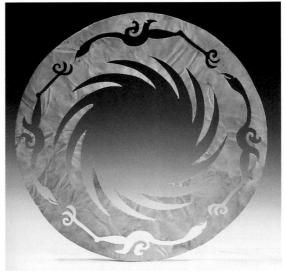

THE SPRING AND AUTUMN AND THE WARRING STATES PERIODS

The Spring and Autumn Period (770–476 BC)
The Warring States Period (475–221 BC)

In 770 BC, the royal court of the Zhou dynasty moved to Luoyi (present Luoyang, Henan), under the protection of marquises of the Zheng, Qin and Jin states, fleeing intrusions of the nomadic tribes from the northwest. This marked the start of the Eastern Zhou dynasty (770–256 BC), also known as the Spring and Autumn period in Chinese history. The Zhou ruling house began to lose prestige and influence. Economically at the mercy of the vassal lords, the weakened Zhou ruling house hanged on for another five centuries till its final demise following the defeat by the powerful Qin of the six vassal states (Han, Zhao, Wei, Chu, Yan and Qi). The Spring and Autumn and the Warring States periods were plagued by disorder and disintegration, with contending powers vying for hegemony. The feudal lords excised despotic rule, rose to power. Incessant wars ensued, in which larger states absorbed weaker ones, resulting in harrowing loss of lives and economic ruins. This

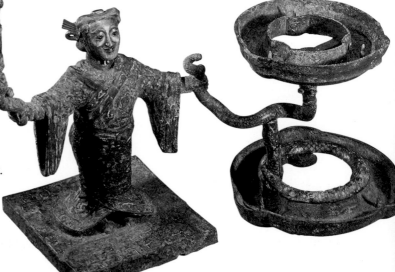

Fig. 73 Bronze Oil Lamp with Standing Figure's Head in Silver

Mid-Warring States period
Height 66.4 cm, width 55.2 cm
Hebei Provincial Museum

Unearthed from Tomb No. 1 at the Sanji site, Pingshan, Hebei in 1977. The standing figure holds the tail of a snake, in a calm, balanced pose. A tiny monkey clings to the middle of the stem, staring down at the coiled snake.

period of great socioeconomic turmoil was also accompanied by increasing cultural exchange and assimilation between regions. The fragmented political order and rivalry of states vying for supremacy ushered in diversification and formation of distinctive regional characters in decorative art.

The late Spring and Autumn period saw increasing intellectual ferment, as

Confucius (551–479 BC) elaborated and began teaching the social concepts that were to be the core of Confucianism. In the ensuring Warring States era, many more Chinese thinkers came forth in a glorious period of "a hundred schools of thought contending and flourishing," as described in the annals of Chinese thought. Drawing upon different intellectual sources and differing in their views, they focused their discussions on the idea of humanity and human relationships; no more the pantheon of gods and spirit-beings. It was an unprecedented phase of intellectual emancipation, when the concern for humanity triumphed over reverence for gods and spirits of the dead. As the rigid feudal order collapsed, there was a greater freedom in the creation and use of the otherwise strictly mandated ritual objects. Decorative arts began to cater for everyday use (fig. 73), with an emphasis on utility. Decorative motifs were frequently associated with everyday life (fig. 74), too, as mysticism and ritual fervor waned. This, together with the shift towards the sensually pleasing to fit the ruling class and nobility's appetite for luxury and extravagance (fig. 75), resulted in a trend that was stylistically refreshing and resplendent.

The start of iron processing is of great significance in the history of

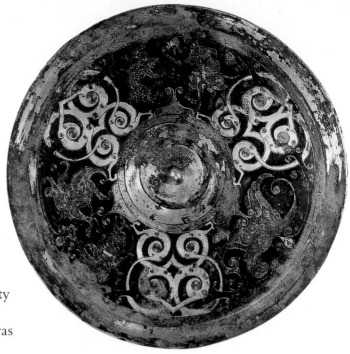

Fig. 74 Bronze Mirror with Hunting Scene of Gold and Silver Inlay
Mid-Warring States period
Diameter 17.5 cm
Eisei Bunko Museum, Tokyo, Japan

Reputed to have been unearthed at Jincun near Luoyang, Henan. The back of the mirror is decorated with a leopard-hunting figure, a pair of phoenix and bird, and two beasts locked in a fight; all separated by cloud scrolls. A mounted hunter subduing the leopard is at the top center.

Fig. 75 Bronze *Hu* with Decorative Grid of Gold and Silver Inlay
Mid- to late-Warring States period
Height 24 cm, rim diameter 12.8 cm
Nanjing Museum, Jiangsu

Unearthed from a site at Nanyao Village in Xuyi, Jiangsu in 1982. The shoulder and body of the vessel are covered with a grid, inlaid in gold and silver, with 96 coiled dragons and 576 tiny Chinese plum flowers. It is part of the spoils acquired by the State of Qi after its defeat of Yan in 315 BC.

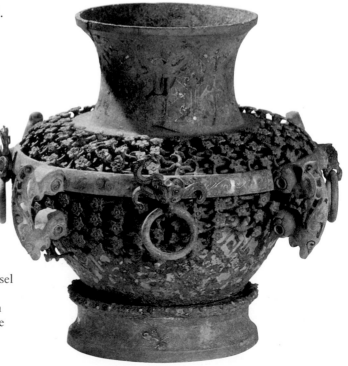

civilization. Sturdy and sharp iron tools were in wide use by the Warring States period in China, which enabled novel techniques for making decorative objects. With the accelerated weakening of the feudal order that relied heavily on ceremonial rituals, utilitarian bronze implements (fig. 76) began to replace ritual objects and drums and bells, and formed the majority of bronzes produced by the end of the period. Lighter and more exquisite lacquerware began to feature prominently in the life of the upper class, marking the start of an era of flourishing lacquer art spanning the Western and Eastern Han (25–220) dynasties. This was accompanied by the development of silk production in China and the rise of the glorious silk art.

Around this time, bronze was still the most prominent medium of decorative art. While the royal court and nobility owned most of the bronzes ever produced in the Western Zhou under powerful central authority, now in the early Warring States period it was the princes and feudal lords who amassed greater quantities. A total of more than 140 pieces of bronze burial objects, weighing a hefty 10 ton, for example, were found at the Tomb of Zenghouyi, a marquis of the Zeng State that had become a mere satellite of the Kingdom of Chu. Also significant was the increase in food vessels and decrease in wine vessels among ritual objects found. *Ding* and *gui* continued to enjoy a noble status and had been reserved for those of higher hierarchical order. But the rules were now repeatedly broken. Bronze

Fig. 77 Sword of Goujian (d. 465 BC), the King of the State of Yue

Late Spring and Autumn period
Length 55.7 cm long, blade width 4.6 cm
Hubei Provincial Museum

Unearthed at a site at Wangshan in Jiangling, Hubei in 1965. The sword's cross guard is inlaid with blue natural glass and turquoise. The text on one side of the blade reads, "(Belonging to) King Goujian of Yue, made for (his) personal use." The sword is renowned for its intact sharpness when unearthed, likely due to the sulfur in its chemical composition that decreased the chance of tarnish.

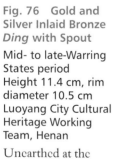

Fig. 76 Gold and Silver Inlaid Bronze *Ding* with Spout

Mid- to late-Warring States period
Height 11.4 cm, rim diameter 10.5 cm
Luoyang City Cultural Heritage Working Team, Henan

Unearthed at the Eastern Zhou city ruins near Luoyang, Henan in 1981. The bronze vessel, dated to the Zhou dynasty, is cast in a unique design with lavish decoration; apparently not intended for sacrificial rituals.

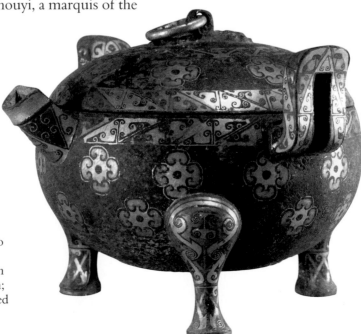

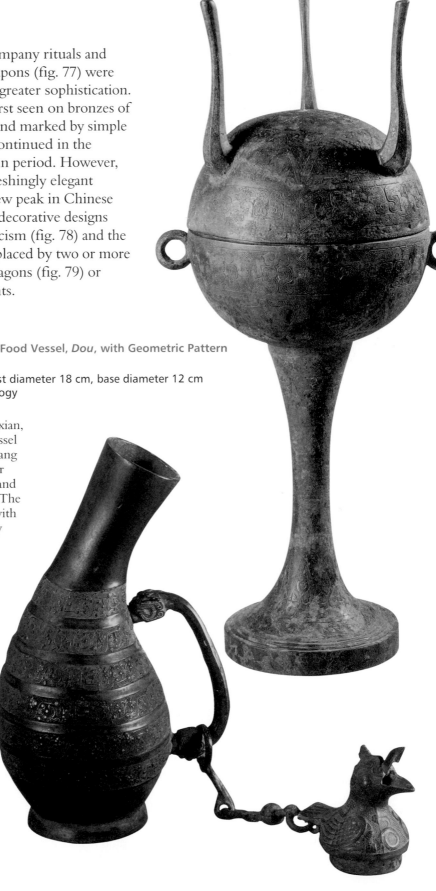

drums and bells to accompany rituals and feasting and bronze weapons (fig. 77) were made with increasingly greater sophistication.

The deterioration, first seen on bronzes of the late Western Zhou and marked by simple and crude decoration, continued in the early Spring and Autumn period. However, the emergence of a refreshingly elegant style brought about a new peak in Chinese bronze art. Formal and decorative designs now featured less mysticism (fig. 78) and the ubiquitous *taotie* was replaced by two or more intertwined hornless dragons (fig. 79) or tightly interlaced serpents.

Fig. 78 Bronze Stemmed Food Vessel, *Dou*, with Geometric Pattern
Early Warring States period
Overall height 50.2 cm, waist diameter 18 cm, base diameter 12 cm
Beijing Institute of Archaeology

Unearthed at a site at Zhongzhaofu Village, Tongxian, Beijing in 1981. The *dou* vessel first appeared in the late Shang dynasty and became popular in the Spring and Autumn and the Warring States periods. The domed cover is decorated with three tall finials; remarkably elegant in its slender form.

Fig. 79 Bronze Gourd-Shaped Flask, *Hu*, with Bird-Form Stopper
Late Spring and Autumn period
Overall height 37.5 cm, rim diameter 5.8 cm
Shaanxi History Museum

Unearthed from a site at Suide, Shaanxi in 1967. The bronze *hu*, of the State of Jin, was designed in a rather unusual form, with a curved neck, and decorated with a fine, dense hornless dragons pattern.

Iron tools allowed the invention of more sophisticated techniques for casting. Farming, sericulture, hunting, feasting and war motifs (fig. 80) were rendered with copper, or gold and silver inlays (Tip 13), and needlepoint incision. The new techniques marked a trend towards decoration carved in relief or flush with the surface. The lost-wax casting enabled designs of more exquisite forms and decoration (see fig. 19 on page 14). The stamp-impression method for building clay molds (Tip 14) not only reduced the labor of carving and incising, but allowed uniform repetition of the pattern. Undecorated bronzes (fig. 81) first appeared in the Spring

Fig. 81　Bronze Duck-Form Wine Vessel, *Zun*
Spring and Autumn period
Height 22.2 cm, rim diameter 18.3 cm
Zhenjiang Museum, Jiangsu

Excavated from the Muzidun site at Dagang near Dantu, Jiangsu in 1982. The plump shape of the duck is designed for both form and function (holding larger volume of libation).

Fig. 80　Bronze Vase, *Hu*, with Copper Inlay of Hunting Scene
Early Warring States period
Overall height 54.9 cm, rim diameter 10.9 cm
National Museum of China, Beijing

Unearthed from a site at Jiagezhuang Village, Tangshan, Hebei in 1952. The bronze vessel, of a rather large size, is decorated with a simplistic, sparse pattern of silhouetted figures, unlike most copper-inlaid bronze vessels with figurative decoration.

Tip 13: Gold and Silver Inlay

Patterns incised with a sharp metal tool are filled with gold or silver wire or foil, and then polished to a shine, so that they are fast and flush with the vessel surface. Such a technique was first in use in the mid-Spring and Autumn period and popular throughout the Western and Eastern Han dynasties.

and Autumn and became popular around the middle of the Warring States period. The smooth surface, though lacking decoration, was resistant to stain, which, together with the thin-walled and lighter design, were to dominate bronze casting in the Qin and Han dynasties. Copper, or gold and silver inlays, gilding (Tip 15), and lacquer painting, when so required, were flush with the surface. These techniques were to be carried on in the Qin and Han.

The prolific production of bronze mirrors and belt hooks was also indicative of the utilitarian trend. The mirror face was polished and its back often decorated. The earliest bronze mirrors in China were uncovered at sites of the Qijia Culture dating back four millennia, but they only began to be mass-produced in the Warring States period and onward. Finds dated to the Warring States were mostly produced in the

Fig. 82 Bronze Mirror with Four "Mountain" Characters

Warring States period
Diameter 14.2 cm
Hunan Provincial Museum

Unearthed from Tomb No. 855 at Yanshanling near Changsha, Hunan in 1952. Mirrors decorated with *shan* (mountain, 山) characters, the significance of which is yet to be deciphered, continued to be made during the Western Han period, though with a lower level of workmanship.

Tip 14: Pottery Molds with Impressed Patterns

Patterns are impressed with a finely carved stamp repeatedly on the leather-dry clay mold for bronze casting. The stamp could be used to make molds for different castings. The repeated patterns can be indicative of the stylistic trend of the time. The technique was widely used during the Spring and Autumn and Warring States periods.

Tip 15: Fire Gilding

The technique involves heating gold foil in liquid mercury to form a paste-like amalgam. The gold-mercury amalgam is then brushed onto the surface or a partial detail of the metal vessel. The vessel is then heated in a furnace until the mercury has vaporized and gold adheres to the surface. The technique first appeared during the Spring and Autumn and Warring States periods.

State of Chu, their backs intricately decorated with a symbol representing the Chinese character for "mountain" (fig. 82), quatrefoil petals, and double diamonds, markedly different from contemporaneous bronzes. In addition to cast patterns, decoration also included painting and inlay with gold or silver (see fig. 74 on page 49), jade or colored glass. An indispensable household item before the glass mirror, it continued to be made up to the Qing dynasty. However, it was during the Warring States period that the artistry of bronze mirror reached its first apex.

Bronze hooks were used on silk or leather belts for tying up robes, while those of a smaller size was attached to the belt for

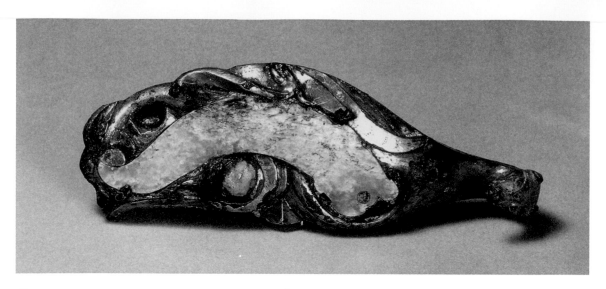

Fig. 83 Gilt Bronze Garment Hook with Jade and Gemstone Inlay

Mid-Warring States period
Length 11 cm
Qufu Cultural Heritage Administration, Shandong

Unearthed from Tomb No. 58 at the Lu State ruins in Qufu, Shandong in 1978. The belt hook was often described in textual references as the most conspicuous sartorial decoration for the aristocracy; designed with care and variation for distinction.

Fig. 84 Gilt Silver Belt Hook with Jade and Glass Inlay

Mid-Warring States period
Length 18.4 cm, width 4.9 cm
National Museum of China, Beijing

Unearthed from Tomb No. 1 of a burial site at Guwei Village, Huixian, Henan in 1951. Belonging to an aristocrat of the State of Wei and being the most conspicuous accessory on a noble's garment, it was lavishly decorated, as all such belt hooks, to reflect the wearer' standing and taste.

hanging ornaments. They first appeared in the late Western Zhou dynasty and were popular in the Warring States period and the Qin and Han dynasties. Their place was to be taken in the Kingdom of Wei and Jin dynasty (265–420) and onward by belt ends and buckles, first introduced from the northern steppes at the beginning of the Western Han (202 BC–AD 8). Such belt ends and buckles, though mere garment accessories, were exquisitely crafted and pleasing to the eye,

serving as a conspicuous symbol of status. The ones worn by the nobility were often inlaid with precious metals or stones (fig. 83), or simply made from jade, gold or silver (fig. 84). However, the belief that the garment buckles first came from the nomadic tribes of the steppes is now subject to debate, for the scattered finds discovered there were dated to a much later era.

The earliest known gold objects in China were unearthed from the burial sites and ruins dated to the Shang dynasty. However, the small number of finds, mostly of gold ornaments and jewelry, were confined to the southwest, central and northern China. Not until the Spring and Autumn and the Warring States periods were abundant gold and silver

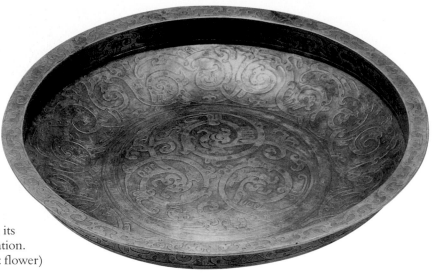

Fig. 85 Gilt Silver Dish with Dragon and Phoenix Pattern

Warring States period
Rim diameter 37 cm, height 5.5 cm, weight 1,705 g
Zibo Museum, Shandong

Unearthed at the companion burial site for the tomb of King Qi of the Western Han in Zibo, Shandong in 1979. It is the earliest known silverware with its prominent areas gilt for decoration. It was referred to as *jinhua* (gilt flower) silverware in ancient times.

implements (fig. 85) widely distributed across China. In addition to ornaments and belt hooks, gold and silver vessels were also uncovered in Shanxi, Zhejiang and Hubei, reflecting the extensive use of the metals. Gold implements fashioned in the form, or decorated with the motifs, of animals such as hawk (fig. 86), tiger, wolf, deer and sheep, were found at nomadic sites of Xiongnu and other pastoral peoples of present Inner Mongolia and Xinjiang. All were ornamental objects. Some show a level of technical sophistication that is truly stunning, reflecting the nomads' love of the precious metals. The realistic animal motifs reflected a way of life centered on hunting

and animal husbandry. In all areas inhabited or kingdoms established by the nomadic peoples, the craft of gold- and silversmith was well developed and the bird and animal motifs prevalent in all forms of decorative art. This became evident in the Spring and Autumn and Warring States periods.

During the Spring and Autumn period, lacquerware began to be decorated with color painting of greater sophistication than before

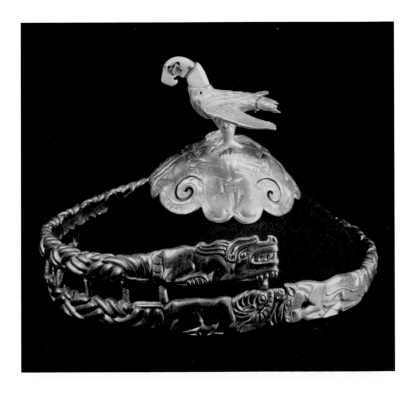

Fig. 86 Gold Crown

Warring States period
Height 7.3 cm
Inner Mongolia Autonomous Region Museum

Unearthed from a Xiongnu tomb at Aluchaideng site in Hangjinqi, Inner Mongolia in 1972. The movable eagle head, inlaid with turquoise, neck, and tail are connected to the body by gold wire. The dome under the eagle's claws is incised with wolves staring down sheep.

(fig. 87). The production of lacquerware flourished in the Warring States period, with notably abundant finds from sites in modern Henan, and Hubei and Hunan representing the culture of Chu in the south. This is likely the result of improved burial insulation leading to better preservation, rather than an indication of lacquer technique being more advanced in the south than in the north. Lacquer implements ranged from food serving vessels to ritual objects, musical instruments, weapon fittings, furniture, decorative items, and grave goods, with most being wood-cored. The use of light-weight wood strips steadily increased, alongside lacquered hemp cloth over clay base (Tip 16), as well as leather and bamboo basketwork cores.

Lacquer items for display were often carved with exquisite openwork patterns. The deeply carved lacquer of extraordinary beauty from the State of Chu had painted details (fig. 88). Many lacquer utensils were fashioned in beautiful animal shapes that were ingeniously designed. Decoration included gold appliqué, needlepoint engraving, and copper bound rim (to enhance toughness and contrast in texture and tone). But the most widely used technique was painting, with an assortment of pigments, often in inspired, fluent brushwork to depict hunting, expedition, feasting with musical accompaniment, birds and animals, geometric and cloud patterns, and even astronomical symbols. In addition to the predominant black and red, colors included brown, yellow, green,

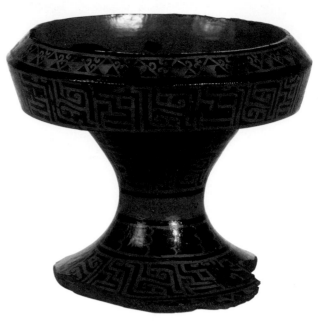

Fig. 87 Lacquer Food Vessel, *Dou*, with Painted Hooked "S" Lines
Spring and Autumn period
Rim diameter 13.8 cm, height 14.5 cm
Yichang Museum, Hubei

Unearthed from Tomb No. 4 at Zhaoxiang site, Yichang, Hubei in 1988. It is applied with red lacquer on the inside and painted with patterns in red and yellow on black ground on the outside. Red and black have been the most common colors in lacquer decoration since antiquity.

blue, white, gold, and silver, in bright and cheerful schemes of intense contrast (fig. 89). Of lighter weight, elegantly crafted, easy to clean, and heat and erosion resistant, lacquer vessels that had better functional attributes came to rival bronzes. As ritual-based feudal order crumpled, bronzes continued to decline and their replacement by lacquerware became inevitable.

Tips 16: Lacquered Hemp Cloth over Clay Base

The method requires first preparing a rough wooden or clay shape and then covering its surface with layers of hemp cloth soaked with a mixture of raw lacquer and powdered clay stone. Once the cloth layers are dry, the wood or clay base is removed to leave the inside hollow. One final coat of lacquer is applied. The technique first appeared in the Warring States period, and became increasingly popular in the Western and Eastern Han dynasties. In Wei and Jin dynasties, it was often used in making Buddha sculptures that were lightweight and easy to carry in a cart or by manpower. Beginning in the Qing dynasty, Fuzhou became famous for its production of the hollow-bodied lacquerware.

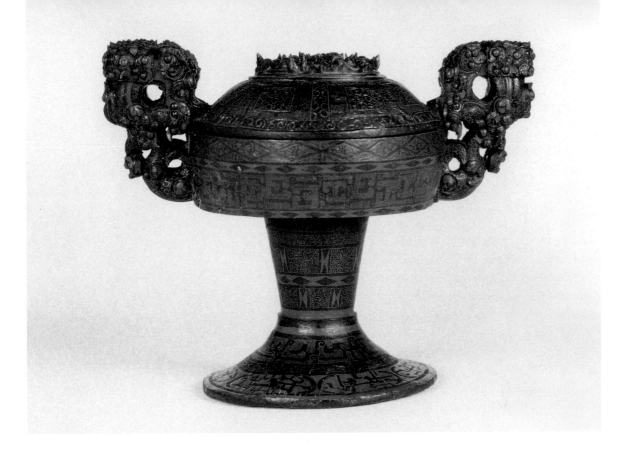

Meanwhile, jade had become indispensable in the life of the aristocracy. The flourishing jade craft, becoming more refined in the mid- and late Spring and Autumn period, reached an even higher level of skillfulness and sophistication by the Warring States period. Abundant finds dated to the latter period were widely distributed, with excavations at some of the larger tombs each yielding several hundred objects. Most were either ceremonial or ornamental pieces. A fair number were belt hooks that came into fashion at

Fig. 88 Lacquer Food Vessel, *Dou*, with Carved and Painted Decoration

Early Warring States period
Overall height 24.3 cm, rim length 20.8 cm, width 18 cm
Hubei Provincial Museum

Unearthed from the tomb of Zenghouyi in Suizhou, Hubei in 1978. It is designed with extremely dense carved and painted decoration; visually striking in effect. It is an interesting example of the romantic and outlandish style rooted in Chu culture.

Fig. 89 Painted Lacquer Accessory Box

Warring States period
Height 10.8 cm, diameter 27.9 cm
Hubei Provincial Museum

Unearthed from Tomb No. 2 at Baoshan site, Jingmen, Hubei in 1987. The sides of the box cover are decorated with an outing scene, featuring four chariots, ten horses and twenty-six figures, in addition to geese, hogs, dogs and willows swinging in the wind; in a palette of red, yellow, blue and brown.

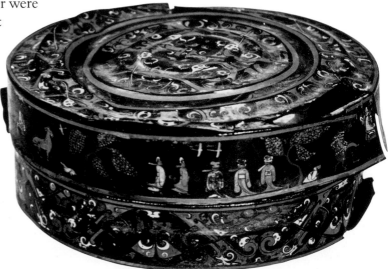

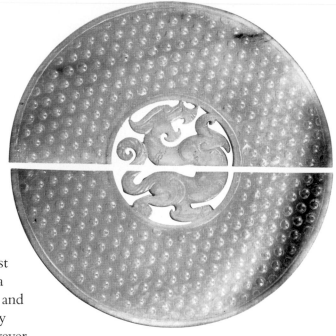

Fig. 90 Jade *Bi* with Openwork Carved Fabulous Beast, *Chihu*

Warring States period
Diameter 7.6 cm, thickness 0.4 cm
The Palace Museum, Beijing

It is ingeniously designed with two separate halves forming a jade disk, *bi*, with openwork carving of *chihu* (half tiger, half dragon) at the center, in place of the round hole found in the usual, more severe design. It was a piece of tribute jade for the Qing court under the Qianlong reign.

the time. Other than the jade hooks, most objects were in flat or plaque forms and a few were carved in the round. The form and decoration of ceremonial jade was usually governed by established regulation. However, new and innovative designs of exquisite beauty broke through from time to time (fig. 90). Ornamental objects, under fewer restrictions to begin with, showed more lively and innovative designs, many of realistic animal forms. Motifs included hornless dragon, rows of commas, and juxtaposed dragon and phoenix, with incision, low relief and pierced carving being commonly employed. Pierced openwork served not only form design but also decoration. Incised patterns were robust and fluent, thanks to iron tools that allowed greater precision in working Hetian jade of extreme hardness. Measuring 48 centimeters lengthwise, the jade pendant in sixteen parts

unearthed from the tomb of Zenghouyi is a splendid masterpiece from the period (fig. 91). The sixteen flexible parts were carved out of five slabs of raw white jade and connected by jade rings. Four of the rings

Fig. 91 Sectioned Jade Ornament with Openwork Carving

Early Warring States period
Length 48 cm, section width at widest point 8.3 cm, thickness 0.5 cm
Hubei Provincial Museum

Unearthed from the tomb of Zenghouyi in Suizhou, Hubei in 1978. With multiple sections of varied design, it is lavishly decorated with elegant openwork carving of *kui* dragon and phoenix; deservedly a national treasure of the Warring States period.

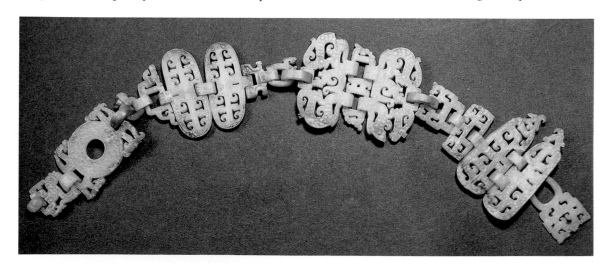

Fig. 92 Brocade Woven with Dancing Figures and Animals (detail)

Mid- to late-Warring States period
Width 50.5 cm, pattern width along warp 5.5 cm, length along weft 49.1 cm
Jingzhou Museum, Hubei

Unearthed from Tomb No. 1 of Mashan site dated to the Chu State, Jiangling, Hubei in 1982. The photo shows dancing figures—detail of the larger fabric pattern that consists of dragon, dancing figure, phoenix, dragon, qilin (a fabulous unicorn beast), phoenix, and dragon in symmetrical and sequential order.

have jade pins that can be removed, creating five independent sections, an ingenious design of remarkable craftsmanship. The sword with jade-adorned grip and scabbard, unearthed from the same tomb, is an ornamental object emblematic of its owner's noble status; reflecting the infatuation of the ruling class and the public at large with jade.

Excavation at the No. 1 tomb of the Chu burial site (ca. 4th–3rd centuries BC) in Mashan near Jiangling (Hubei Province) yielded the finest of extant early silk artifacts. They fell into eight categories (plain or tabby weave silk, heavy plain weave silk, gauze, silk gauze, damask on tabby, brocade, and satin cord and band). Brocades were woven with threads of two or three different colors. The tri-color brocade had a raised pattern of stylized dancing figures and animals (fig. 92), indicating use of the advanced pattern loom and weaving technology. Plain weave silk and silk gauze were embroidered, using threads of over a dozen colors and a "raised chain band stitch" (with chain stitches over straight stitches to create a raised effect that looks like a row of braids). A primary technique developed before the 7th century, it was used to create vivid pictorial patterns of dragon, phoenix, tiger (fig. 93), serpent, and flower,

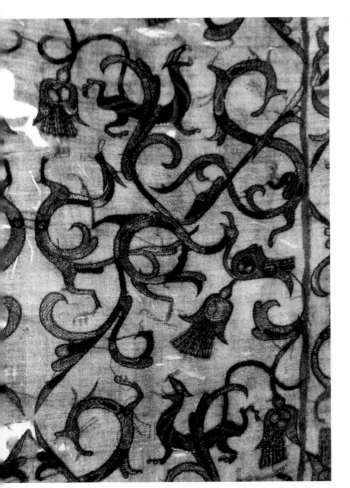

Fig. 93 Silk Embroidered with Dragon, Phoenix and Tiger Motifs

Mid- to late-Warring States period
Length 29.5 cm, width 21 cm (of the pattern)
Jingzhou Museum, Hubei

Unearthed from Tomb No. 1 of Mashan site dated to the Chu State, Jiangling, Hubei in 1982. It was suggested by archaeologists that the pattern was symbolic of the contention between the State of Chu and the Ba, Wu, and Yue states; potent with aspiration for and confidence in Chu's triumph.

of either dense and spacious composition. The tomb belonged to a mere nobleman of the *shi* class of the late mid-Warring States period. Therefore, the silk and embroidered pieces found there probably could not represent the best of his time.

Development of pottery was slow, compared with that of other decorative arts at the time. The Western Zhou tradition continued into the current period without major change. Some pottery and porcelaneous stoneware apparently copied the shapes of bronze and lacquerware (see fig. 23 on page 16) and ritual objects were common. Of interest is the burnished pottery with patterns created by impression when the clay body was leather-dry, which faintly showed through the polished surface after firing (fig. 94). Another unique type is pottery painted after firing with various pigments, occasionally gold (fig. 95). As the paint thus applied tended to come off easily, such pottery, being not suitable for everyday use, was mainly for funerary use. The painted pottery first appeared in the late Neolithic age, but became popular in the Warring States period and the Western and Eastern Han dynasties. Such funerary objects, either sculpted or molded, continued to be produced in later eras.

The production of glass, variously named in ancient China, also required firing. Glass may have been made in China as early as in the Western Zhou and in increasing numbers in the Warring States period. Small glass objects often copied jade shapes such as *bi*, seal, sword ornaments, and cicada. A type of glass beads, with blue dots centered in light-colored concentric circles, known as "dragonfly eyes" (fig. 96), were originally imported from the West (the earliest examples being found in Europe and on the Mediterranean coast), and later produced in China in imitation of the imports. Glassmaking started much earlier in the West, and was for a long time technically more advanced. Ancient Chinese glass contained lead and barium that made it less clear and heat-resistant than the soda-lime glass produced in the West. High-quality glass vessels in ancient times were mostly imports from the West, as the locally made were deemed less appealing and useful. The

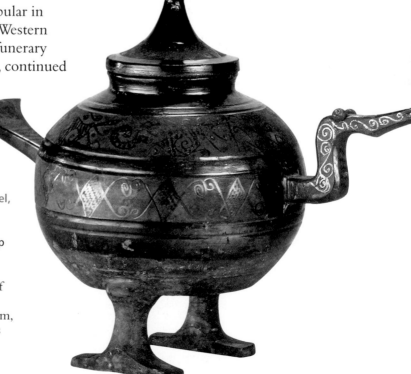

Fig. 94　Duck-Form Pottery Wine Vessel, *Zun*, with Incised Pattern

Early Warring States period
Overall height 28 cm, length (between tip of beak to tail) 36.2 cm
Hebei Provincial Institute of Archaeology

Unearthed from the tomb of the King of Zhongshan State at Pingshan, Hebei in 1977. It is designed in a unique duck form, with faintly incised or scratched patterns that display both classical elegance and almost a modernistic feel.

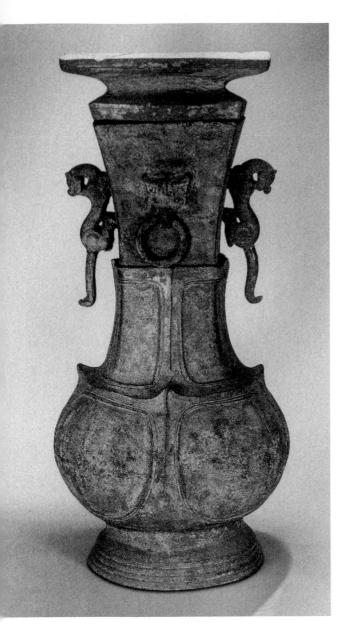

situation persisted until the reign of Emperor Kangxi (1661–1722) of the Qing dynasty.

Up to the mid-Spring and Autumn period, change and advance in decorative arts remained slow, largely under the constraints of the mid- and late-Western Zhou tradition. However, times were changing and the pursuit of sensual delight became abiding, even though the worship of celestial and earthly gods and ancestral spirits, and reverence of social hierarchy remained important. By the late Spring and Autumn period, refreshingly airy and bright decoration was in vogue. Decorative arts were more inclined to everyday life, rather than for ritual and ceremonial purposes. During the Warring States period, the new airy style became prevalent and firmly established; the mysticism and crude simplicity of the earlier era having all but disappeared.

Fig. 95 Painted Pottery Vase, *Hu*
Warring States period
Height 71 cm, rim side length 20 cm
The Capital Museum, Beijing

Unearthed from a tomb dated to the Warring States period at Songyuan, Changping, Beijing in 1956. The vase, over 70 centimeters tall, has a magnificent, haughty form in imitation of bronze vessels of the time. Only scant traces of decoration painted in red remain.

Fig. 96 Glass Beads
Early Warring States period
Bead diameter 2.5 cm
Hubei Provincial Museum

Unearthed from the tomb of Zenghouyi in Suizhou, Hubei in 1978. The beads, slightly flattened, are of various sizes. The compound colorants added to the surface of the bead created the concentric circles in white or dark blue on light blue or green ground.

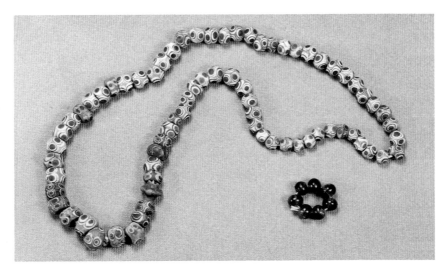

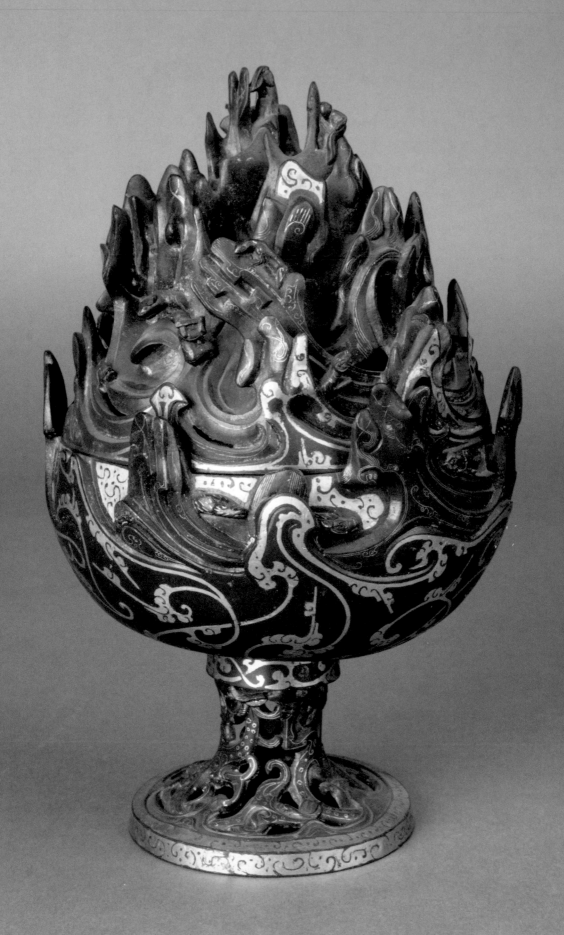

THE QIN AND HAN DYNASTIES

The Qin Dynasty (221–206 BC)
The Western Han (202 BC–AD 8), The Xinmang Period (9–25)
The Eastern Han (25–220)

For most of the time, the Qin and Han were powerful empires in which decorative arts thrived. The centralized administration prompted the tendency towards uniformity in decorative styles. In forming what was described as the Qin and Han character, the culture of Chu, with a penchant for romantic charm and outlandish grandeur, played an important role.

Of all Han emperors, Emperor Wu (156–87 BC), personal name Liu Che, was of particular significance to the development of decorative arts. Under his reign (141–87 BC), China's territories expanded and its power and influence were at their peak. In an empire known for its wealth and great civilization, various forms of decorating art greatly flourished, reaching unprecedented levels, thanks to two initiatives of far-reaching impact by Emperor Wu of Han (156–87 BC): according Confucianism the status of supremacy and opening up the Silk Road.

As Confucianism alone was recognized as imperial ideology and all non-Confucian

scholars dismissed by the court, the making of decorative implements, those by royal workshops in particular, came under Confucian influence. The notions of "loyalty and filial piety," and the "five cardinal values" (benevolence, righteousness, good manners, wisdom, and trustworthiness) that came to dominate the Chinese feudal society were reflected in decorating art. Stories of loyal worthies and filial duty were frequently featured in pictorial decorations on lacquerware and bronze mirrors. Although contacts with the West had long existed, the opening of the Silk Road was still of epochal significance, marking the start of closer trading links and cultural exchange between China and the West. As the trade route was long and meandering, only the high-grade items were worth the treacherous trek. They were often made with superior craftsmanship and materials, representing exquisite artistry and having powerful influences on the importing states.

The elite in the Qin and Han societies were afflicted with a universal desire for immortality, the nobler their station and more pampered their life, the stronger their craving. The first Qin Emperor (259–210 BC) and Emperor Wu of Han did everything possible in pursuit of immortality; sending out convoys in search of an elixir of life and building weird contraptions as bridge to eternal life. Such aspirations found expression in pictorial patterns of immortals, auspicious beasts, and cloud scrolls over enchanted hills

On facing page

Fig. 97 Bronze "Hill" Incense Burner, *Boshanlu*, with Gold Inlay and Cloud Pattern

Mid-Western Han dynasty
Height 26 cm, waist diameter 15.5 cm, weight 3,400 g
Hebei Provincial Museum

Unearthed from the tomb of Prince Liu Sheng of Zhongshan, near Mancheng, Hebei in 1968. The cover of the censer is cast in the "hill" form adorned with beasts and hunters. Liu Sheng was an ancestor of Liu Bei (161–223), founder of the Shu Han dynasty (221–263).

and isles (fig. 98). The shape of *boshan* incense burner (see fig. 97 on page 62) was thought to be inspired by the imaginary island of immortality.

The most exciting achievement was in silk. As a conspicuous fabric of high value, its woven patterns represented the finest of decorative art, reflecting the prevailing trend of the time, with tremendous influence on other media. This was evident in textile finds from the Han dynasty and onward, which included plain or tabby weave silk (*juan*), *jian* (plain weave silk of light yellow color, with the weft yarn passing over and under two warp yarns), gauze (*sha*), *hu* (silk crepe), silk gauze (*luo*), damask on tabby (*qi*), *ling* (twill damask), brocade (*jin*), and pile-loop brocade. Silk gauze produced in the Western Han was extremely sheer, comparable to the delicate wings of a cicada. An unearthed garment of finely woven gauze, with a length of 1.2 meters and full yoke-sleeve length of 1.9 meters, weighs only 49 grams. It was tightly woven with an even texture resembling a fine mesh, comparable to modern georgette. Silk crepe was light, delicate and had a soft hand, with a thickness of only 0.07–0.1 millimeters. The most complex weave was pile-loop brocade, with loops of yarn that stood up from the base fabric creating raised patterns; likely a precursor to velvet.

Silk fabric or yarn could be dyed for decorative effect. Textile finds show finely woven patterns, printed designs, embroidery and glued feather. Silk fabrics unearthed from the No. 1 tomb at Mawangdui site, Changsha, had been dyed or printed in more than twenty colors, with even tones and minimal fading; indicating a technical prowess in silk dying and printing that was for a very long time well ahead that of the West. For silk decoration in this period, woven patterns included the ubiquitous cloud scrolls of great fluency that are rectilinear (see fig. 98), in swirls, or interspersed with other images (fig. 99). Stylized, exaggerated, lively and

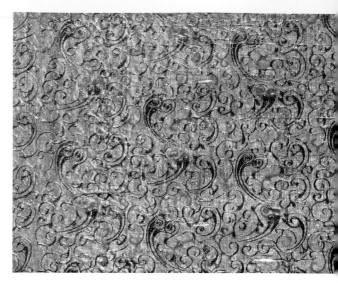

Fig. 98 "Swallow" Silk Embroidery (detail)
Early Western Han dynasty
Full length 50 cm, width 49.5 cm
Hunan Provincial Museum

Unearthed from Tomb No. 1 of Mawangdui in Changsha, Hunan in 1972. The embroidered pattern, also named "regularity," consists of cloud scrolls and swallows, a migratory bird, from whose seasonal habit the name of the embroidery was derived.

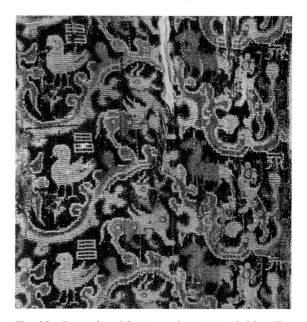

Fig. 99 Brocade with "Yongchang" Mark (detail)
Eastern Han dynasty
Fabric length 53.4 cm
Institute of Archaeology of Xinjiang Uygur Autonomous Region

Unearthed from Tomb No. 2 at the raised burial site of the ancient Loulan ruins, Lop Nur, Xinjiang in 1980. The woven pattern is similar to, but not as refined as, those of pottery, lacquer and stamped brick of the Han dynasty, due to loom constraints.

Fig. 100 Pattern on Silk Gauze (detail)

Early Western Han dynasty
Diamond pattern height (warp direction) 6 cm
Hunan Provincial Museum

Unearthed from Tomb No. 1 of Mawangdui in Changsha, Hunan in 1972. The "cup pattern" mentioned in textual references should be the same as this, though it is woven in straight lines without any curve that the looms were incapable of at the time.

silhouetted images of birds, beasts or human figures, all pleasing to the eye, were frequently found. The geometric designs were highly consistent all over, with the rhombus pattern (fig. 100) being the most prominent, usually on fabrics of monochrome color. There were also overlay or intricate designs within the rhombus outline. Floral patterns were rare and that of the auspicious dogwood, thought to ward off evil and ill fortune, occasionally seen. The dense overall design was preferred, often with intricate details filling spaces around the main motif.

Finds from Mawangdui best represent silk of the Western Han, while those from burial sites in the north and northwest of China, where the nomads roamed, that of the Eastern Han. Animal patterns on the Western Han silk fabrics feature birds in sparing numbers and of elegant light hues, which, despite some similarities, are different from those on the Eastern Han silks that often featured trotting beasts

accompanied by auspicious Chinese characters (see fig. 99). Brocades of the later period show a wider range of colors, highlighting contrast in tone, with robust, masculine designs. Such stylistic variations were the result of regional and ethnic cultural differences, in addition to changes over time.

The Silk Road caravans carried Chinese goods, silk being the most representative, westward to the faraway Roman Empire, where the beautiful fabric with a soft hand was all the rage with the nobility. The road was long and treacherous, and silk inevitably cost dearly, which at one point or another even became burdensome on the Roman treasury. Still, knowledge about silk was limited, despite its ubiquity, and for a long time, there was a belief in the West that silk grew on trees. Trade went both ways and with it came the influence of the western civilizations. Patterns of grape, a fruit from the West, appeared on Chinese brocade. Wool, also from the west, and wool tapestry in particular (fig. 101) that was to have great

Fig. 101 "Cut-Wool" Tapestry with Striped Pattern (detail)

Eastern Han dynasty
Fabric length 59 cm, width 57 cm
Institute of Archaeology of Xinjiang Uygur Autonomous Region

Unearthed from Tomb No. 2 at the raised burial site of ancient Loulan ruins, Lop Nur, Xinjiang in 1980. The decoration and technique of this type of wool tapestry, which had been imported from West Asia, inspired the creation of the striped pattern and *kesi* silk tapestry in silk production of the Tang.

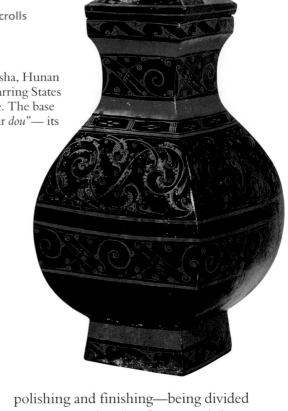

Fig. 102 Square Lacquer Vase Painted with Cloud Scrolls
Early Western Han dynsaty
Overall height 51.5 cm, rim side length 13 cm
Hunan Provincial Museum

Unearthed from Tomb No. 1 of Mawangdui in Changsha, Hunan in 1972. This type of square vase was popular in the Warring States and Western Han periods and most were cast in bronze. The base of this lacquer vase is marked with two characters, "four *dou*"— its volume in Chinese measure (roughly 44 liters).

significance later, were found at sites in Xinjiang. So were fabrics of cotton printed or dyed with patterns of apparent Western design, though cotton cultivation and weaving of any significant scale did not appear in China's interiors until a millennium later.

The production of lacquerware in the Qin and Western Han periods was remarkable. At burial sites of the nobles, it was common to find dozens or even up to a hundred lacquer objects. More abundant finds of lacquer plates, numbering in the thousands, were from royal tombs. The imperial workshops produced lacquerware of superior workmanship, with various stages of manufacture—base preparation, priming, lacquering, gilding (such as that of the wine cup with "ear-shaped handles"), painting,

polishing and finishing—being divided among specialized craftsmen. While centers of lacquer manufacture were found in places as far south as Guangzhou and Guiping, Chengdu remained most celebrated for its

Fig. 103 Nested Lacquer Box Painted with Cloud Scrolls
Early Western Han dynasty
Height 20.2 cm, rim diameter 35.2 cm
Hunan Provincial Museum

Unearthed from Tomb No. 1 of Mawangdui in Changsha, Hunan in 1972. Lacquer on hemp-cloth for the cover and sides, and on wood base for the base of the box. At the time of excavation, the lower chamber was found to have nine nested boxes and the upper chamber gloves, silk ribbons and a bronze mirror bag.

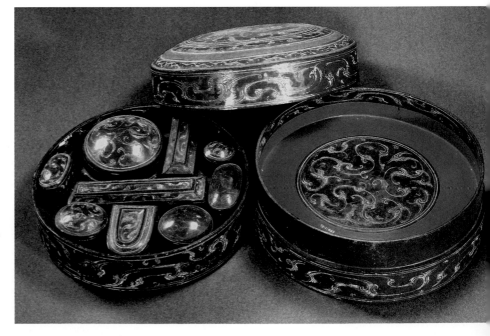

Fig. 104 Lacquer Jar with Cover

Late Western Han dynasty
Height 6.9 cm, waist diameter 7.8 cm
Yangzhou Museum, Jiangsu

Unearthed from Tomb No. 101 at Yaozhuang site, Ganquan Township, Hanjiang, Jiangsu. It is decorated with extremely fine cloud scrolls and geometric patterns, created by needle-point incising. Similar technique was used on a lacquer box with incised hunting scene, unearthed from Tomb No. 3 at Mawangdui.

unrivalled lacquer products. The exquisite lacquerware was also expensive, costing as much as ten times that of bronze.

Wood, hemp-cloth, and occasionally bamboo basketwork, were used as base on which lacquer was applied. Most lacquerware objects were food-serving vessels, having by then partially replaced bronzes. Lacquer makers often copied the shapes of bronze vessels. Some objects were quite large (fig. 102), while others small, all of intricate designs. Two fine specimens are the nested storage box (fig. 103), and the wine cup box (snuggly packing multiple wine cups with ear

handles). Small items were neatly put away in these covered boxes after use. Their decoration included painting in colors (see fig. 1 on page 1), needlepoint incising (fig. 104), carving and filling the lines with gold leaf (Tip 18), gilding with gold or silver (fig. 105), and inlay with mother-of-pearl or gemstone. Painted motifs included the stylized bird head, in crude brushwork and of spacious composition during the Qin dynasty, and cloud scrolls

Fig. 105 Lacquer Make-Up Box with Gold Appliqué and Silver-Bound Decoration

Late Western Han dynasty
Height 6.7 cm, length 15.6 cm
Cultural Heritage Administration of Hanjiang County, Jiangsu

Unearthed from a Han era tomb at Changjie Village, Yangmiao Township, Hanjiang, Jiangsu. The gold appliqué technique for cloud scrolls and animals was a precursor to gold and silver inlay on lacquer, which was invented in the Tang dynasty.

Tip 18: Gilded Incised Pattern

The technique involves filling the lines, after they are first incised and painted, with gold or silver leaf. Its origins can be traced back to the Han dynasty patterns that were incised with a needlepoint tool and then had gold leaf sunk into them. Examples from the Song dynasty were most refined and splendid.

interspersed with birds, beasts and geometric patterns in the Han. There were also vivid, colorful images of immortals, ancient worthies and figures exemplifying filial piety, done with compact and fluent brushwork.

However, lacquer production began to decline after reaching its zenith in the mid-Eastern Han period, which was marked by decreasing output and less elaborate decoration. Despite odd examples of fine craftsmanship, the trend continued unabated, largely due to advances in pottery making and the advent of porcelain.

Grey pottery fired at a temperature around 1,000℃ became common for everyday use

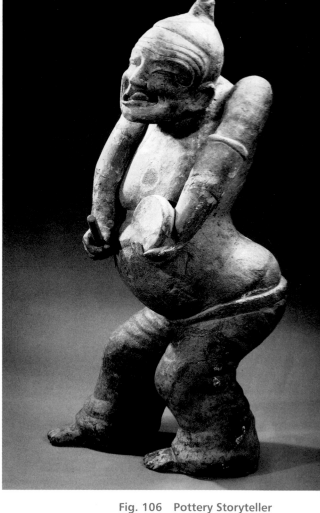

Fig. 106　Pottery Storyteller Figure

Late Eastern Han dynasty
Height 66.5 cm
Sichuan Provincial Museum

Unearthed from a Han era tomb in Pixian County, Sichuan in 1963. The wonderful rendering of the story telling figure in exaggerated and spirited pose could put a modern sculptor to shame.

Fig. 107　Lead-Glazed Stoneware with Hunting Pattern in Relief

Han dynasty
Height 42.5 cm, rim diameter 12.5 cm
National Museum of China, Beijing

Unearthed from a site at Guojiacun near Xi'an, Shaanxi. Sturdily potted, with vivid decoration and a warm luster to its glaze, it is deemed a masterpiece of low-fired, lead-glazed pottery of the Han dynasty.

Fig. 108　Long-Necked Yue Celadon Vase

Eastern Han dynasty
Height 29.9 cm, rim diameter 3.3 cm, foot diameter 12.8 cm
Zhejiang Provincial Museum

The vase, with a slender and unencumbered form, is rather elegant, despite technical defects (of specks and the yellowish tint in the glaze).

during the Qin and Han. Burnished and often undecorated, the hard-bodied ware was shaped in a severe, uniform form, frequently in imitation of bronzes. Pottery was also widely used for funerary purposes, given changing burial practices. Miniature pottery houses and figurines were to serve the dead in afterlife. The storyteller figurine in a spirited pose unearthed in Chengdu was the most splendid (fig. 106). A stoneware with lead glaze (fig. 107) began to be made in large numbers around the mid-Western Han, also mainly for funerary purposes. Its sudden popularity was probably due to Western input.

Technical advances achieved by kilns in the south led to the invention of the high-fired stoneware of celadon (fig. 108) and black glazes in the 2nd century. Fired at a temperature around 1,300℃, it had an even harder body and a glossy glaze that bound better to the body, with a higher transparency and imperviousness. Such stoneware, though not yet porcelain proper, gained increasing recognition for its fine qualities.

Bronze manufacture also showed a utilitarian tendency during the Qin and Han, with production for household use on the increase and that of ritual

Fig. 109 Bronze Garlic-Form Vase

Qin dynasty
Height 36.7 cm, foot diameter 12 cm
Hubei Provincial Museum

Unearthed from Tomb No. 9 of Suihudi site at Yunmeng, Hubei in 1975. The elegant and refined form, true to Qin character, continued to be emulated in porcelain design by imperial kilns even in the Ming and Qing dynasties.

vessels in decline. New bronze vessels tended to be lighter, with less elaborate decoration. Unadorned wares (fig. 109) became the mainstream. Even bronzes made for the royal court and nobility were now often undecorated, though examples of lavish decoration with gold, silver or gemstone inlay (fig. 110) were found up to the mid-Western

Fig. 110 Bronze Wine Vessel, *Zun*, in Rhino-Form with Gold and Silver Inlay

Early Western Han dynasty
Height 34.4 cm, length 58.1 cm
National Museum of China, Beijing

Unearthed from a site at Douma Village, Xingping, Shaanxi in 1963. It is designed, in a naturalistic manner, in the shape of a Sumatran rhinoceros living in China then, displaying masculine vigor. Some archaeologists dated this vessel to the Warring States period.

Fig. 111 Gilt Bronze Wine Vessel, *Zun*

Early Eastern Han dynasty (AD 45)
Height 41 cm, rim diameter 35.3 cm, base dish diameter 57.5 cm
The Palace Museum, Beijing

This wine vessel, according to its inscription, was made for the imperial court by a government workshop in Shu prefecture. It sits on a bronze base called *chengxuan*. Both the vessel and the base are supported on bear-shaped feet inlaid with turquoise and rock crystal.

Fig. 112 Bronze Cylindrical Container Painted with Lacquer Figures and Animals

Early Western Han dynasty
Height 42 cm, rim diameter 14 cm
Guangxi Zhuang Autonomous Region Museum

Unearthed from a site at Luobowan, Guixian, Guangxi in 1976. Belonging to an aristocrat of the Nanyue state, the cylindrical bronze vessel resembles a section of the bamboo in form, with patterns of indistinct motifs painted in lacquer.

Han. Mercury gilding (fig. 111), which creates a smooth and glistening surface of a well-designed body, became very popular. Common vessel shapes included *lei* (large wine vessel), *zhong* (goblet), *hu* (a pear-shaped container), *zun* (wine drinking vessel), *pan* (platter), *bei* (cup), and *tong* (cylindrical container) (fig. 112). A variety of finely crafted bronze lamps and incense burners (see fig. 97 on page 62) were found in large numbers. Some lamps were designed with an elegant form (fig. 113), and others with ingenious mechanisms to contain smoke and adjust light intensity, such as the hollow-bodied lamp in the shapes of human figure, ox, bird, or censer. The most well-known is the Changxin Palace Lamp (see fig. 12 on page 10), originally belonging to the Han court and later passed onto Prince Liu Sheng (165–113 BC).

While bronzes were still cast in significant numbers in the Han

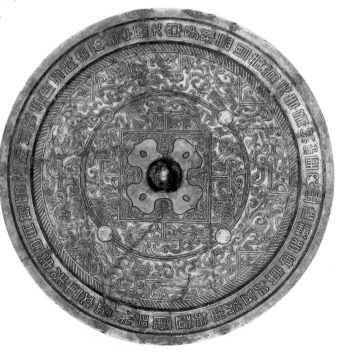

Fig. 113 "Red Phoenix" Bronze Lamp
Mid-Western Han dynasty
Height 20 cm, flat bowl
diameter 19 cm
Hebei Provincial Museum

Unearthed from the tomb of Dou Wan at Mancheng, Hebei in 1968. The lamp is cast in high-leaded bronze that has a lead content of 17.21%. The increased weight makes it more solid and stable.

dynasty, bronze art had begun to decline, as indicated by the tendency towards less refined decoration. Bronze wares were less ornate than lacquer and more costly than porcelain. It was inevitable that porcelain and lacquer would take the place of bronzes by the end of the Han dynasty, except for bronze mirrors that remained at the peak of artistry throughout the period. A distinct Han character began to emerge in mirror decoration towards the end of the 2nd century BC. The dense allover background went out of use and inscriptions that were first used at the start of the Han became lengthier. The symmetrical patterns around the central knob included petals, cloud scrolls, hornless dragons, squares, TLVs (fig. 114), arcs arranged along the outer band, *kui* dragons and phoenixes, coiled dragons, other fabulous creatures and pictorial designs. The casting became more refined and patterns finer and sharper. Of great significance were mirrors bearing the so-called TLV pattern. Linked to a certain cosmological belief, the TLV was often accompanied with mythical symbols of the four directions (dragon, tiger, mythic bird, and turtle snake), five auspicious creatures (the four directional beasts plus the mythic deer), and immortals. Han mirrors were usually small, but some could still have a diameter of more than 45 centimeters, and those of an oblong shape a height of 115 centimeters. The magic "light

Fig. 114 Gilt Bronze "TLV" Mirror
Xinmang period
Diameter 18.6 cm
National Museum of China, Beijing

Unearthed from a site near Changsha, Hunan in 1952. The back is cast in relief with T, L and V motifs as well as immortals, birds and animals, encircled by an inscription "Universal peace for the central kingdom."

Fig. 115 Magic "Light Transmission" Bronze Mirror

Late Western Han dynasty
Diameter 7.4 cm
Shanghai Museum

The back of the mirror is cast with the inscription "As the sun shines through, light prevails in all lands under heaven." Other mirrors known to have such a magic attribute of allowing patterns on the back to appear in a reflection of the mirror surface include "virtuous light" (*zhaoming*) mirror of the Western Han period and the lobed, flower-shaped (*baoxiang*) mirror of the Tang dynasty.

transmission" (fig. 115) had been a topic of interest since the Sui dynasty more than a millennium ago. When a source of light shines on the polished surface of the mirror, the pattern on its back can mysteriously appear on a screen in front of the mirror. According to researchers, this is mainly due to the stress caused on the mirror surface during casting, grinding and polishing.

Of all bronze finds outside central China, those from the northern steppes and Yunnan are the most outstanding. Birds and beasts were predominant in bronze decoration in the north, a tradition that continued into the Northern Wei dynasty (386–534) and beyond, reflecting the nomadic lifestyle there. Bronze casting in Yunnan, beginning as early as in the Warring States period, had reached a higher level of excellence towards the end of the 1st century BC, with a great number of extant artifacts. Techniques of lost-wax, gilding, gilding with tin, incising, and inlaying were employed. The bronze cowrie

Fig. 116 Bronze Cowrie Shell Container with Weaving Figures

Western Han dynasty
Overall height 48 cm, cover diameter 24 cm
Yunnan Provincial Museum

Unearthed from a site at Lijiashan in Jiangchuan, Yunnan in 1992. The cover is surmounted by figures weaving with waist looms, under the watchful eye of a slave owner. The traditional loom is still extensively used by ethnic peoples in Yunnan.

Fig. 117 Round Silver Box with Raised Petals

Overall height 12.1 cm, rim diameter 13 cm
Guangzhou Nanyue King's Tomb Museum,
Guangdong

Unearthed from the tomb of Zhao Mei, King of
Nanyue, near Guangzhou, Guangdong in 1983.
Archaeologists agreed that the box was an import
from the West, but differed in their opinion whether
it was Roman or ancient Iranian.

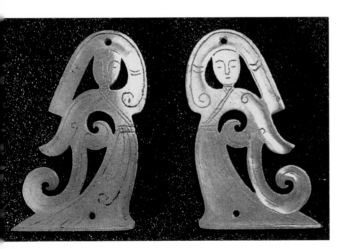

Fig. 118 Jade "Dancer" Plaques

Late Western Han dynasty
Height 5.5 cm
Beijing Dabaotai Han Tomb Museum

Unearthed from Tomb No. 2, dated to the Han
dynasty, at Dabaotai site in Beijing in 1975. The
elegant plaques are finely carved with dancing figures
in flowing long skirts, with one arm held above the
head. Jade plaques in the form of dancing figures
were often found buried with wives of nobles in
the Han era. Chronicles of the era referred to royal
consorts being mostly good at dancing.

shell containers from Yunnan were the most
remarkable. Cast with figures on the lid, they
had intricate designs replete with farming,
weaving (fig. 116), hunting, battle, or ritual
scenes, some conveying an epic sense.

Gold and silver ornamental objects
reached a high level of refinement during
the Qin and Han dynasties. The technique
of soldering onto metal surfaces gold beads,
or strips of metal bent or curved into a
pattern, was developed. It was more often
applied to gold objects, because of their
suitable texture and luster. Its wide use might
have been prompted by the popularity of
gilt bronzes. However, solid gold vessels
similarly decorated were extremely rare and
silver ones were seldom seen. Of special
interest are silver containers with raised petal
patterns (fig. 117) that have been excavated
from sties in both south and north China.
Their decorative style is evidently foreign and
differs from any Chinese tradition.

Jade objects of the Western Han had a
greater fame than those of the Eastern Han,
due to more abundant finds and higher
artistic attainment of the former. According
to archaeological findings, jade objects of
the earlier Han period were decorated with
high relief or carved in the round. Openwork
carving and polishing were perfected.
Ceremonial jade was in decline, with only
bi (disk with central orifice) and *gui* (tablet)
being still in use, while *cong* (square tube with
cylindrical interior) and *zhang* (jade scepter)
rarely made any more. *Huang* (flat arc-shaped
jade) and *hu* (tiger-shaped jade) were only
used as ornaments. Decorative pieces were
either pendants of graceful shapes carved with
great fluency (fig. 118), or fittings on various
implements, mostly swords. Most jade objects
for display were carved in the round, in the
form of hawk, bear (see fig. 120 on page 75),
galloping horse, or *bixie* (a winged, lion-like
mythical beast). They were elegantly carved,
and of severe, yet animated designs. Jade belt

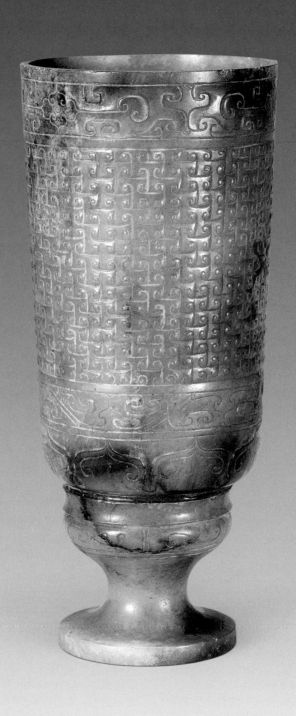

Fig. 120 Bear-Shaped Jade Ornament

Western Han dynasty
Height 4.8 cm, length 8 cm
Xianyang Museum, Shaanxi

Unearthed from a site northwest to the Wei Tombs near Xianyang, Shaanxi in 1972. The charming ornament is minimally carved to extreme perfection. It was unearthed at a location close to the tomb of Emperor Yuan of Han (74–33 BC) and deemed a courtly jade ornament.

hooks, seals, and a small number of jade vessels (fig. 119) were made for everyday use. Of note is a horn-shaped jade rhyton unearthed from the tomb of the King of Nanyue, near Guangzhou. Nanyue was a kingdom that existed in Lingnan (south of the Nanling Mountain) from the late Qin to the mid-Western Han times. Its exotic form should have its origins in Western decorative arts.

It was a common belief during the Han that jade accorded protection to the body and the spirit of the dead. Jade garments, jade plugs for sealing the nine orifices of the body, and plaques held in the fists of the dead were unearthed in considerable numbers. The most notable is the jade burial suit, reserved only for members of the royal house and nobility. However, the practice was deemed too extravagant and banned shortly after the founding of the Kingdom of Wei. The beautifully crafted Han jade always inspired great admiration and imitations were rife—so much so that it became quite a challenge to tell the genuine pieces from fake copies in extant

On facing page

Fig. 119 Jade Stem Cup

Qin dynasty
Height 14.7 cm, rim diameter 6.4 cm, foot diameter 4.5 cm
Xi'an Cultural Heritage Administration

Unearthed from the Epang Palace site in Xi'an, Shaanxi in 1976. Similar jade objects dated to the Qin dynasty were found in two excavations of tombs belonging to aristocrats of the Nanyue State, which was founded by a Qin army general sent on an expedition to conquer Lingnan.

objects claimed to be Han.

Throughout the Han dynasty, the concern with everyday life was prevalent in decorative arts, a trend that had first emerged during the Warring States period. While utility was still valued above all else, decoration became more vivid and unrestrained. By then, Chinese decorating art had rid itself of eerie mysticism and obsession with the world of spirit-beings.

Decorating art in the Han dynasty is noted for its tremendous diversity and magnificence, characterized by either realistic or exaggerated pictorial designs, elaborate or simple decoration, dense or spacious composition, majestic or intricate forms, with either a severe, vigorous, or graceful, elegant feel. Central to the Han decorating art is the spirited rendering and representation of figures and forms. This is particularly true with objects of superior workmanship. The inspired and ingenious design, animated form, and uplifting force all contributed to the character of the Han decorating art.

Chronologically, the first six to seven decades of the Han dynasty were a period of transition and incubation for new styles in decorating art, with the tradition of the Qin and Chu cultures of the Warring States largely retained. The new styles were not fully established until the reign of Emperor Wu of Han. By the time of Emperor Zhang's demise (AD 88), the fabulous and enchanting character of the Han decorating art was on the wane, as the empire itself began its gradual decline.

THE THREE KINGDOMS, THE JIN AND THE NORTHERN AND SOUTHERN DYNASTIES

The Three Kingdoms (220–280)
The Jin Dynasty (Western Jin 265–316, Eastern Jin 317–420)
The Southern (420–589) and the Northern (439–581) Dynasties
The Sixteen Kingdoms (304–439)[1]

For nearly four centuries after the demise of the Han, China was mired in prolonged strife and division, with rivaling states and dynasties rising and unraveling in quick succession. Assimilation of nomadic cultures and extensive international contacts continued despite political chaos, which led to a period of rich diversity and brilliance in Chinese decorating art.

After the collapse of the Jin dynasty's capital in the north at the start of the 4th century, the northern regions began to be ruled by successive kingdoms founded by nomadic tribes from the steppes. The society, of largely Han Chinese population, remained feudalistic. Decorative arts thus continued to demonstrate a strong Chinese character, though evidently influenced by traditions of the nomadic peoples, a result of assimilation and fusion of Chinese and nomadic elements. Another source of influence was "western," due to the continued influx of people and decorative goods from the western regions, especially in the 5th and 6th centuries. The imported gold and silverware (fig. 121), jade, and glassware were highly prized for their exquisite beauty by the aristocracy, the possession of which was something to brag about. Decorative arts in the Northern dynasties therefore often had an exotic touch.

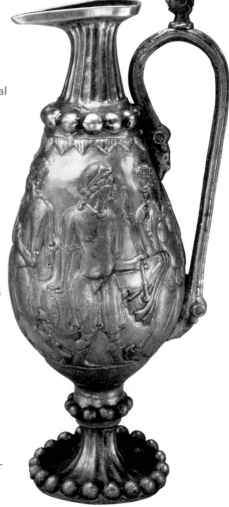

Fig. 121 Gilt Silver Ewer with Western Mythical Motifs

Height 37.5 cm, waist diameter 12.8 cm
The Guyuan Museum of Ningxia Autonomous Region

Unearthed from the tomb of Li Xian of the Northern Zhou dynasty (AD 569) in Guyuan, Ningxia in 1983. Li Xian was an esteemed general of the Northern Zhou dynasty (557–581). Such ewers imported from West Asia had great influence on Tang era ewers of exotic West Asia style.

1 Translator's note: A string of short-lived parallel dynasties in northern China.

Fig. 122 Silver Bowl with Lotus Pattern

Eastern Wei (534–550) and Northern Qi
(550–577) dynasties
Height 3.4 cm, rim diameter 9.2 cm, foot
diameter 3.5 cm
Cultural Heritage Preservation Center,
Zhengding County, Hebei

Unearthed from the tomb of Li Xizong (d. 544)
and his wife (d. 575) near Zanhuang, Hebei in
1975. The silver bowl, though plausibly made in
China, was greatly influenced by Western design, as
of its wave pattern hammered out.

The south remained predominantly Han Chinese despite the presence of many ethnic minorities that were culturally less developed and mostly under Han Chinese rule. Fusion of cultures in the south was largely a matter of various ethnic elements being Sinicized. The south had frequent contacts with foreign lands, too, but few were with the major civilizations to the west that could rival that of China. Besides, the ruling class in the south was not as interested in exotic imports as the rulers in the north. Thus, the development of decorative arts there, set against a predominantly Chinese background, was mostly free from external influence.

Buddhism became a popular religion embraced by followers from all sectors of society in both north and south. Visits by eminent monks, translation of scriptures, sessions of teaching, and constructions of temples and grottoes were events of great significance. Buddhist philosophy and art profoundly influenced decorative arts. Lotus flower (fig. 122) became an important decorative motif. Buddhist tapestry (fig. 123) became a new genre of embroidery art. Buddha statues built with lacquer on hemp cloth base added a new category to lacquer art.

However, incessant wars in the north left the economy in ruins and private production of decorative arts dwindled. The manufacture of high-grade products all but collapsed during the period of the Sixteen Kingdoms, when hardly a month went by without a military battle. The silk and pottery production did not recover slowly until the northern part of

Fig. 123 Embroidery with Images of Patrons (detail)

Northern Wei dynasty (the 11th
year of Taihe reign, AD 487)
Length 49.4 cm, width 29.5 cm
Dunhuang Academy, Gansu

Unearthed in the forecourt of
Caves 125 and 126 at Mogao
Grottoes, Dunhuang, Gansu
in 1965. This is the remnant
of an embroidered tapestry
given to Dunhuang by Prince
Yuanjia of Guangyang in
the Northern Wei dynasty,
showing his wife and daughter
in Xianbei (a nomadic people)
costumes.

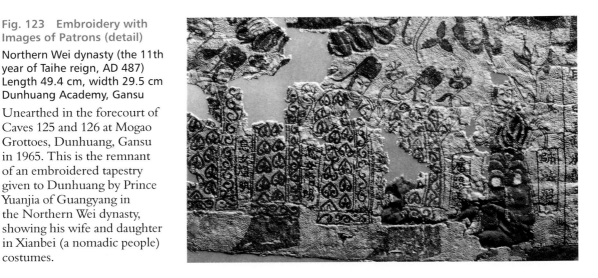

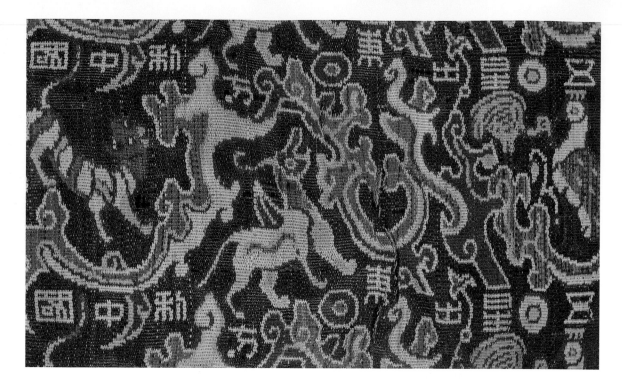

the country was reunified under the Northern Wei. However, its flourishing would have to wait until the Sui and Tang dynasties. In the relatively peaceful south, private production continued to grow, but only for pottery, lacquer and textiles. In contrast to paltry private output, imperial workshops churned out lavish decorative objects to gratify the whims of the newly enthroned rulers bent on pleasuring-seeking. Their production of lavish and extravagant goods such as high-grade silk, gold and silver vessels greatly flourished, especially in the north.

During the Three Kingdoms era and the Southern and Northern dynasties, silk produced in the north surpassed that in the lower Yangtze valley that excelled in pottery and lacquerware. Meanwhile, the Sichuan basin along the upper Yangtze was famed for both silk and lacquerware.

The level of sophistication achieved in silk and pottery during this period was the highest of all decorative media. Decorative patterns on silk produced in the Three Kingdoms and the Jin dynasty, marked by their bold simplicity and fluency in composition, bear similarities to those in the preceding Eastern Han period (fig. 124). However, silk finds from sites in

Fig. 124 Brocade Arm Guard Woven with Auspicious Characters
Han and Jin dynasty
Length 18.5 cm, width 12.5 cm
Institute of Archaeology, Academy of Social Sciences of Xinjiang Uygur Autonomous Region

Unearthed from burial site No. 1 at Niya ruins in Minfeng, Xinjiang in 1995. The brocade, decorated in a style similar to that of the Eastern Han era, is woven with the characters, "Five stars rising in the east favoring the Central Kingdom."

the north, where contact with the "west" was more direct, show a different character, as seen on the brocade fragments excavated from the ancient tombs at Gaochang in Turpan, Xinjiang. They were woven with representational images in balanced, well-structured composition (fig. 125), and images encircled by dots (fig. 126), a distinct pattern that had influenced brocade weave in the succeeding Sui and Tang dynasties. Such silk fabrics were also documented to have been produced in the interior of China earlier than silk finds from the northwest. Advances in the Southern and Northern dynasties predicated the glorious achievements in silk production during the Sui and Tang dynasties. An improved design for the pattern loom by Ma Jun, who lived in Kingdom of Wei

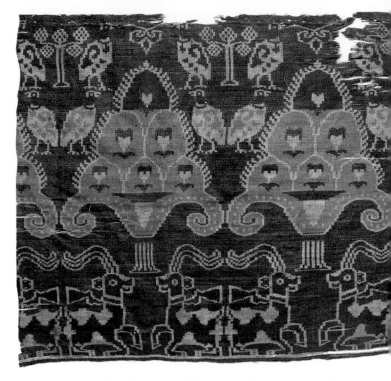

Fig. 125 Brocade Woven with Pairs of Roosters and Sheep and Lantern and Tree Pattern

Ca. 5th–7th centuries
Length 24 cm, width 21 cm
Xinjiang Uygur Autonomous Region Museum

Unearthed from the Astana tombs in Turpan, Xinjiang in 1972. While the lantern and tree motifs were apparently influenced by Western designs, rooster and sheep were homophonic with "auspicious" in Chinese, suggesting a plausible auspicious pattern.

and was known for his significant contribution to the development of Chinese silk and textile, not only enhanced silk production but created superb weave patterns that could be compared to the renowned *shujin* (brocade of Shu, present Sichuan).

Silk production began to grow in the south, with several important centers emerging, such as Yangzhou and Jingzhou (present Jiangling, Hubei), both being close to the north. In the northwest of China, Xinjiang began to produce silk in the 3rd and 4th centuries, and could boast several important centers of production by the 5th and 6th centuries. Being at the intersection of East and West trade, Xinjiang, though less developed in technology, was well-exposed to both Chinese and "western" patterns and techniques as they passed in both directions.

The lower Yangtze basin (present Zhejiang and southern Jiangsu) was well known for its fine pottery and the firing technique developed there represented the best at the time. Its celadon wares were evenly potted with a fine, highly transparent glaze. Elegantly and uniformly shaped, they showed varied decorative patterns, including simply painted ones. Remarkably, zoomorphic form

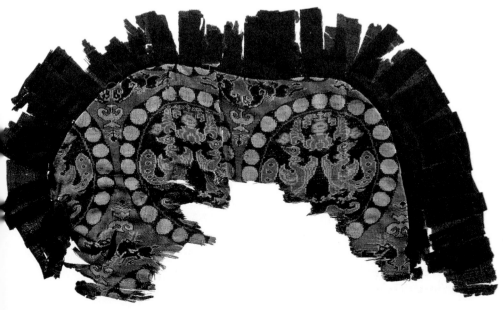

Fig. 126 Brocade Woven with Peacocks in Circular Dots

Ca. 5th–7th centuries
Length 13.5 cm, width 20.5 cm
Xinjiang Uygur Autonomous Region Museum

Unearthed at Tomb No. 170 (dated to 558) at Astana site in Turpan, Xinjiang in 1964. Used as face covering for the deceased, it is the oldest extant brocade woven with the circular-dot pattern.

Fig. 127 Ram-Shaped Celadon Candle Holder

Western Jin dynasty
Height 19.5 cm, length 26 cm
Nanjing Museum, Jiangsu

Unearthed from a Western Jin era tomb at Xigang, Nanjing, Jiangsu in 1974. The candle holder is designed in the manner that serves both practical and decorative purposes; a long-held Chinese tradition.

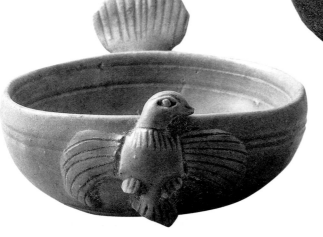

Fig. 128 Celadon Wine Cup with Handles in Bird's Head and Tail Forms

The Wu Kingdom (221–280)
Height 6.1 cm, rim diameter 10.5 cm
Zhejiang Provincial Museum

Unearthed from a brick-chambered tomb at Fengshan, Baiguan Township, Shangyu, Zhejiang in 1974. One handle of the bowl is molded in the shape of the head of a pigeon in flight and the other its tail; an ingenious fusion of function and aesthetics.

(fig. 127) was sometimes used for either the body or main parts of a vessel (fig. 128), subject to functionality requirements. Some kilns began applying a semi-liquid clay slip to the body of the vessel before firing. Called "cosmetic" coating (Tip 19), it was later widely used in the production of the mid- or low-grade wares. The tea bowl with a high-footed stand (fig. 129), a notable new design, also appeared during this period. Some of the stoneware vessels with a glassy black glaze (fig. 130), similar in form and decoration to the celadon ware, were very refined. The

prestige of Yue kilns and the like in Zhejiang began to wane after the Eastern Jin, their products showing signs of deterioration, as kilns further south became more prolific.

Pottery production in the north started later, with sites of the earliest known kilns dated to the late 6th century found in modern Hebei and Shandong. Northern porcelain showed less variety in form, being potted in thick, sturdy shapes with bold, masculine decoration. Marvelous decorative patterns found on finer specimens (see fig. 131 on page 82) were often molded or applied to the surface, relief in effect, with an exotic "western" touch (see fig. 132 on page 82), likely influenced by the repoussé technique for gold metalwork (Tip 20) from the Sasanian empire (a Persian dynasty before the Arab conquest in 651). One notable example of northern pottery was the white porcelain, though at the time its glaze had a

Tip 19: "Cosmetic" Coating

The technique involves applying a slip (of fine white china with low iron content and well tempered with water) to the clay body before firing. This is done to cover any undesirable color or coarse surface, so that even low-grade clay may be put to good use.

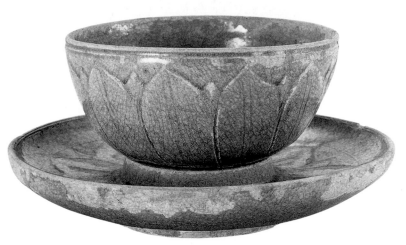

Fig. 129 Celadon Stoneware Cup, with Modeled Lotus Petals and Stand

Southern dynasties (Qi, 479–502)
Height 10.7 cm, rim diameter 15.5 cm
Jiangxi Provincial Museum

Unearthed from a tomb (AD 493) of the Qi dynasty at Ji'an, Jiangxi in 1975. Such stoneware cups, of the Eastern Jin and Southern dynasties, being made for tea-drinking is only a plausibility, proposed on the basis of tea being grown and tea-drinking popular in the lower Yangtze basin.

yellowish tint (see fig. 133 on page 82). This new type of porcelain had profound and far-reaching influence on later eras and white glaze became an ideal base for varicolored decoration yet to come.

The fact that the white porcelain first appeared in northern China, with neither a long history of, nor a good foundation for, porcelain production, had something to do with the north being under nomadic rule. White was an auspicious color in shamanistic belief systems on the northern steppes. Thus, the development of white porcelain in northern China then and later best illustrates that decorative arts cater to human aspirations and needs, which in turn determine the shape and feel of things decorative.

Gold objects are quite abundant among extant relics dated to the period and the number of ornaments far outweighs that of vessels. Gold ornaments produced in the north in the 4th century and thereafter, particularly those fashioned in animal forms, had an apparent nomadic touch. Gold or silver utensils are rare among archaeological finds, most of which

Tip 20: Repoussé Technique for Gold Metalwork

A technique with a metal sheet being embedded face down in a mold, with the portions to be raised being hammered down. Not only the shape, but also the patterns of an object could thus be hammered out, with raised effect akin to relief.

Fig. 130 Black Stoneware Jar with Ring-Shaped Mouth

Eastern Jin dynasty
Height 24.9 cm, rim diameter 11.4 cm, waist diameter 18.8 cm, base diameter 11.4 cm
Shanghai Museum

Finely potted, it is covered in a rich black glaze. Black stoneware first appeared in the Han dynasty, but none made before the Eastern Jin had attained the level of perfection as shown in this piece.

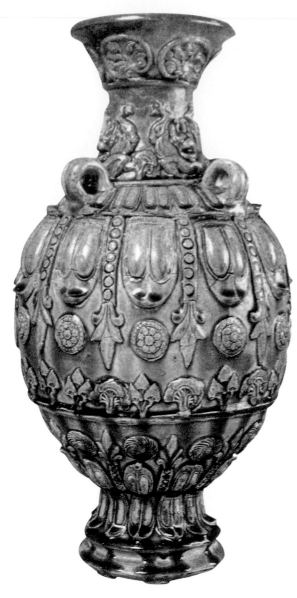

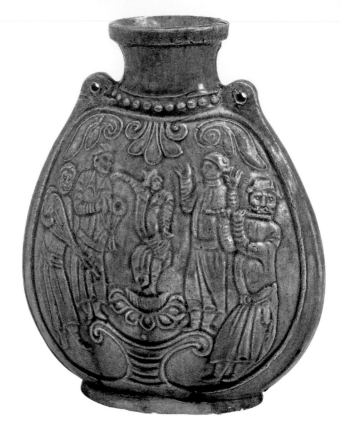

Fig. 132 Yellow-Glazed Flattened Flask, *Hu*, Molded with Dancing Figures

Northern Qi dynasty
Height 19.5 cm, rim diameter 6.4 cm
Henan Provincial Museum

Unearthed from the tomb of Fan Cui (d. 575) in Anyang, Henan in 1971. The figures should be doing the Central Asian dance with typical fast swirls or leaps, whose popularity continued into the Tang. The renegade general An Lushan (703–757) was known to excel in such moves.

Fig. 131 Celadon Jar Molded with Lotus Petals and Four Lug Handles

Northern Qi dynasty
Height 51.2 cm
Kansas City Museum, U.S.

The salient West Asian character of this stoneware jar, with lavish, dense decorative patterns, was never seen before then in the south of China.

Fig. 133 White Porcelain Jar with Four Lug Handles

Northern Qi dynasty
Height 20 cm
Henan Provincial Museum

Unearthed from the tomb of Fan Cui in Anyang, Henan in 1971. Celadon jars with four lug handles that were similar to this were made in the Southern dynasties, but they never had the sturdy, masculine feel of the northern type.

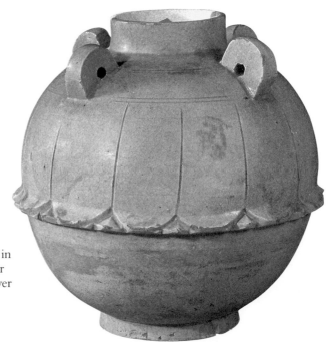

Fig. 134 Gold Ornament with Gemstone Inlay
Northern Qi dynasty
Length 15 cm
Shanxi Provincial Institute of Archaeology

Unearthed from the tomb of Lou Rui (d. 570) near Taiyuan, Shanxi in 1981. Inlaid materials include pearl, turquoise, sapphire, agate, and natural glass, the last three being not sourced in China then.

were imported from the "west" (see fig. 121 on page 76). Even those produced locally had a strong "western" touch (see fig. 122 on page 77). Such a tendency continued into the early Tang. Gold and silver metalwork finds in southern China are also predominantly ornaments, most of which being silver. Inlay with gemstones from foreign lands was more common in the north (fig. 134), though also occasionally seen in finds from the south.

The exquisite lacquer wares excavated from the tomb of Zhu Ran (182–249), a Wu Kingdom (221–280) General, were variably decorated with varicolored painting (fig. 135), incised and gilt patterns (see fig. 136 on page 84), or "rhino skin" (*xipi*) paint (see fig. 137 and Tip 21 on page 84), showing a high level of craftsmanship. Some of the pieces were made by workshops in Shu (modern Sichuan). Hollow-bodied lacquer Buddha statues were

popular throughout the Jin and Southern and Northern dynasties, for which the Eastern Jin painter and calligrapher Dai Kui (326–396) was renowned. Statues of lacquer on hemp cloth base were said to be easy to carry, for parading and public display to promote Buddhism, though none from the period have survived. Litharge was widely used as a pigment in oil paint for lacquer decoration. The lacquered wood screens and coffins excavated from the tombs dated to the Northern Wei (of the Northern dynasties) were richly decorated, likely with litharge paint.

The character of Chinese decorative arts changed markedly through the political upheavals of this period. The Han dynasty traditions largely continued into the Three Kingdoms. By the Western Jin, a gentle and natural style gradually took hold, which was then carried on and evolved into one of

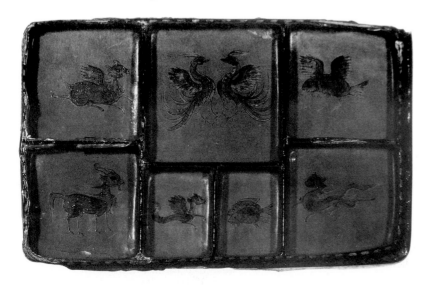

Fig. 135 Partitioned Lacquer Box Painted with Bird, Beast and Fish Motifs

The Wu Kingdom
Height 4.8 cm, length 25.4 cm, width 16.3 cm
Ma'anshan Museum, Anhui

Unearthed from the tomb of Zhu Ran (d. 249) near Ma'anshan, Anhui in 1984. Such lacquer vessels continued to be popular during the succeeding Jin dynasty. The ingenious design was truly remarkable and is still being applied in making utensils today, because of its practicality.

Fig. 136 Lacquer Box and Cover with Incised and Gilt Pattern
The Wu Kingdom
Height 11.5 cm, width 22.6 cm
Ma'anshan Museum, Anhui

Unearthed from the tomb of Zhu Ran near Ma'anshan, Anhui in 1984. Fabulous beasts, birds and figures were finely and densely needle-incised with great fluency on cloud scroll ground; exquisite in effect.

elegant simplicity in the Eastern Jin and the Southern dynasties. In the succeeding Sixteen Kingdoms and the Northern dynasties, a robust, masculine style became prominent. Overall, this was a transient period between the mighty Han and Tang dynasties, its achievements barely on par with the glorious. Nonetheless, it is a period of transformation, with new styles ushered in on the heels of the old. The paths blazed then were largely followed in the Sui, Tang and Five dynasties.

The Northern and Southern dynasties were of particular interest for their extensive use of floral patterns and the tendency towards pictorial designs. Floral motifs were used in earlier decorative arts, but never as extensively as in the Southern and Northern dynasties. Such patterns, with those of lotus and honeysuckle being the most representative, were used with increasing variations, gaining greater importance. Pictorial designs, though also appearing in Chinese decorative arts

Tip 21: "Rhino Skin" Paint

This technique involves modeling with a putty consisting of a thick mixture of lacquer. Over this uneven surface are applied layers of varicolored lacquer before it is polished to a fine finish. Depending on what has been modeled on the base layer, the multi-colored surface show patterns of clouds, round flower petals, or pine bark. First invented probably before the Three Kingdoms, it became popular in the Tang and Song dynasties.

very early on and having never ceased being in use, became predominant from then on. Prior to this, the pictorial patterns were often used with some exaggeration and distortion, bordering on being abstract, especially in the Three Kingdoms era, as seen in silk patterns of animal motifs in particular.

Chinese decorative arts of this period greatly influenced their "western" equivalents, though the reverse was also true. With the burgeoning export of Chinese silk, the sericulture technology spread westward to Central Asia, Persia, and even Byzantium, giving birth to the famed Persian silk brocade with its weave patterns and technique in turn becoming wildly popular in the East.

Fig. 137 "Rhino Skin" Lacquer "Ear" Cups
The Wu Kingdom
Height 2.4 cm, length 9.6 cm, width 5.6 cm
Ma'anshan Museum, Anhui

Unearthed from the tomb of Zhu Ran near Ma'anshan, Anhui in 1984. The exterior is decorated, more pronouncedly than the interior, in marbled lacquer with fluent black, red and yellow swirls. The rim and ear handles are copper bound and gilt.

THE SUI, TANG AND FIVE DYNASTIES

The Sui Dynasty (581–618), The Tang Dynasty (618–907) The Five Dynasties (907–960)

In the four centuries spanning the Sui, Tang and Five dynasties, Chinese decorative arts initially carried on the traditions of the Northern dynasties. Towards the end of this period, however, came a revival of the culture of the Southern dynasties. Overall, this period, and the Tang especially, witnessed a great flourishing of decorative arts, with remarkable achievements across all media. The rebellion led by the Tang renegade generals An Lushan (703–757) and Shi Siming (703–761) at the end of 755 affected the development of decorative arts. Turmoil wrought by the rebellion dragged on for years before ending in 763. By then, the Tang had begun the decline from the peak of its fortunes.

China had been remarkably open to "western" influences before the An Lushan Rebellion. Decorative arts, of silk (see fig. 20 on page 14), gold and silver (fig. 138) in particular, often manifested apparently "western" styles. The major civilizations to the west of China—the Sasanian Empire, Arab Empire, and Byzantine—were known to be lands of exotic riches and industry. Tucked between these civilizations and China was Sogdiana, an ancient state of Central Asia (in modern Uzbekistan). It had by then become a prosperous and productive center critical to trade along the Silk Road. Via this intermediary of East-West trade, "western" styles and preferences came to China after

first being adopted and modified by Sogdiana. Its decorative arts thus had direct and apparent influence on Chinese production (see fig. 139 on page 86).

The impact of rebellion was twofold: decreasing contact with the west, and a southward shift of centers of production.

Fig. 138 Eight-Lobed Silver Cup with Gilt Musician Figures
Ca. 650–755 of Tang dynasty
Height 6.6 cm, rim diameter 7 cm, foot diameter 4.3 cm
Shaanxi History Museum

Excavated from a treasure hoard at Hejia Village, Xi'an, Shaanxi in 1970, the cup was decorated with "western" looking musicians and attendants in relief, and the loop handle adorned with human protome of "western" features, all speaking to a close relationship with West Asia.

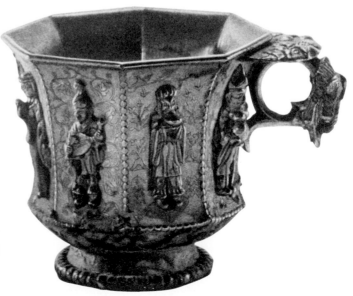

As internal strife weakened Tang, the trade route, as well as East and West cultural exchange, was further interrupted by Tibetan tribes from the plateau. Output in the lower Yangtze River drainage basin with an undiluted Chinese character (less exposed to "western" influences) began to gain importance, thanks to two factors. The first was greater stability in the south, as the north continued to be ravaged by ceaseless wars leaving its economy in ruins. The second was less partiality to "western" goods, out of spite for the rebels such as An Lushan and Shi Siming, who were of non-Han Chinese ancestry, and the Tibetan and muslin tribes threatening to challenge central authority. If decorative arts in China adopted "western" elements, albeit watered down via Sogdiana, before the turmoil, thereafter they showed a more salient Chinese character.

Production was always centered in major towns. Both Chang'an (modern Xi'an) and Luoyang, successive capitals of the empire, were home to most imperial workshops with masterful craftsmen in their employ, turning out superior decorative goods. Other cities across China were variously famed for what they specialized in:

- Yangzhou (brocade and bronze mirror),
- Chengdu (ultra-light gauze, brocade, and pottery with hand-carved or pierced decoration),
- Dingzhou (twill damasks and gauze),
- Runzhou, modern Zhenjiang of Jiangsu (gold and silver wares),
- Xuanzhou, modern Xuancheng of Anhui (imitation damask on tabby woven with rabbit wool, and heavy silk tapestry),
- Yuezhou, modern Shaoxing of Zhejiang (silk gauze, gauze, twill damask, and porcelain),
- Xiangzhou, modern Xiangfan of Hubei (lacquer ware).

Silk was the most important of all products. The top-grade gauze and silk gauze

Fig. 139　Brocade with Pattern of Boar Mask Set in Circular Dots
Ca. 650–755 of Tang dynasty
Length 16 cm, width 14 cm
Xinjiang Uygur Autonomous Region Museum
Excavated from Tomb No. 138 at the Astana site, Turpan, Xinjiang in 1969. The Sasanian pattern features the Zoroastrian god of war in one of his incarnations. Such a symbol went out of use after the Islamization of Persia and Central Asia.

were extremely light and had a delicate hand. A garment fashioned out of such a fabric was superlatively described in one account as akin to a mist-like veil. The single warp silk gauze (*dansiluo*) was so light that a bolt (measuring about half a meter across and 12 meters long) could weigh as little as 200 grams. Scores of twill damask weaves appeared in the Tang, with *liaoling* produced in the lower Yangtze basin being the most well-known. Woven with fine silk strands, the fabric would then be pressed with a stoneroller to achieve paper-thinness and ultra-smoothness. Brocade, a high-grade silk fabric, was highly sought after. Woven with the weft-facing technique, it had raised floral designs of rich colors, often with a distinct "western" look. Most silk finds dated to this period were from sites in the northwestern region of China, where the arid climate had helped to preserve the delicate material. Those of a finer quality were of interior China origins, usually with symmetrical patterns (see fig. 20 on page 14), while coarser varieties had been either

Fig. 140 Patterned-Weave Brocade *Pipa* Bag (detail)

Ca. 650–755 of Tang dynasty
Shosoin Repository, Nara, Japan

The surviving portion of a *pipa* bag, dated to the Tang dynasty, shows a composite floral pattern, the most splendid known of patterned-weave brocades. The magnificent design of lavish colors blends multiple flowers in a roundel; a work of fine craftsmanship.

produced locally in the northwest or imported from Central Asia, with singular rather than paired pictorial designs (see fig. 139).

Brocade and twill damask patterns created for the imperial court by the famed early Tang designer Dou Shilun (595–672) featured bird and animal motifs, often in symmetrical arrangements. They were later known as the "Duke of Ling Yang Patterns," with reference to his royally bestowed title. The symmetrical pairs of birds and animals ringed by circular dots found on excavated brocades and twill damasks are believed to have been based on his design. In the 8th century, however, the popularity of the ringed pattern came to an abrupt end and, in its place, rose the composite flower (fig. 140) and floral and bird patterns (fig. 141). Thereafter,

Fig. 141 Brocade with Floral and Bird Pattern

Mid-Tang period (766–835)
Length 24.5 cm, width 36.5 cm
Xinjiang Uygur Autonomous Region Museum

Excavated from Tomb No. 381 at the Astana site, Turpan, Xinjiang in 1968. The woven pattern shows mostly peonies, which became all the rage with the wealthy in Chang'an, the capital, by the early 8th century (713–741) and later.

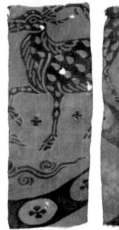
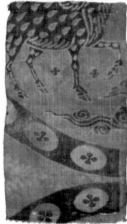
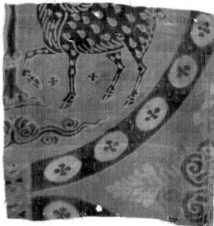

the auspicious birds, flowers, and geometric patterns became prevalent in silk as well as other media, with the floral design gaining increasing prestige.

Tie-dyeing, clamp-resist dyeing, batik, and resist printing (masked by an alkaline-based paste) were commonly used for silk dyeing and printing in the Tang dynasty. Tie-dyeing, still in use to this day, creates blurred, abstract patterns (fig. 142) and was widely used by private dyeing shops because of its easy application. Clamp-resist dyeing creates the sharpest and most refined patterns, often in several colors (fig. 143) (Tip 20). The dense, flowery patterns so achieved are indicative of the preference for elaborate decoration at the time.

Embroidery motifs and techniques

Fig. 144 Embroidery of Shakyamuni Buddha Preaching

Ca. 650–755 of Tang dynasty
Height 208 cm, width 158 cm
Nara National Museum, Japan

Embroideries of large sizes dated to the Tang dynasty were also found in the "Library Cave," Dunhuang, but none of them was nearly as good as this piece in composition and stitching.

became more varied. The rise of Buddhism brought about prolific output of tapestries embroidered with Buddhist scriptures and figures (fig. 144), by both imperial workshops and private artisans. Straight and satin stitches that produced smooth, fluent patterns of natural color transition replaced the raised chain band stitch that was capable of only crude, rigid patterns. Embroiderers' superb needlework and pious dedication to Buddhism created exquisite patterns and figures of stunning realism. After the Tang dynasty, calligraphy masterworks and scenes taken from well-known Chinese paintings appeared in embroidery, which was to require more refined skills.

The Tang textiles display superb craftsmanship and love of pageantry. Princess Anle, for example, who lived at a time when

the empire's fortunes were at their peak, was famed for having a most lavish gown made from ultra-light single-warp gauze sent up from Shu (modern Sichuan) for her wedding. The gown was decorated with floral and bird patterns of fine strands of gold. Her skirt, adorned with feathers of a hundred birds, shimmered with varying colors when seen from different angles or under different lights. Her saddlecloth was woven with the wool of a hundred beasts, showing pictorial patterns depicting each of them; similar to the one owned by her mother, Empress Wei.

Pottery production of the period was widely distributed throughout the land, in modern Shanxi and Hebei in the north, Fujian and Guangdong in the south, Jiangsu and Zhejiang in the east, and Sichuan and Shaanxi in the west. But the largest clusters of kilns were in Henan and Zhejiang. From the

Tip 20: Clamp-Resist Dyeing

A technique with folded fabric being held on either side by wooden boards carved with identical openwork patterns and then dyed. This produces symmetrical patterns of lush color after repeat dyeing. The technique should have been invented by palace dyers under Emperor Xuanzong (685–762), and was later widely adopted throughout the land.

various pottery finds dated to this period, a progression of style and firing sophistication could be seen, reflecting the changing trends of fashion and technical advances over time. As a rule, the earlier pieces tended to be tall and sturdy (fig. 145) and later ones lighter and more exquisite (fig. 146); a trend shared by vessels of all media at the time.

Glazes were prized for their purity, an ideal quality. They were admiringly described as "capturing the soft blue of a thousand mountain peaks" or as near "frost-white." The monochrome and dappled glazes, as if not lavish enough, were surpassed by the more brilliant *sancai*, or tri-color glaze, that had been allowed to slip or run naturally over the surface (fig. 147). The varied, free-flowing patterns display a passion for life and the pride of a nation at its most glorious. Not content with incised, stamped, pierced, sculptured and pinched patterns, the ceramists turned to glaze pigments and painting. In addition to a great variety of pictorial motifs, calligraphy was used in decoration. The earlier pieces showed an emphasis on the elaborate, relief effect through layering, pinching and sculpting, often with an exotic touch (see fig. 145). In the later part of this period, however, smooth surface decoration of a moderate character became the norm.

The extraordinary development of ceramics owed much to technical advances during the Tang. In the late Tang, music-making by hitting bowls filled with different amounts of water was in vogue. Such bowls had to be high-fired, hard-bodied porcelain. The fine white porcelain produced by Xing kilns (fig. 148) had perfectly potted shapes covered with a luminous, soft-toned glaze, which became popular throughout the land. Celadon wares

Fig. 145 Celadon Ewer with Dragon-Headed Handle and Phoenix-Headed Lid

Early Tang period (618–712)
Height 41.2 cm, rim diameter 9.4 cm
The Palace Museum, Beijing

Said to have been unearthed at a site in Jixian, Henan, this "western" style ewer has a slender, tall form, with decorative bands and patterns molded and applied to the surface that are rather exotic, while the phoenix finial and dragon-headed handle suggest a Chinese touch.

Fig. 146 White Porcelain Dish with Guan Mark from Ding Kilns

Late Tang period (875–907)
Height 2.9 cm, rim diameter 11.7 cm
Xi'an Museum, Shaanxi

Excavated from a treasure hoard at Huoshaobi in Xi'an, Shaanxi in 1985, the dish has a charming form, with a pure, elegant glaze. A total of 33 white porcelain wares with the "guan" (official) mark were found at this site.

Fig. 147 Tri-Color Glazed Earthenware Camel with Mounted Musicians

Ca. 650–755 of Tang dynasty
Camel height 58.4 cm, length 43.4 cm, figurine height 25.1 cm
National Museum of China, Beijing

Excavated from the tomb of Xianyu Tinghui (d. 723) near Xi'an, Shaanxi in 1957. The Bactrian camel, native to Central Asia, is vividly depicted in a spirited pose, carrying five musicians—two being Chinese and the rest foreign. The splendid sculpture is evidence of the cultural ties with the "west" at the time.

Fig. 148 Xing White Porcelain Jar with Attachment Rings

Mid-Tang period
Height 29.5 cm, rim diameter 7.3 cm
Shanghai Museum

With four attachment rings to loop through a strap for carrying, it was produced at Xing kilns in the north of China where contacts with nomadic tribes were frequent; hence the design.

from Yue kilns in the late Tang and the Five dynasties, unlike the plain Xing wares, had more elaborate and varied low-relief decoration. A rare "secret glaze" with a warm luster, showing a jade-like quality (fig. 149) (Tip 21), came to represent a new, superior style of porcelain decoration.

Changsha kilns were known for their wine vessels and teapots of graceful and elegantly simple forms (fig. 150), decorated with painting that was to become a great tradition lasting a millennium. Tri-color pottery horses and figurines were used as funerary objects by the aristocracy. Though destined for burial with no chance of seeing the light of day, they were crafted with no less technical rigor. Vividly sculptured in spirited poses and covered with brilliant glazes, they were truly timeless masterpieces worthy their place in the history of sculpture.

Gold and silver metalwork also reached a peak during the Tang, which was marked by the great volume and quality of production, and the variety of designs. A large silver vase,

Fig. 149　Dish with "Secret Glaze" from Yue Kilns
Late Tang period
Height 6.1 cm, rim diameter 23.8 cm, foot diameter 17.4 cm
Famen Temple Museum, Shaanxi

Excavated from the crypt of the pagoda (dated to 874) at Famen Temple, Fufeng County, Shaanxi in 1987. Its glaze has a jade-like warm luster, which was deemed an ideal quality for porcelain glaze from the middle of the 8th century onward in China. Fragments of wrapping paper dated to the Tang were seen on its surface.

Tip 21: "Secret Glaze" Celadon

This is a stoneware with green-grey glaze of varying tones made for the court by the Yue kilns from the late Tang to the mid-Northern Song period (960–1127). The small-sized ones were often fired while being suspended on nail-like props to minimize unglazed biscuit. Such wares, sometimes decorated with precious metal mounts, had a soft, warm luster to their glaze. Celadon wares produced by kilns other than the Yue kilns were also described as having the "secret glaze" in Song dynasty accounts.

Fig. 150　Ewer Painted with Playing Child from Changsha Kilns
Late Tang period
Height 19.5 cm
Changsha City Cultural Heritage Working Team, Hunan

Excavated from the ruins of the Changsha kilns at Wangcheng, Hunan in 1978. Despite being a reject with body and glaze defects, the ewer remnant shows exquisite decoration, with the vividly painted child.

Fig. 151 Oblong Eight-Lobed Silver Cup with Gilt Floral and Bird Pattern

Ca. 650–755 of Tang dynasty
Height 3.5 cm, length 15.1 cm,
width 6.7 cm
Hakutsuru Fine Art Museum,
Kobe, Japan

The lobed silver cup shows a Sassanian Persian design. Such lobed dishes or shallow cups continued to be made in the mid- and late-Tang periods, but with a more roundish form of fewer lobes.

Fig. 152 Silver Mesh Basket with Gold Wire Decoration

Late Tang period
Height 15 cm, weight 355 g
Famen Temple Museum, Shaanxi

Excavated from the crypt of the pagoda (dated to 874) at Famen Temple, Fufeng, Shaanxi in 1987, the silver mesh basket was decorated with gold wires and used for picking cherries. What a sight to behold when it was laden with the bright red fruits!

for example, was as tall as 2.4 meters, and a silver platter 90 centimeters in diameter. On the other end of the scale, a small sliver bell was only 1.5 centimeters in diameter and a tiny gold box 1.5 centimeters in height. The gold- and silversmiths in the early Tang often borrowed foreign shapes and then added Chinese-style decoration (fig. 151), but this was replaced later by a distinct Chinese style in both form and decoration (fig. 152). The incense burner, as shown in fig. 13 on page 11, was most

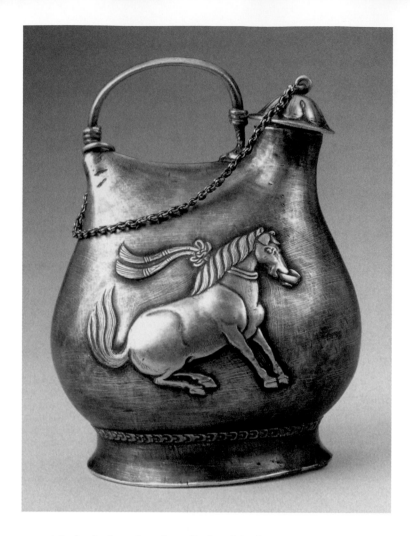

Fig. 153 Silver Flask with Gilt Dancing Horse Holding a Cup in Its Mouth

Ca. 650–755 of Tang dynasty
Height 18.5 cm, foot diameter 7.2–8.9 cm, weight 549 g
Shaanxi History Museum

Excavated from a treasure hoard at Hejia Village, Xi'an, Shaanxi in 1970. Horses, decked out with ribbons (homophonic with "longevity" in Chinese) and dancing to merry tunes for court entertainment, were commonly featured at Emperor Xuanzong's birthday celebration.

exquisitely designed and crafted, achieving an ingenious unity of function and aesthetics.

Repoussé technique (see fig. 151 on page 93) and chasing (fig. 153) were the two commonest techniques used for gold or silver metalwork in the Tang, both capable of creating fine, precise and realistic patterns. Repoussé is the primary technique for gold and silver metalwork in the West, producing patterns in low relief. Chasing, accomplished with hammer and special punches, produced patterns in intaglio, which was associated with the Chinese tradition of stone tablet engraving. Owing to their different origins, hammered patterns, mostly found in the early Tang, often had a western touch, whereas chased patterns, more prevalent in the late Tang, were Chinese in character.

Silverwares could be fire-gilded, with an allover coating or only the main part of the surface covered in gold (see fig. 153). Such gilt silver, stunningly beautiful and precious, were deemed superior to gold ware. The process was by then so refined that gilders could apply it following the most intricate designs, seldom with any slip or spillover. However, as the Tang began to weaken, the art of gold- and silversmith slowly declined from the mid-Tang times on.

New and massive bronze objects continued to be cast, despite increasing scarcity of copper. Two well-documented imperial undertakings under Empress Wu (624–705) best represented the decorative grandeur of the Tang era. The first was a towering eight-sided bronze column named Tianshu (center of the land), erected in 695 in celebration of the empress' glory. It was 31.5 meters high and 3.9 meters in diameter, decorated with figures and animals sculpted in the round. The second was the casting of nine bronze *dings* in 697, weighing over 280 tons in total and ranging in heights from 1.2 to 2.4 meters. They were decorated with pictorial designs representing the land and treasures of the provinces of the empire.

Also during the Tang, the art of bronze mirrors reached its apex. Melting and casting became most sophisticated. The casting of the famed Yangzhou mirror, for example, required multiple rounds of heating and melting to achieve the desired alloy. Mirrors were cast in various shapes—square, round, or with a lobed rim. Decoration was more liberal, with varied patterns in flexible composition, often featuring a single motif on the back of the mirror (fig. 154). This was a departure from the earlier tradition of circular bands radiating out from the central knob. A special class of mirrors with more elaborate decorations appeared during the first half of the 8th century when production of bronze mirrors flourished, which included:

- *luodian* (inlay with mother-of-pearl on lacquer base),
- *baozhuang* (inlay with mother-of-pearl and jade on lacquer base),
- *baodian* (gold wire pattern soldered-on and inlaid with jade and gemstones),
- gold-plated (gold sheet with chased patterns mounted on mirror back),
- silver-plated (silver sheet with chased patterns mounted on mirror back),
- gold and silver inlay (specially shaped gold or silver pieces on lacquer base) (see fig. 3 on page 3) (Tip 22).

Bronze mirrors were usually displayed in palaces and temples with the back facing out. This is an important reason for their back to be so elegantly decorated. However, by the 9th century, mirror decoration became increasingly gaudy in effect and shape design crude. The art of the bronze mirror never

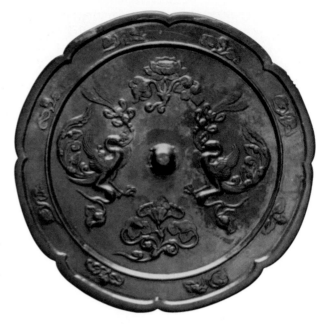

Fig. 154 Lobed Bronze Mirror with Two Phoenixes Holding Ribbon on the Back
Ca. 650–755 of Tang dynasty
Diameter 24.2 cm
National Museum of China, Beijing

Elegantly casted with two phoenixes each with a ribbon in its mouth, the mirror was likely used as a birthday gift, as "ribbon" is homophonic with "longevity" in Chinese.

regained the level of refinement it once had.

Lacquer production of the period was prolific, according to contemporaneous accounts, though few specimens have survived due to their lack of durability. Lacquer wares were light to carry and handy to use. The fancier ones were ornamented with gold, silver and jade. The famed center of manufacture was Xiangzhou, and its plain, monochrome lacquer vessels were copied throughout the land by the late Tang. It was made by applying lacquer on a base of bent wood strips held together by glue. Under Empress Wu, grandiosity befitting an empire

Tip 22: Gold and Silver Inlay on Lacquer

A technique for decorating high-grade lacquer wares, it was first developed during the Han dynasty and reached the peak of its popularity in the Tang. It involves embedding gold and silver sheet cutouts in layers of lacquer and then polishing them down to show the metal patterns that are flush with the surface. The technique was mostly used for decorating lacquered woodwork, but often on bronze mirrors and even porcelain wares, too, in the Tang.

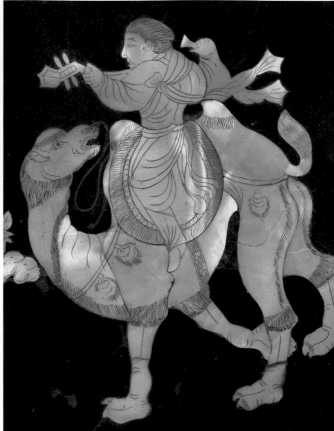

Fig. 155 *Zitan* (Purple Sandalwood) *Pipa* Lute with Mother-of-Pearl Inlay

Ca. 650–755 of Tang dynasty
Height 108.1 cm, width 30.7 cm
The Shosoin Repository (North Section), Nara, Japan

The *pipa* is a four- or five-stringed instrument, with the former being originally from Persia and latter India. The captioned is a Tang dynasty five-stringed lute, while the musician on camel back in the inlaid decoration was playing a four-stringed one (see also fig. 156).

Top right

Fig. 156 Decoration on the Belly of *Pipa* with Mother-of-Pearl Inlay (detail)

Bottom right

Fig. 157 Decoration on the Back of *Pipa* with Mother-of-Pearl Inlay (detail)

The flowers' pistils and leaves' centers were lavishly and intricately inlaid with amber, on stained or gold painted ground.

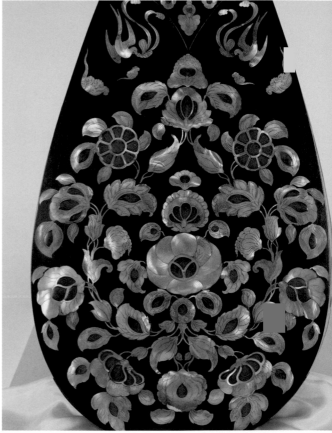

at the peak of its power was seen in large lacquer works. A colossal lacquered statue of the Buddha, 270 meters tall according to one Tang chronicler, was built at Luoyang. Constructed with layers of lacquered hemp cloth, the statue was so large that its "nose or small finger was about the size of a raft capable of carrying scores of people."

Tables, chairs or stools of taller heights came into wide use in the second half of the 7th century, given influence of the "western" furniture. Objects of decorating art were now placed on taller tables, rather than on the erstwhile low table, bed, or the floor that required stooping to reach. This also caused other design changes after the mid- and late Tang times: vases and ewers were shorter and dishes with a tall foot were rarely made any more. Extant examples of the Tang woodwork of extraordinary beauty include the five-stringed *pipa* lute of *zitan* (purple sandalwood) decorated with mother-of-pearl inlay (figs. 155 to 157), and the *weiqi* (go) game board of purple sandalwood with exquisite marquetry (see fig. 4 on page 3) (Tip 23), both in the collection of the Shosoin Repository in Nara, Japan. They display stunning craftsmanship, and superlative elegance and aesthetic taste.

Ivory carvings of this period were highly esteemed, too. Ivory rulers with engraved patterns (fig. 158) were often given by the emperor to his worthy ministers to spur diligence, uprightness and ethical compliance. The ivory rulers and weiqi pieces in the collection of the Shosoin Repository, some with engraved patterns on dyed surface, were

Tip 23: Wood Marquetry

A technique for decorating fine woodwork. The marquetry is made with small pieces of ivory, antler, or boxwood, either colored or plain, on purple sandalwood or other hardwood ground. The technique was first used in the Eastern Jin and became highly refined in the Tang.

the most exquisite and beautiful.

Extant jade objects from the period are extremely rare, despite many textual references. This is probably due to jade being prone to damage. The primary source of nephrite then was Hetian, while agate and rock crystal came from the "west." Fine jade vessels often had an exotic touch, especially

Fig. 158 Ivory Rulers with Engraved Motifs
Ca. 650–755 of Tang dynasty
Length 29.8 cm
The Shosoin Repository (North Section), Nara, Japan

The rulers have no numerical markings, except for engraved flowers of alternating shades of color, each marking a Chinese inch.

in the early Tang (fig. 159). They were often ornamented with gold-filled designs throughout the Sui and Tang dynasties. The union of the two materials, of opposing and complimentary attributes, was done with such artistry and skill that it gave a majestic touch to their beauty; lavish without being vulgar. Jade plaques for garment belts were highly valued and sought after during the Tang; some being of incomparable beauty (fig. 160).

The Sui, Tang, and the Five dynasties spanning nearly four centuries were a glorious period for decorative arts that reflected shared aspirations for grandeur and pageantry. However, there was a clear change in form and decoration between the early and later parts of the period. The robust and rather powerful forms prevalent before the An Lushan rebellion were thereafter replaced by a tendency towards smooth and roundish

Fig. 160 Jade Belt Plaques with Gemstones Set on Gold Sheet

Early Tang period
Shaanxi Provincial Institute of Archaeology

Excavated from the tomb of Dou Jiao (d. 627) in Chang'an, Shaanxi in 1992, the jade plaques, with gold sheet sunk in the center and decorated with gemstones in lavish floral arrangement, were used as belt ornaments. Dou Jiao, an aristocrat in the early Tang, was the younger brother of the famed designer Dou Shilun.

Fig. 159 Ox-Head-Shaped Agate Cup
Ca. 650–755 of Tang dynasty
Height 6.5 cm, length 15.6 cm, rim diameter 5.9 cm
Shaanxi History Museum

Excavated from a treasure hoard at Hejia Village, Xi'an, Shaanxi in 1970, the cup was fashioned out of sardonyx, or banded agate with a fine ripple pattern. The drinking vessel, of borrowed rhyton form terminating in a beast protome, was popular throughout the land during the Tang dynasty.

shapes. The changes were also apparent in decorative motifs and composition. Birds and animals, depicted with masculine vigor, on ground of plump petals, intertwined leafy sprigs and sweeping curvilinear lines, were dominant in the early phase. This was later replaced by dominant floral patterns that were curvy and delicate, reflecting a longing for nature. Birds and beasts were encircled by flowers to soften their ruggedness and enhance harmony. All this underscored a stylistic shift from the masculine, extravagant and noble to moderation, elegant simplicity and affinity with the joy of the everyday.

The decorative arts of the period both embraced "western" elements and inspired emulation in other lands. Chinese silk and porcelain products were exported in great quantities to, and greatly sought after in, vast areas stretching from Japan in the east to Egypt in the west, influencing and even altering the evolution of their decorative arts. Untold quantities of imitation products were made in those lands, too. Indeed, Chinese achievements in decorative arts during this period had global significance and were the shared glory of humanity.

THE SONG DYNASTY

The Song Dynasty
(Northern Song 960–1127, Southern Song 1127–1279)
Liao (916–1125), Western Xia (1038–1127), Jin (1115–1234)[1]

This is another period of division in Chinese history. The Song, however, remained dominant in decorative arts, with prolific output and higher levels of artistic achievements that influenced the evolution of decorative arts in the other three dynasties.

In the waning years of the Tang, powerful military elites rose and rivaled each other, bringing down successive short-lived ruling houses. To avoid the same fate, the Song dynasty sought to eclipse the power of the military soon after its founding, by instituting an imperial examination system for competent civil administration, and promoting cultural development. This policy had great influence on the development of decorative arts in the country.

However, curtailing the military foreboded a weakening of the Song's might. With powerful neighbors on its northern and western borders, wars became incessant, which always ended in territorial concessions by the Song. The rise of Dangxiang, a tribe of the Qiang people, in particular, brought interruptions to the Silk Road, the main link of the East and West trade. As a result, decorative arts of the Song dynasty, rooted in Chinese culture, largely developed without evident foreign input.

The Song was an epoch of brilliant culture. Academia and scholarship flourished

Fig. 161　Jade Plaque Carved with Standing Figure
Southern Song dynasty
Length 10 cm, width 4.6 cm, thickness 0.7 cm
Jiangxi Provincial Museum

Unearthed from the tomb of Zhao Zhongyan (d. 1131) in Shangrao, Jiangxi in 1956. Zhao Zhongyan was the uncle of Emperor Gaozong of Song (1107–1187), but the jade belt ornament used in his burial was of such humble simplicity. The contrast with the lavish elaborateness of the Tang was only too obvious (see fig. 160 on facing page).

to an unprecedented extent, given the promotion of the civil service examinations and favorable treatment of the literati. The Chinese society reached a high point in cultural sophistication, producing some of the finest in decorative arts (fig. 161). The

1 Translator's note: The three are several parallel kingdoms that rose and controlled parts of China.

refined elegance and classic splendor, best represented by the Song decorative arts, was what set Chinese art apart from foreign equivalents.

Painted decoration and imitation of archaistic forms were two important tendencies in decorative arts during the Song. They were also the means to achieve classic elegance. In an environment that valued culture, the literati class became increasingly infatuated with the art of painting. Even though not everyone could be a practicing artist, understanding of art became a mark of cultural sophistication and art connoisseurship a dedicated pursuit in life. Painted decoration was in vogue (fig. 162). Revived interest in arts of antiquity also prompted the study of bronze and jade of the ancient Xia, Shang and Zhou dynasties, inspiring imitation of archaic specimens by imperial workshops and private artisans (fig. 163). Under Emperor Huizong of Song (1082–1135), imperial workshops led a rising trend of imitation production, which was to have a far-reaching impact on decorative arts in later eras.

While its military power declined, the Song economy boomed, supporting high-quality output of decorative arts by imperial workshops.

Fig. 162 Cizhou Jar with Painted Floral Motif
Northern Song dynasty
Height 23.8 cm, rim diameter 11.9 cm, base diameter 9.6 cm

The vase, produced by a private kiln, is painted with flowers in white on a brownish-black ground below a band of flowers and sprigs painted in a brownish-black slip on white ground. The fine workmanship in rendering such a rich and elaborate pattern through merely two colors attests to the remarkable Song sophistication.

Fig. 163 Bronze Ritual Food Vessel, *Ding*, with Zhenghe Inscription
Northern Song dynasty
Height 23 cm
National Museum of China, Beijing

This bronze vessel was made in imitation of a Shang dynasty *ding*, with an inscription imitating the Zhou dynasty style, as were the case with several noted vessels produced in the Song, all emulating archaic forms with great finesse. It was bestowed by Emperor Huizong of Song in 1116 on Tong Guan (1054–1126), a favorite eunuch, for use in his family hall of ancestral worship.

Fig. 164 Ding Kiln White Porcelain Dish with Molded Pattern

Northern Song dynasty
Height 4.2 cm, rim diameter 19.7 cm
Palace Museum, Taibei

The molded décor of this dish, with a set of archaistic motifs (*bogutu*), remained popular in the Ming and Qing dynasties.

Excellent products also came from private artisans. Those made for the literati were particularly noteworthy, which, together with the output of imperial workshops, contributed to the emergence of a distinct Song character. In the post-Song eras, products dictated by the literati taste would prove most resilient against frivolous novelty and exoticism pursued by the imperial workshops.

The Song dynasty also marked a golden era for Chinese pottery, with a great number of kilns widely distributed across the country. The densest clusters were in areas of present Henan and Zhejiang. In addition to enhanced technical sophistication, Song wares were noted for their uniform, finely potted shapes and the slip or "cosmetic" coating applied to the clay body. The discovery of the lime-alkali glaze led to the creation of a thicker coating. Improved kiln design and the use of *huozhao* (firing samples) allowed better control of temperature and atmosphere. The stacked firing (bowls and dishes being stacked up and fired mouth downward) greatly enhanced productivity.

There were many well-known kilns in the Song, esteemed universally for the unique design and superb quality of their wares that were emulated across the land. Ding kilns built a great reputation earlier with their white porcelain that had a milky, translucent glaze and incised or impressed patterns (fig. 164), and *ziding*, a dark purplish glaze. Some wares were embellished with

gilt patterns. The technique of stacked firing was invented by the Ding kilns. This left an unglazed rim that was afterward bound with a metal band for decoration and to conceal the coarse edge. Jingdezhen kilns were known for their white wares with a glaze of aquamarine tone (*qingbai*) whose shapes and decoration had been greatly influenced by Ding wares. Hard-bodied and thinly potted, of great elegance in shape and purity in glaze, *qingbai* wares of the Northern Song period were deemed the finest (see fig. 11 on page 9). By the Southern Song, *qingbai* wares were much sought after throughout the southern regions.

Cizhou wares were made by kilns widely distributed in northern China, with decorations of elegant simplicity and vividness, including, most notably, patterns painted in black on white ground (see fig. 162), or *sgraffito* reserved on plain ground or a ground of densely carved pearl pattern. They stood in sharp contrast to courtly wares. Yaozhou kilns, on the other hand, were well-known for their finely and

uniformly potted celadon wares with fluently carved (fig. 165) or densely stamped patterns. Their influence reached as far as Guangdong and Guangxi in the far south.

Jun kilns were best known for its opalescent stoneware of lavender blue glaze, often suffused with irregular tracks of crimson purple (fig. 166), produced by copper oxide through reduction firing (Tip 24). The legacy of such objects of delightful charm could be found on products of southern China kilns in the Ming and Qing dynasties. Some high-grade wares with splashes of pinkish red or crimson purple in their glaze were said to have been made for the royal court. Ru kilns (see fig. 28 on page 19) and Guan (official) kilns (see fig. 14 on page 12) both produced a celadon ware that has a body covered with a lustrous glaze. Other than the fine crackle of varying sizes in its glaze (Tip 25), it was plain and unadorned. Such wares had an artless simplicity in shape and jade-like quality to its glaze, with supreme, understated elegance. They were emblematic of Chinese ceramic art in the Song dynasty and the very essence of Chinese art. Finer celadon wares produced by Longquan kilns, though richly decorated

Tip 24: Reduced Copper Oxide Glaze

A technique that creates splashes of purple or crimson on Jun ware, produced by the copper oxide in the glaze through reduction firing. Such wares, which stood apart from others with their bright, irregular coloration, and for which Jun kilns were renowned, were copied by many kilns in the post-Song eras.

Tip 25: Glaze Crackle

The network of fine cracks in the glaze is caused by the body and glaze shrinking at different rates on cooling. Initially deemed a defect, the crackle was later deliberately induced as a decorative device. It was variously named for their different, pleasing patterns.

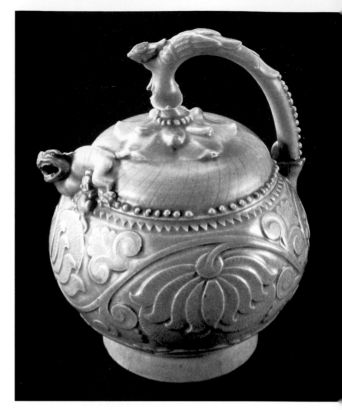

Fig. 165 Yaozhou Celadon Pot with Carved Pattern

Northern Song dynasty
Overall height 18.3 cm, waist diameter 14.3 cm, body height 12 cm
Shaanxi History Museum

Unearthed at a site in Binxian, Shaanxi in 1968. The pot has a hole in the base with a tube running from it to near the top. Thus it can be filled through the bottom and turned the right way up without spilling.

Fig. 166 Jun Kiln Lobed Jardinière Covered with a Purple Glaze

Northern Song dynasty
Height 14.4 cm, rim length 24.5 cm
National Museum of China, Beijing

The interior is covered with a lavender-blue glaze and the exterior deep purple. The planter may have had a matching four-lobed stand.

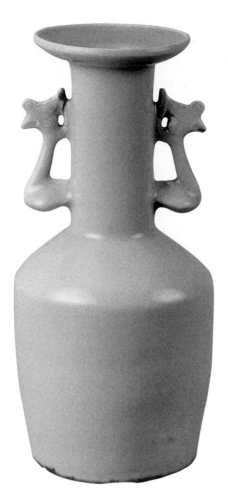

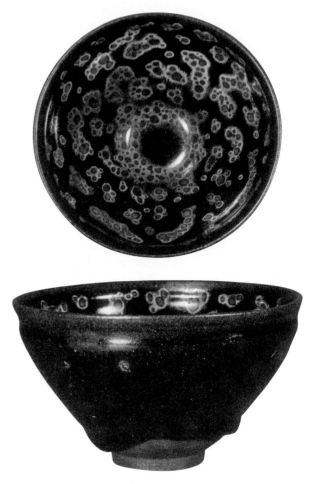

Fig. 167 Longquan Celadon Vase Flanked on the Neck by Two Handles
Southern Song dynasty
Height 30.7 cm, rim diameter 11 cm
Kuboso Memorial Museum of Arts, Osaka, Japan

This Song celadon vase has a warmer and more lustrous glaze than those of the imperial kilns, though drawing influences from them in design. It displays a reserved elegance without the distraction of any decorative crackle. It is deemed a national treasure in Japan.

Fig. 168 Jian Ware "Oil Spot" Black-Glazed Bowl
Song dynasty
Height 6.8 cm, rim diameter 12 cm, base diameter 3.8 cm
Seikado Bunko Art Museum, Tokyo, Japan

Extant Jian ware tea bowls with oil-spot effect (referred to as "yohen temmoku" by the Japanese) are quite rare. This piece in the Seikado Bunko collection is deemed a national treasure in Japan.

with incised or stamped patterns early on, also took on the style of simplicity and quiet elegance idealized by Guan wares by the late Southern Song period. Those of *fenqing* glaze, grayish green in color (fig. 167), and *meiziqing*, a translucent glaze of "plum-green," were most sought after for their splendid beauty.

Black-glazed wares were produced by kilns in both south and north, with those of Jian kilns being the most renowned. The conical tea bowl is quite representative of Jian wares. Covered inside and out with a lustrous black glaze with streaks of silvery

"oil spots" or "hare's fur" markings (Tip 26), it has great decorative charm. On some Jian wares, larger spots of crystallization in the glaze took on a marvelous iridescent tint, as if sun halo (fig. 168). Jizhou kilns were also notable for their black-glazed stoneware, in

Tips 26: "Hare's Fur" and "Oil Spots"

The dense silvery markings in the black glaze were produced by crystallization of iron oxide during firing. The most prestigious of Jian wares had markings resembling hare's fur or the silvery splattering of oil spots.

addition to a full range of porcelain wares produced there. Other than "oil spots," tortoiseshell or partridge patterns in various glazes, imprints of papercuts (Tip 27) or leaf fired to a yellowish-buff (fig. 169) were also used to remarkable effect.

Silk production grew greatly during the Song dynasty, with centers of manufacture gradually shifted southward and Zhejiang in the south gaining increasing importance. Brocade finds dated to the Song are rather rare. Those excavated from sites in Xinjiang turned out to have been made locally or imported from regions to the west of China, with decorative styles similar to those of Central Asia. Chengdu was an important center of silk production. According to textual references, floral and bird patterns were prevalent at the time. Popularity of twill damask and damask on tabby had begun to wane, while silk gauze became more esteemed. The latter could be extremely light, with a vest weighing as little as 16.7 grams, and a piece of silk gauze fabric of 47 by 1,127 centimeters, and a thickness of 0.08 mm, weighing only 116 grams. Such ultra-light fabrics were better suited for regions with a warm or hot climate. Their increasing importance and refined weaving techniques owed much to the southward retreat of the Song. Silk decorations mainly featured intertwined stems and flower sprigs (fig. 170), with occasional geometric and, infrequently, quadruped animal patterns. Auspicious birds were often added to flower patterns, which

Fig. 169 Jizhou Black-Glazed, Leaf-Decorated Tea Bowl

Southern Song dynasty
Height 5.3 cm, rim diameter 15 cm, foot diameter 3.4 cm
Museum of Oriental Ceramics, Osaka, Japan

The decoration was created by affixing a specially treated mulberry leaf to the interior of the bowl which was then fired in the kiln. The result is a charming, naturalistic pattern unmatched by any carving or incising.

include peony, lotus, Chinese peony and plum blossom in graceful arrangements; all typical motifs used at the time.

Kesi, literally "cut silk," is woven with the weft threads not running right across the width, a new technique in silk production in the Song dynasty. First used by woolen weavers in Central Asia, it was introduced to the northwest of China during the Tang dynasty. With the east- and southward shift of silk production during the Song, Dingzhou and Lin'an (present Hangzhou,

Fig. 170 Silk Gauze Pattern with Peony and Chinese Plum

Fujian Provincial Museum

Unearthed from the Tomb of Huang Sheng (d. 1243) near Fuzhou, Fujian in 1975. Flowers of different seasons being woven in the same pattern ("pattern of seasons") was a tradition that began at the end of the Northern Song period.

Tip 27: Papercut Impression

A decorative technique for black-glazed stoneware of Jizhou kilns. The papercut, either of figures or auspicious Chinese characters, is first pasted onto the body and then peeled off after a slip of glaze is applied before firing. The pattern so created can have a simplistic yet festive feel.

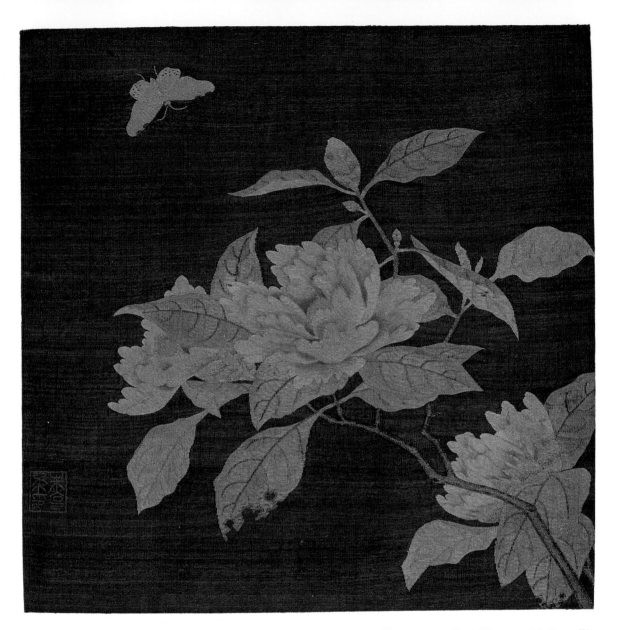

Zhejiang) became known for their output of this fine silk tapestry. Although laborious and time-consuming, the weave allowed greater flexibility with colors and patterns, and was often used for translating painting into tapestry with great vividness (fig. 171). As silk threads were finer than the tip of the brush, a painting so rendered had much more exquisite detail.

Embroidery was done either on garments or decorative silk panels for display and appreciation (see fig. 172 on page 106). The former were found in large numbers showing elegant and visually pleasing patterns. They were rendered with varied techniques and

Fig. 171 Silk Tapestry, *Kesi*, Woven with Camellia Pattern by Zhu Kerou
Southern Song dynasty
Length 26 cm, width 25 cm
Liaoning Provincial Museum

The fine silk tapestry is comparable to a flower and bird painting by Song era artists. It is woven with such extreme perfection that even the tiny spots of leaf scorch look so realistic. Zhu Kerou was a renowned silk artist of the Southern Song period, recognized by connoisseurs of the late Ming dynasty.

stitches to achieve the required feel. The latter, highly lauded in later eras, often copied well-known paintings and calligraphy. However, extant examples of such embroidered panels are few and far in between. Textile dyeing and

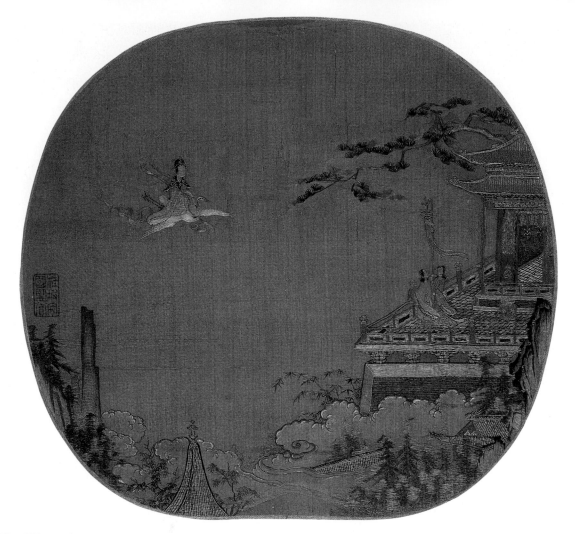

Fig. 172 Embroidered Picture of "Xi Wangmu Riding a Crane"
Southern Song dynasty
Height 25.4 cm, width 27.4 cm
Liaoning Provincial Museum

The round fan leaf depicts Xi Wangmu ("Queen Mother of the West") returning to her celestial pavilion atop a crane. It is embroidered with colored and gold threads, creating a splendid likeness of a Chinese ink and color painting from the imperial court.

printing were also well developed in the Song, with the most common being tie-dyeing and block printing. Garments for women of wealthy families were often edged with finely printed bands embellished with gold or color painting.

Lacquer output of the Song was dominated by undecorated, monochrome wares of refined shapes (fig. 173). The thin-walled vessels were light and practical. However, high-grade lacquer wares were decorated with gilt patterns, elegantly carved human figures and floral designs (fig. 174). Such refined

Tip 28: Carved Lacquer

Said to have been first produced during the Tang dynasty, such wares had patterns carved into the lacquer that had hardened after being built up with dozens, or up to a hundred layers of various colors. The carving would cut to the right layer to expose the required color, such as red (*tihong*), black (*tihei*) or marbled red and black (*tixi*). Carved lacquer became synonymous with Chinese lacquer after the Yuan dynasty. The red lacquer, carved through layers of red, was predominant in Chinese lacquer art.

Fig. 173　Lobed Black Lacquer Box

Southern Song dynasty
Height 8.5 cm, rim diameter 12.4 cm
Changzhou Museum, Jiangsu

Unearthed from a Song era tomb in Jiangyin, Jiangsu in 1978. Lacquer without added colorants turns black over time, as shown on this elegantly finished lacquer box that is charming and pleasing to the eye. Extant specimens of such aged black lacquerware were abundant.

Fig. 174　Red Lacquer Accessory Box with Incised and Gilt Figure

Southern Song dynasty
Overall height 21.3 cm, diameter 19.2 cm
Changzhou Museum, Jiangsu

Unearthed from Tomb No. 5 of a Southern Song burial site at Wujin, Jiangsu in 1977. The exterior of the cover is decorated with an incised and gold filled pattern of a female figure with a folding fan. The belief that the folding fan first came from Korea in the Ming dynasty was proved wrong by the decoration on this box.

decoration points to the maturity of the Song lacquer art. Commentators in the Yuan dynasty had lauded the beauty of the carved red lacquer of the Song imperial court. As the extant Song carved lacquer wares (Tip 28) are only those of the marbled red and black (*tixi*) type (Tip 29), the splendor of the Song carved red lacquer could be glimpsed in the extant Yuan equivalents that must have been inspired by the Song masterpieces. Inlay with very thin pieces of mother-of-pearl appeared no later than the Southern Song period, as shown in contemporaneous textual references and paintings, despite a lack of extant examples. Such fine shell pieces were used to create more intricate patterns, iridescent in effect.

Prosperity gave rise to love of luxury and pageantry, leading to sharply increased

Tip 29: Marbled Red and Black Type of Carved Lacquer

It is created by first applying dozens, or even a hundred layers of lacquer of either red or black, with an interlaced layer of a different color. After a drying interval for the lacquer to harden, cloud scrolls or stylized cloud patterns are carved through the fine layers of red or black with interlaced layers. The earliest known specimen is dated to the Song.

production of gold and silverwares and the popularity of silver food serving and drinking vessels. Their shapes and decoration were often copied by potters and lacquerware makers (fig. 175). Decoration increasingly featured scenes of everyday life. Gilt silverware became common, but most were gilt allover; monochrome in effect. Applying ornamental pieces hammered out to the surface of a vessel by soldering was a new technique. The new double-walled technique gave the silverware a sturdier look, and was used in imitating archaic bronze wares (fig. 176).

Bronze mirrors produced during the Song were often crudely cast, with their back being undecorated, continuing the trend of deterioration, despite attempts at novel yet increasingly weirder embellishments and shapes. There was a revival of archaic forms, including those for bronze mirrors, during the Song. Fine specimens from both imperial workshops and private artisans showed splendid craftsmanship with realistic mimicry. Such reproductions were made on a large

Fig. 175 Silver *Meiping* Vase with Stylized Cloud Scrolls
Southern Song dynasty
Overall height 21 cm, rim diameter 3 cm, base diameter 5.5 cm
Sichuan Provincial Museum

Unearthed from a treasure hoard at Deyang, Sichuan in 1959. Stylized cloud scrolls were often used on gold and silverware in the Song and Yuan dynasties, which had influenced the marbled red and black type of carved lacquerware; an input of significance in art history.

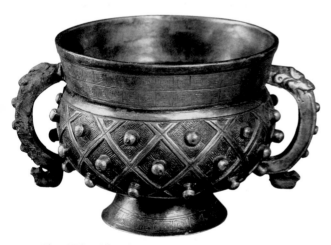

Fig. 176 Gilt Silver Food Serving Vessel, *Gui*
Southern Song dynasty
Height 7.1 cm, rim diameter 8.7 cm, weight 178 g
Zhenjiang Museum, Jiangsu

Unearthed from a treasure hoard at Liyang, Jiangsu in 1981. It is designed with a form and decoration of nipple/lozenge, in adept imitation of bronzes of the late Shang and early Zhou dynasties, albeit of a much smaller size.

scale by imperial workshops under Emperor Huizong's reign (1100–1126). Replicas of ancient bronze ritual vessels (see fig. 163 on page 100), with forms and decoration recreated to exacting standard in imitation of archaic vessels collected from around the country, were produced in large numbers to the great satisfaction of the cultured emperor.

The Song dynasty jade was of great renown, which was amply supported by archaeological finds. Most were fine ornaments, decorated with representational

floral and bird patterns of elegant simplicity. Vivid and realistic, the images were extremely beautiful and pleasing. The jade vessels, rare among excavated objects, were ingeniously designed in the prevalent archaistic style (fig. 177).

Of note was the emphasis on eliciting the beauty of the material in Song decorative arts. Ru and Guan wares, rising to prominence after Ding wares, were most lauded for their warm and lustrous glaze. Their replacing the courtly Ding wares, mostly decorated and with metal-bound rims, indicated the shift from valuing decoration to valuing the beauty of the material, in keeping with the prevalent Song aesthetics. Vessel shapes were gently curved or flaring, with no sharp bends. Simply shaped and without ornamental appliqué, they nonetheless displayed vigor in form. Decoration, should there be

Fig. 177 Jade Wine Vessel, *You*, with Mask Pattern

Southern Song dynasty
Height 6.4 cm, rim diameter 3.2–3 cm
Anhui Provincial Museum

Unearthed from the tomb of Zhu Xiyan and his wife (both d. 1200) at Xiuning, Anhui in 1952. This jade object is carved in imitation of the bronze wine vessel of the Shang and Zhou dynasties. Given scarcity of jade in the Song, the replica was of a very small size.

any, often featured flowers on ground of intertwined stems or sprigs—softly curved; representational, yet more exquisite than realistic foliate.

Monochrome or harmonious color schemes were preferred. The jacquard weaves often used yarns of similar colors. Silver wares were gilt all over. Porcelain wares were mostly undecorated, or had carved, incised or impressed monochrome patterns more than painted ones, if decorated at all. The perfect union of material, form, decoration and color contributed to an elegant splendor. The classic specimens were perfectly crafted, with a refinement beyond the mere technically dazzling and outlandish. Their understated elegance is artless, yet most endearing, with power in the seemingly plain, surprising charm in the mundane, and profoundness in unaffected grace; all speaking to the essential qualities of Chinese aesthetics.

The Song produced splendid masterpieces of classic elegance, of a pure Chinese character without obvious foreign influence. Such was the immensity of the Chinese culture that any external input could be well assimilated in continuous evolution and self-rejuvenation. The development of decorative arts in the Tang and Song bore witness to this.

The Song decorative arts greatly influenced the Liao and Jin kingdoms in the north and the Western Xia that took over the north-western part of the country, all posing a threat to the Song. Their decorative arts had their own unique character; that of the Liao being the most salient.

The tribes that established the Liao dynasty were the Khitan, a hunter-gatherer people from the north. In addition to imports from the hinterland of China, artifacts of decorative arts found there had been produced locally by Han Chinese craftsmen, often with a distinct Khitan character. Dated to the mid-Northern Song period or earlier, the fine specimens showed a rugged, masculine vigor in form.

Many of the extant artifacts of the Liao are pottery and gold and silverwares. The former include stoneware of white, green, brown, black, yellow, or tri-color glazes. White-glazed pottery (fig. 178) made by virtually all kilns of any importance in the Liao was the most common, representing the finest in pottery production. Reverence of white color was a Khitan custom rooted in its Shamanistic beliefs. Potters often borrowed the shapes of leather and woodwork objects, which is rather unique in the history of decorative arts. Many implements were

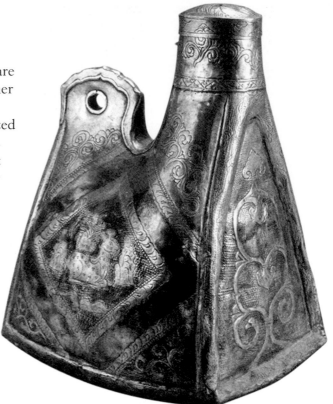

Fig. 179 Sliver Pilgrim Flask with Gilt Deer Pattern
Liao dynasty
Height 26 cm, base length 21 cm, width 16 cm
Chifeng Cultural Heritage Center, Inner Mongolia

Unearthed from a treasure hoard at Donghou Village, Chifeng, Inner Mongolia. Silverwares decorated with the deer motif were common in Central and West Asia, and in China of the Tang dynasty. Their being made in the Liao, in the shape of a leather water or wine pouch, should have something to do with the fall hunting tradition of the Liao ruling elite.

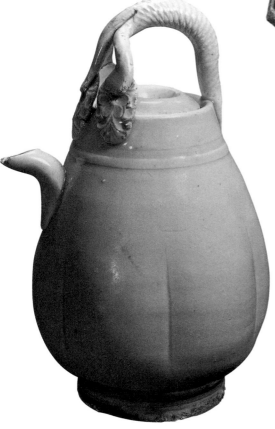

Fig. 178 White-Glazed Melon-Shaped Ewer
Liao dynasty
Overall height 15 cm
Jilin Provincial Museum

Collected from a donor in Zhaluteqi, Inner Mongolia. Such melon-shaped ewers were quite common in the Liao and Song dynasties. Given existence of silverwares of similar shapes at the time, the porcelain ewers were probably made in imitation of them.

designed for easy strapping or carrying, such as the pottery pilgrim flask (see figs. 9 and 10 on page 8), slender "chicken leg" jar, and flask with rings for looping a strap. Their popularity and evolving forms had much to do with the changing Khitan way of life.

Gold and silverwares of the Liao fell into two categories: a) those related to the Khitan lifestyle, such as fittings for harnesses, funerary objects and pilgrim flasks (fig. 179); b) those having affinity with the Five dynasties and the Northern Song, such as bowls, cups, dishes and belt ornaments, some of which were imports from the hinterland

Fig. 180 Amber Pendant Carved with a Figure Taming Lion

Liao dynasty
Length 8.4 cm, width 6 cm, thickness 3.4 cm
Institute of Cultural Heritage and Archaeology, Inner Mongolia

Unearthed from the tomb of a Liao dynasty princess (of the State of Chen) and her husband (both d. 1018) in Naimanqi, Inner Mongolia in 1986. The figure with western features is depicted as trying to rein in the lion, leaning backwards in a spirited posture and with vivid expressions. The pedant was found at the midriff of the princess' remains at the time of excavation.

of China. Gold and silver finds are abundant, with their shapes, decoration and crafting techniques showing more affinity with the Tang than the Song. This is due to a) the Liao being geographically closer to where the center of the Tang empire had been, and b) few contemporaneous gold and silver artifacts of the Song have been found. The Liao decorative arts overall had a closer link to the Tang, showing more West Asia influences. All the exquisite glassware finds from the Liao were imports from West Asia, and amber ornaments (fig. 180) were made from fossil resins imported from there.

A full range of silk fabrics were produced in the Liao, with refined techniques. Notably, *kesi* and gold-ornamented fabrics were abundant, an indication of the nomads' love of precious and valuable items. The pattern with circular dots of "western" origin (fig. 181) appeared in silk weave again, indicating that the tradition of the steppes had been carried on by the Khitan tribes.

The Western Xia kingdom was established by the Dangxiang tribes in the region of present Ningxia and Gansu. With an economy largely dependent on raising sheep and cattle, the Dangxiang developed farming after gaining a foothold in the valley region. Their decorative objects of woolen, silk, pottery and metalwork were made locally while others were imports

Fig. 181 Scripture Pouch Embroidered with Mounted Figure in Circular Dots

Liao dynasty
Length 27.5 cm, width 28 cm
Balingyouqi Museum, Inner Mongolia

Discovered (ca. 1988–1992) in the finial of the Qingzhou White Pagoda (built 1049) at Balinyouqi, Inner Mongolia. The embroidery depicts spring hunting with a hunter on horseback and a falcon perched on each of his raised arms.

Fig. 182 Black Stoneware
Flattened Flask, with Peony Pattern
in *Sgraffito*, Lingwu Kiln
Western Xia dynasty
Height 30.4 cm, waist width 27 cm

The flattened moon-flask with
strap handles on either shoulder
were designed for portability. Such
stoneware flasks of the Western Xia
were quite common, owing to the
Western Xia practice of hunting and
animal husbandry.

Fig. 183 Cizhou Stoneware Vase
with Russet-Splashed Peony Motif
Jin dynasty
Height 43 cm
Tokyo National Museum, Japan

The russet brown markings are found
on Cizhou stoneware produced in the
north of China in the Song and Yuan
dynasties. The markings were created
by applying splashes of an iron-oxide
rich russet glaze over the overall black
glaze.

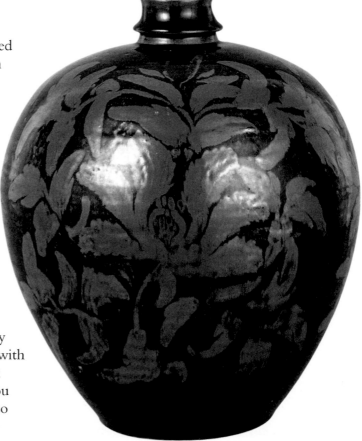

from the Song. The Western Xia was famed
for its fine woolen and silk products, with
decorative styles very similar to those
of the Song. Its pottery had a crude,
unrestrained character (fig. 182)
and was profoundly influenced by
Cizhou wares and private kilns in the
hinterland, but showed little affinity
with Yaozhou kilns which were
geographically closer.

The Juchen tribes that established
the Jin dynasty were also from the
North. Having long settled down to a
life based on farming, they had closer
connections with the Han Chinese, as
they expanded their territory and moved
their capital further south. This was largely
the cause for their decorative arts' affinity with
the Song styles. The Jin pottery carried on
the Northern Song tradition. Ding, Cizhou
(fig. 183), Jun and Yaozhou wares were also
produced in the Jin kingdom, copying the

Fig. 184 Silk Panel of Phoenix and Floral Motif Woven with Gold Thread (detail)

Jin dynasty
Full panel length 155.6 cm
Institute of Cultural Heritage and Archaeology, Heilongjiang

Unearthed from the tomb of the king and queen of the State of Qi of the Jin dynasty at Acheng, Heilongjiang in 1988. The silk chest panel was part of the king's robe, with double-phoenix and plum blossom motifs quite in tune with the Song style. The techniques for weaving with gold thread were rather varied and extensively used in the Jin dynasty.

Fig. 185 Jade Ornament with "Spring Water" Hunting Motif

Jin dynasty
Height 5.9 cm, width 3.9 cm, thickness 1 cm
The Palace Museum, Beijing

The ornament is carved with graceful curves in a material of great purity, which is contrasted with the fierce power and tragic demise in hunting over water. The piece is deemed to have a very high level of artistic attainment.

Jade of the Jin kingdom was finely crafted, with sophisticated grounding and drilling matching those of the Song. A type of jade ornaments called *chunshui* ("spring water") with openwork pattern of fishing and hunting scenes (fig. 185) were the most representative of Jin jade. Reflecting the practice of seasonal royal hunting expeditions (Tip 30), which began in the earlier Liao, *chunshui* became a frequently used decorative motif. *Chunshui* jade produced in the Jin was deemed the best. Because of its beautiful design, *chunshui* jade continued to be made as late as in the Ming dynasty, even though the practice of royal hunting expeditions had long been abandoned.

shapes and decorative styles of the Northern Song. Silk production of the Jin had a high level of refinement, adopting patterns and styles akin to those of the Song, but with a greater preference for fabrics woven with gold threads (fig. 184). The earliest extant example of *zhuanghua*, a raised pattern (achieved by the weft threads not running right across the width), was also found in the region. White, again, was the preferred sartorial color for the northern tribes.

Tips 30: Seasonal Hunting Expedition

A Khitan tradition of royal encampment staged for the different seasons of the year. First practiced in the Liao kingdom, it involved seasonal expeditions led by the king and queen, with an entourage of ministers and royal guards, to locations of summer retreat or overwintering. Fishing and swan-hunting were done on the water in spring. Thus, depiction of such scenes was called *chunshui* (spring water). Big game hunting took place in the hills in the fall, hence the term *qiushan* (fall hills). The practice continued in somewhat modified fashion in the Jin, Yuan and Qing dynasties.

THE MONGOL EMPIRE AND YUAN DYNASTY

The Mongol Empire (1206–1271)
The Yuan Dynasty (1271–1368)

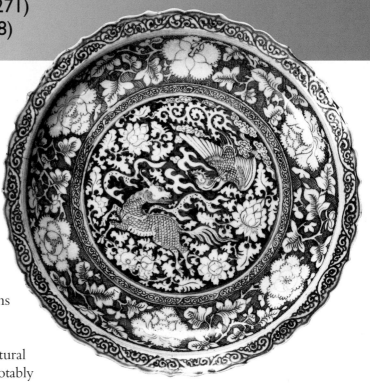

Fig. 187 Jingdezhen Blue-and-White Dish with *Luduan* and Phoenix Motifs

Yuan dynasty
Height 7.9 cm, rim diameter 46.1 cm, foot diameter 26.1 cm
The Palace Museum, Beijing

Luduan, a fabulous unicorn, was a motif often used in the Yuan as a symbol of Genghis Khan's benevolence. Yelü Chucai (1190–1244), Genghis Khan's advisor, was said to have used the fabulous unicorn fable to persuade the Khan to refrain from further conquests, after numerous casualties caused by his military expeditions.

The Mongol Empire was founded by Genghis Khan (1162–1227) in 1206, which renamed itself the Yuan dynasty after unifying China in 1279. The Mongols conquered the Western Xia and Jin kingdoms before defeating the Southern Song, beginning thereafter to have a restrictive impact on the development of decorative arts.

Because of Mongol military campaigns sweeping across vast domains and the unprecedented growth of the East-West trade, the Yuan was a society of great cultural diversity. Its decorative arts were most notably influenced by Mongolian, Islamic and Han Chinese traditions, and to a lesser extent, by Tibetan Buddhism, Christianity and Goryeo.

A great number of artifacts decorated in blue and white were produced, given the Mongolian preference for the two basic

On facing page

Fig. 186 Jingdezhen Blue-and-White Eight-Lobed Vase, *Yuhuchunping*, with Lion Motif

Yuan dynasty
Height 32.5 cm
Hebei Provincial Museum

Unearthed from a treasure hoard in Baoding, Hebei in 1964. A great proportion of such vases produced during the Yuan had decorative patterns arranged in nine horizontal bands. Called *yuhuchunping* and with a pear-shaped body, slender shoulder and spreading rim, it first appeared in the Song dynasty. Initially for storing wine, it became mostly an item for display and appreciation in the Ming.

colors; a tradition vigorously kept by the conquering Mongols. Many blue-and-white porcelain wares had nine decorative registers or bands (fig. 186), but none seven, because of their liking for number nine and aversion to seven. Food-serving and libation vessels of enormous sizes (fig. 187) were

Fig. 188 Brocade Quilt Facing with Griffin Motif in Lobed Circle (detail)
Yuan dynasty
Height (lobed circle) 17 cm
Inner Mongolia Autonomous Region Museum

Unearthed from a treasure hoard at Jininglu ancient city ruins, in Chayouqianqi, Inner Mongolia in 1976. The mythological creature with a lion's body and a bird's head originated in West Asia. This brocade should be of *zandaniji* silk, a traditional product of Central Asia, produced by muslin weavers in an imperial workshop of the Yuan.

produced, catering to the nomad's voracious gastronomic and drinking traditions. Great quantities of portable wares were made in keeping with the nomadic lifestyle. Felt and woolen fabrics suited for the cold climes in the wind-swept north, where the economy was centered on animal-husbandry, were introduced into the hinterland of China. Many imperial workshops of considerable scale were set up, pandering to the Mongol royals' love of the finer things; a notable

feature of the period.

Cottage industry in the early Mongol Empire was rather paltry. However, with its conquest of Islamic states came finely made decorative objects and capable craftsmen. In addition to exotic items being imported continuously from West Asia, items of Islamic designs (fig. 188) were also produced by imperial workshops with muslin artisans in their employ, using materials and following ornate decorative patterns from West Asia.

Almost all traditional Chinese forms, decorations and techniques were preserved and continued to be used, as the feudal order and the populace over which the Mongols ruled had remained largely Chinese. In addition, private workshops carried on the tradition of the Song. Thus, the Yuan culture became ever more Sinicized as time went on.

In Yuan silk production, brocades woven with gold weft threads was all the rage,

Fig. 189 *Nasij* Brocade with Sphinx Motif in Lobed Circle
Mongol Empire
Inner Mongolia Autonomous Region Museum

Unearthed from the Mingshui burial site in Damaoqi, Inner Mongolia. The sphinx motif is definitely not indigenous to China. Bronze mirrors and brocades with similar motifs were frequently found in Central and West Asia.

Fig. 190 *Kesi* Silk Tapestry of Encircled Deity (Vajrabhairava Mandala)

Mid-Yuan dynasty
Height 245.5 cm, width 209 cm
Metropolitan Museum of Art, New York City
U.S.

This *kesi* tapestry is extremely rare for its massive size. It is most sumptuously woven (with an encircled image of the fierce deity Vajrabhairava). At the bottom are portraits of the patrons, from left to right: Emperors Wenzong (1304–1332) and Mingzong (1300–1329), and their wives.

and satin damask was widely produced. *Nasij* (fig. 189) and *jinduanzi* were the two gold brocades produced then. The former, deemed the most prestigious, was made for the royalty and aristocracy by muslin weavers in imperial workshops using West Asia techniques and decorative motifs. The latter was mostly produced by Chinese weavers in both imperial and private workshops, using traditional Chinese techniques and decorative patterns, and in larger quantities for both the aristocracy and wealthy. Such gold brocaded silk, much sought after then, showed intricate patterns of lavish, resplendent colors, reflecting the Yuan's love

of luxury and extravagance. Satin damask, called *zhusi* up to the end of the Qing dynasty and already being produced in the Song dynasty, albeit with yet-to-mature techniques and in smaller quantities, became increasingly popular in the Yuan. The fabric had a smooth, graceful drape, and a soft hand, manifesting the best attributes of Chinese silk. It became synonymous with Chinese silk, in place of brocade, after the Yuan. Because of Mongol emperors' love of finely woven silk, portraits of past kings and queens were often created in *kesi* silk tapestry. Given their devotion to Tibetan Buddhism, Buddha portraits were so made, too (fig. 190).

Fig. 191 Twill Damask Robe with Magpie and Plum Blossom Motif (detail)

Yuan dynasty
Robe length 130 cm, sleeve length 102 cm, detail panel 30 (L) cm × 32 (W) cm
Cultural Heritage Administration of Zouxian County, Shandong

Unearthed from the tomb of Li Yu'an and his wife (both d. 1351) in Zouxian County, Shandong in 1975. The combination of magpie and plum blossom is phonetically evocative of the Chinese phrase "beaming with a happy smile"; still one of the most commonly used auspicious patterns today.

In addition to the prevalent floral motifs, auspicious signs were often seen in silk patterns (fig. 191) (Tip 31). For high-grade silk fabrics, however, animal motifs were increasingly used. Silk brocades woven in the style of *nasij* and *zandaniji* (of Central Asia origins), mostly by muslin weavers in the Yuan, often featured fabulous beasts of exotic origins, such as griffin (see fig. 188 on page 116) and winged sphinx (see fig. 189 on page 116).

Production of felt and wool rugs was on the rise. The former, of matted, compressed wool, was made in larger quantities than the elaborately woven wool rugs. Felt *ger* (tent) coverings and carpets were of enormous sizes and the finer ones were in imitation of West Asia equivalents. During the Yuan,

cotton became popular, gradually replacing hemp cloth and silk as the chief clothing fabric. Cotton cloth produced in Songjiang (now in Shanghai) in the south became famous throughout China, helped by Huang Daopo, a textile pioneer in the early Yuan who invented tools and techniques for cotton spinning and weaving, greatly enhancing productivity. Decorative patterns for cotton were mostly woven at first, before the gradual rise of cotton printing and dyeing, both labor- and time-saving.

The Yuan was also a brilliant age for Chinese pottery. The fame of Jingdezhen as the world's capital of porcelain was sealed. The Fuliang kiln, the only government kiln then, was located there. Many well-known types of porcelain were produced in Jingdezhen and its blue-and-white wares (Tip 32) became emblematic of Chinese porcelain.

The rise of blue-and-white porcelain (see fig. 15 on page 12 and figs. 186 and 187 on pages 114 and 115) was rather extraordinary. The underglaze blue on white porcelain (with patterns of either blue on white ground

Tip 31: Auspicious Patterns

They include floral or figured patterns that are homonymous with or symbolic of auspicious notions in Chinese. There is a great variety of such patterns reflecting myriad aspirations for life. With roots in antiquity, the practice became the most popular during the Ming and Qing dynasties.

Tip 32: Blue-and-White Wares

Cobalt oxide is used as a pigment for the underglaze blue on fine white porcelain. The patterns are either blue on white ground or white on blue ground. First seen in the Tang, the popularity of such underglaze blue decoration began to rise rapidly in the mid- to late Yuan dynasty. For a long time, those produced in Jingdezhen were deemed the best.

Fig. 192　Jingdezhen Blue-and-White Octagonal Gourd Vase with Flower and Bird Pattern

Yuan dynasty
Height 58.2 cm, rim diameter 8.4 cm, base diameter 15.5 cm
Kikusui Kogeikan Museum, Japan

The octagonal body makes it easier for lashing, and to hold in the hand, than the usual round shape; a design with consideration for travelling and migration.

Tip 33: Underglaze Red

A technique similar to that for the blue-and-white ware. However, the pigment for underglaze red was copper oxide, with patterns of either red on white ground or white on red ground. First invented during the Yuan dynasty, underglaze red tended to take on a brownish black hue due to firing difficulty. Perfect examples of underglaze red were only found among those made by official kilns during the Ming and Qing dynasties.

or white on blue ground) had much to do with the Mongols' color preference. Variation in decoration reflected social standing and cultural affinity. Many extant pieces, once belonging to the aristocracy and with evident signs of Islamic influence, were deemed the most representative of blue-and-white wares (fig. 192). The cobalt pigment in the glaze was imported from West Asia and muslin potters had participated in their production. The painted multiple borders or bands were in imitation of metalwork patterns from West Asia. Several new glazes, too, were invented at Jingdezhen, including underglaze red (Tip 33), blue, and red. Still, the egg-white glazed wares were made in the largest quantities and their popularity due to the Mongolian reverence of color white. Such wares of white glaze with a bluish tinge were made commercially, but the finer ones were reserved for the royalty and government only (fig. 193).

Porcelain wares produced by kilns other

Fig. 193　Jingdezhen Egg-White Glazed Bowl with Molded Pattern and "Shufu" Mark

Yuan dynasty
Height 4.5 cm, rim diameter 11.5 cm
Chongqing Museum

The bowl with sides rising from a broad base to gently flaring rim is the most common shape for egg-white glazed ware. The "shufu" (privy council) mark indicates that it was commissioned by the Yuan court, though probably embezzled for private use, which often occurred during the Yuan.

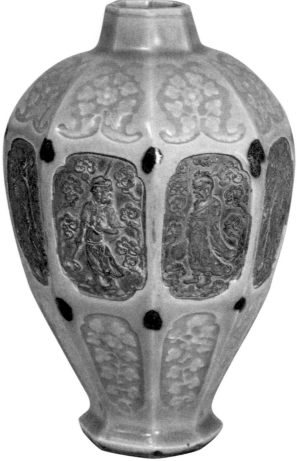

Above

Fig. 195 Longquan Celadon Octagonal Vase with Eight Figures

Yuan dynasty
Height 23.4 cm, rim diameter 5.6 cm, waist diameter 16.8 cm
The British Museum, London, U.K.

The vase is molded, incised and carved in relief with panels and cartouches in three colors; representing quite a departure in style from the monochrome Longquan ware of reserved elegance in the Southern Song dynasty.

Left

Fig. 194 Cizhou Vase with Children Motif Painted in Black on White Ground

Yuan dynasty
Height 88.9 cm, rim diameter 26.7 cm
Seattle Art Museum, Seattle, U.S.

The children motif suggests "prolific fertility." The vase is very densely decorated, which is rather rare, even though Yuan ware typically has more registers of decoration, painted in black on white ground, than those of previous eras.

than Jingdezhen were popular in various regions. They included Cizhou wares that were painted in black on a cream slip (fig. 194), Jun wares with an opalescent blue glaze mottled in purple by reduction firing, celadon wares from the family of Longquan kilns (fig. 195), and *qingbai* white wares from kilns in the lower Yangtze basin. They were all densely decorated following the prevailing Yuan taste, though not as finely potted or glazed as those of the preceding Song age. Of note was the tendency to imitate Song wares. The Huo kilns in Shanxi and a number of egg-white glazed wares, for example, copied Ding wares, and the Ge kilns (fig. 196) (formerly thought to belong to the Song era) imitated Guan wares. However, such attempts to revive Song styles were deemed untimely, even renegade, against the mainstream culture of the Yuan.

The Mongol royalty and aristocracy were

Fig. 197 Gold Stem Cup with Floral Motif

Mongol Empire
Height 14.4 cm, rim diameter 11.1 cm
Inner Mongolia Autonomous Region Museum
Unearthed from the Mingshui burial site in Damaoqi, Inner Mongolia. The stem cup is a common form for gold, silver and porcelain wares produced in the Mongol Empire and Yuan dynasty.

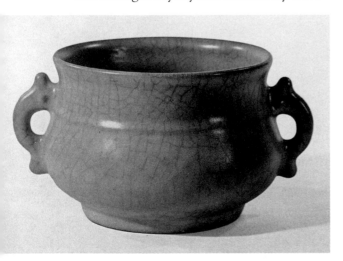

Fig. 196 Ge Celadon Censer Flanked by Handles with Animal Motif

Yuan dynasty
Height 8.4 cm, rim diameter 11.2 cm, waist diameter 12.4 cm, base diameter 8.5 cm
Shanghai Museum
Unearthed from the tomb of Ren Ming (d. 1351) in Qingpu, Shanghai in 1952. Porcelain wares of such a design were first produced by Guan kilns in the Song dynasty. Ge wares, said to be hardly distinguishable from Guan wares, were made in imitation of the latter.

fond of gold and silverwares, and those for drinking especially. However, because of the Mongolian practice of simple burial and the extensive destruction of Yuan courtly artifacts in the early Ming, the splendor of the Yuan gold and silverwares could only be glimpsed in textual references. Extant gold and silverwares excavated from burial sites in the south, though abundant in number, did not belong to the Mongolian aristocracy and their design was often in imitation of Song styles. Most Yuan gold and silverwares were wine vessels (fig. 197) and many plain and unadorned. When they were decorated at all, chased composite floral patterns or stemmed flowers were the most common. Most wares had shapes of simplicity and vigor. Animal shapes were common in the early Yuan and fruit shapes thereafter. Zhu Bishan, a renowned silversmith in the mid-late Yuan, created silverwares catering to the taste of

the Han Chinese literati (fig. 198). Bronze mirrors continued the trend of decline. However, several bronze artisans became well known for their bronze objects that reflected a literati sophistication.

The Mongol ruling elite were infatuated with jade, which was used extensively to adorn their palaces and furniture. The literati also continued the tradition of placing great value on jade. The *chunshui* jade ornaments (of hunting and fishing motifs), excavated from the tombs of Han Chinese in the lower Yangtze basin, were apparently influenced by the Mongolian tradition. However, such unearthed artifacts barely display the full splendor of the Yuan jade. The extant "*Dushan giant jade jar*" (fig. 199), created before the founding of the Yuan dynasty, was of a sturdy form and tremendous size, truly a colossal masterpiece of ancient Chinese jade.

The Mongols did not have a particular liking for lacquerware. Those made by imperial workshops were mostly monochrome and unadorned. Lacquer jars of tremendous sizes were used for storing wine in the royal court. However, fine examples of lacquer art mostly came from private artisans. They were densely decorated with carved

Fig. 198 Silver Bough-Shaped Cup with Zhu Bishan Mark

Yuan dynasty (the fifth year of Zhizheng reign, 1345)
Height 18 cm, weight 616 g
The Palace Museum, Beijing

Cast in the form of a gnarly bough with a sitting figure and superbly finished, it is akin to a fine sculpture, instead of a utilitarian vessel. Made by Zhu Bishan for his own family, it was intended to "stay in the family and be cherished for perpetuity."

Fig. 199 "Dushan" Giant Jade Jar

Mongol Empire (1266)
Height 70 cm, depth 55 cm, rim diameter 135–182 cm, max circumference 494 cm, weight 3,500 kg
Circular Fortress (Tuancheng), Beijing

Of great significance for the imperial court of the Yuan, it was abandoned after its demise. When Emperor Qianlong (1711–1799) bought it as an antique, it had been used by a Taoist monk to make pickles.

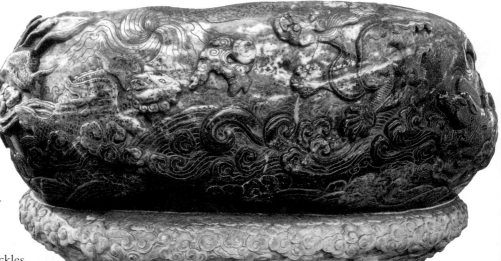

patterns sunken with gold or silver, showing a marked departure from Song styles. Mother-of-pearl inlays (fig. 200) were incomparably exquisite, akin to intricate painting. The art of carved lacquer achieved a greater maturity. Works by the famed lacquer masters Zhang Cheng (fig. 201) and Yang Mao showed classic elegance and connections with Song art in form; notably different from the prevalent Yuan styles. Both were from Jiaxing in south China and lived in the late Yuan period. Their works represented the pinnacle of the art of carved lacquer.

Advances in archaeology and research have challenged the notion, first proposed in the late Ming, of decorative arts of the Mongol Empire and the Yuan dynasty being masculine yet crude. *Nasij* brocade and blue-and-white porcelain, exquisitely decorated and resplendent in effect, represented the ideal of decorative arts in this period, with far-reaching influences. A great emphasis was

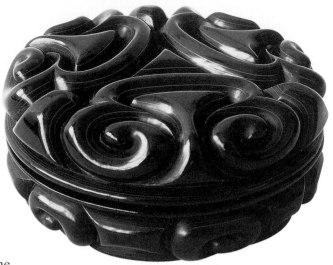

Fig. 201 *Tixi* **Carved Lacquer Box with Zhang Cheng Mark**
Yuan dynasty
Overall height 6.2 cm, diameter 14.8 cm
Anhui Provincial Museum

Tixi lacquer (of marbled red and black type) is often carved with a cloud pattern (hence also called "cloud pattern carved lacquer"). Silverwares cast in a similar fashion in the Song and Yuan dynasties had been unearthed from several sites.

placed on elaborate and lavish decoration, which marked a shift from the preceding Song dynasty. Imperial workshops in the succeeding Ming and Qing dynasties attempted to reverse such changes, but to no avail. They never managed to move away from the direction set during the Yuan.

Having been influenced by West Asia, decorative arts of the Mongol Empire and Yuan dynasty in turn greatly influenced their equivalents in lands far beyond their borders. The export of silk and porcelain enabled the production of the same in those lands. Some of the embroidered silk tapestries made in Persia in the 14th century borrowed Chinese patterns. Bronze mirrors, and silver and pottery wares produced in towns of the Golden Horde along the Volga were apparently influenced by Chinese input. The most notable were efforts by potters in West Asia and Europe in the late 14th century and beyond to imitate Chinese blue-and-white wares, the influence of which is still evident in porcelain production today.

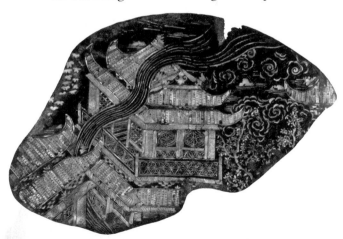

Fig. 200 Fragment of Black Lacquer Dish with Mother-of-Pearl Inlay Pattern of Pavilion
Yuan dynasty
Length 20 cm
The Capital Museum, Beijing

Unearthed from the site of a Yuan era settlement (Houyingfang) in Beijing in 1970. The inlaid pattern is so refined that it resembles a color painting. The ideal of lacquerware with mother-of-pearl inlay, subscribed to by lacquer makers in the Ming, had been executed to perfection two centuries earlier.

THE MING DYNASTY

(1368–1644)

After Zhu Yuanzhang (1328–1398) was enthroned as the first emperor of the Ming dynasty, the sartorial styles, language, family names, and custom of the Mongols were banned, and the Yuan imperial palaces dismantled. Destruction of decorative objects of the Yuan court was imperative, with tremendous efforts to eradicate any styles emblematic of the Yuan. In the nascent years of the newly founded Ming, as the economy needed to recover and grow, restraint and austerity was officially encouraged and generally practiced, leading to a return to conservatism and rustic simplicity. Decorative objects produced by imperial workshops at the time began to take on a refreshing character of simple elegance (fig. 202).

However, by the reign of Emperor Jiajing (1522–1566), the tendency towards extravagance and superfluity returned. Decorative arts began to display a love of grandiosity (see fig. 26 on page 18), given pervasive sentiments of conceit and appetite for luxury, of the aristocracy and commoners alike, that persisted until the demise of the Ming. However, decorative objects catered to the literati taste manifested a high level of workmanship and classic elegance. Fine specimens included carved bamboo vases from Jiading, *zisha* teapots from Yixing, and hardwood furniture (see fig. 27 on page 18) that was most representative of the elegant Ming-style.

Jiangsu and Zhejiang were primary centers of silk production, with cities such as Nanjing, Suzhou, and Hangzhou boasting both large-scale imperial production and numerous private workshops. Most of the well-known silk products came from the region. Satin damask had begun to replace brocade as the premium silk fabric. There were chiefly four weave types for satin

Fig. 202 Jingdezhen Blue-and-White Stem Cup with Phoenix and Cloud Motif

Ming dynasty (Yongle reign, 1403–1424)
Height 11.6 cm, rim diameter 14 cm
Jingdezhen Institute of Ceramics Archaeology, Jiangxi

Unearthed at the ruins of imperial kilns in Jingdezhen, Jiangxi in 1984. Reconstructed from broken pieces, the cup should have looked perfect even to the most discriminating eye. The fact that it had been smashed and buried with rejects is testament to the incredibly high standard of the imperial kilns.

Fig. 203 A Painting of Brocade Pattern with Peony Motif

Ming dynasty

The well-proportioned flowers, woven with supplementary gold threads, are reserved on foliate ground of curved leafy stems. The varied colors of the flowers show at once contrast and harmony.

Fig. 204 Satin Damask with "Universal Festivity" Pattern (detail)

Ming dynasty

The satin damask panel was the front cover of the Ming dynasty imprint of Buddhist scripture, *Tripitaka*. The lantern pattern consists of flowers and geometric shapes, flanked by ears of grain, with bees darting about. The composition, though somewhat disordered, was altogether joyful.

damask in the Ming dynasty: *anhua*—patterns woven with wafts and fillings of the same color, *zhijin*—woven with gold fillings, *suhua*—plain weave, and *zhuanghua*—woven with colored fillings. The *anhua* weave was mostly used in private production while the rest in imperial workshops.

Floral and foliate motifs were the most common. Patterns often had floral sprays on ground of leafy vines and stems (fig. 203). Panels woven or embroidered with auspicious birds and animals were used to decorate the front and back of formal robes for different civilian and military ranks, according to sartorial rules. Bird and animal patterns were thus often found on high-grade fabrics dated to this period. Revived archaic motifs were common in brocade and satin damask decoration, such as "universal festivity" (fig. 204) (Tip 34), "pattern of eight directions" (see fig. 205 on page 126) (Tip 35)

Tip 34: "Universal Festivity"

An auspicious pattern that first appeared during the Five dynasties. It features lanterns with tassels in the shape of ears of grain, surrounded by bees; both being homonymous with the Chinese phrase for bumper harvest. The pattern was extensively used in silk decoration beginning in the Song dynasty. The earliest extant example is dated to the Ming.

Tip 35: Pattern of Eight Directions

The pattern that first appeared during the Five dynasties features eight-lobed flowers repeated along (imaginary) vertical, horizontal and diagonal lines extending in eight directions from the tips of the eight lobes of any flower in the pattern. It was extensively used during the Song dynasty, but the earliest extant example is dated to the Ming.

Fig. 205 Brocade with "Pattern of Eight Directions"

Ming dynasty

Metropolitan Museum of Art, New York City, U.S.

Such a pattern is often used in color decoration for traditional buildings. Indeed, decorative patterns are often linked to architecture, such as decorative openwork panels that bear a resemblance to openings in garden walls.

Fig. 206 Satin Damask with Pattern of Fish and Flowers Fallen on Flowing Water (detail)

Ming dynasty

The Palace Museum, Beijing

The image of flowers adrift on water, often in simple representation, is evocative of melancholy at the ephemeral spring. However, this pattern is densely woven with supplementary gold threads; bright and cheerful in effect.

and "pattern of six directions." They were first invented in the Shu kingdom during the Five dynasties and regained popularity in the Ming. Increasingly stylized auspicious patterns were much liked. Garments worn by the imperial harem for the Dragon Boat Festival had a special auspicious pattern. Embroidered or woven, it contained five venomous creatures (centipede, toad, gecko, snake, and scorpion) to ward off evil spirits. The continuous repetition of patterns in four directions was a common composition. The repeated patterns were well spaced, of different sizes, and with distinct primary and secondary images, which remained largely unchanged. Brocades were woven with brightly colored yarns, with gold and silver threads being often used (fig. 206), resplendent in effect.

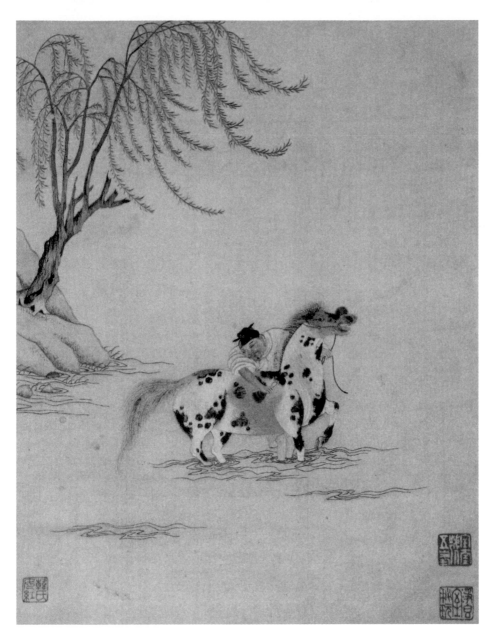

Fig. 207 Picture of "Bathing a Horse in a Stream" Embroidered by Han Ximeng

Ming dynasty (the 7th year of Chongzhen reign, ca. 1634)
Height 33.4 cm, width 24.5 cm
The Palace Museum, Beijing

This (a donation to the museum from Ms. Guan Ruiwu) is one of the eight reproductions of famous paintings of the Song and Yuan dynasties embroidered by Han Ximeng in the spring of 1634. These embroideries aptly translated the artistic style and sophistication of Zhao Mengfu (1254–1322), the Yuan dynasty master of calligraphy and painting.

Embroidery was marked with salient regional characteristics. Towards the late Ming, Gu embroidery from Shanghai was most renowned for its high attainment. Patterns were often based on paintings of celebrated artists, embroidered with extremely fine silk threads and varied stitches, with occasional touch-up in color by brush, achieving stunning realism. The ability to render Chinese paintings in embroidery hence became a requisite for a superior embroiderer. The masterpieces by Han Ximeng (fig. 207), the most representative of Gu embroidery and very much to the liking of the literati, were widely celebrated in the late Ming. Ni Renji (1607–1685), from Yiwu, Zhejiang, also made a name for herself with embroidery in silk augmented by painting and hair embroidery. She also produced a book entitled *Beauty Perpetuated—a Collection of Embroidery Patterns*, which was unfortunately lost to history due to the ravages of war.

Jingdezhen remained the center of pottery production. But private kilns

Fig. 208 Jingdezhen Blue-and-White Dish with Summer Morning Motif

Ming dynasty (Tianqi reign, 1621–1627)
Height 2.3 cm, rim diameter 22 cm, foot diameter 14.5 cm
Tokyo National Museum, Japan

The dish, though somewhat irregular in shape and with defects in glaze, has quite interesting decoration; evocative of *Sights and Tastes of a Summer Morning*, a poem by the Southern Song poet Yang Wanli (1127–1206). Rendering scenes depicted in well-known poems and prose was a common practice in decorative arts in ancient times.

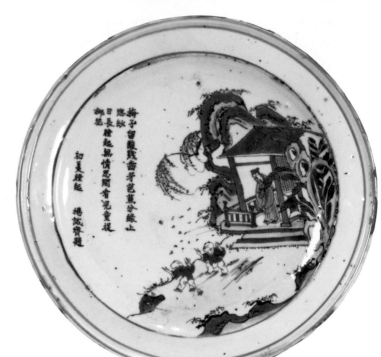

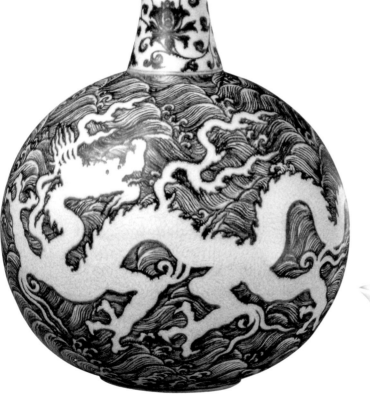

Fig. 209 Jingdezhen Blue-and-White Moonflask with Dragon on Ocean Wave Ground

Ming dynasty (Xuande reign)
Height 45.8 cm, rim diameter 8.1 cm, foot width 14.8 cm
National Museum of China, Beijing

Moonflasks of the Yongle reign, similar to this one, have been unearthed from the ruins of the imperial kilns. Blue-and-white wares from the two periods are quite "indistinguishable," as connoisseurs suggested.

Fig. 210 Jingdezhen Underglaze Red "Three Fish" Stem Cup

Ming dynasty (Xuande reign)
Height 8.8 cm
Museum Yamato Bunkakan, Japan

The mandarin fish is painted to perfection, vividly in brilliant red and in a simplistic manner. The beautiful underglaze red of this cup well surpasses the level achieved in the late Yuan and early Ming dynasties.

Fig. 211 Jingdezhen *Doucai* "Chicken" Cup
Ming dynasty (Chenghua reign)
Height 3.8 cm, rim diameter 8.3 cm, foot diameter 3.8 cm
Palace Museum, Taibei

were also flourishing, producing works of refreshingly new and graceful styles (fig. 208). Accomplished ceramicists such as Cui Guomao, Zhou Danquan, and Wu Wei were acclaimed for their highly refined creations in the late Ming. The imperial kilns were still the standard-bearers; their works often being emulated by private potters (see fig. 26 on page 18). Their dedication to perfection and elaborateness at all costs was hard to equal.

Porcelain wares from imperial kilns were either painted in color or covered with monochrome glaze. For the former, the blue-and-white wares were the most well-known. Their form, decoration and cobalt blue evolved over time, taking on varied characteristics. Those of Emperors Yongle (1403–1424) and Xuande (1426–1435) eras were lauded for their conserved refinement (fig. 209), and those of Emperors Chenghua (1465–1487) and Hongzhi (1488–1505) eras a refreshingly simple charm and elegance. By Jiajing's reign,

Thinly potted and with lustrous glaze, these cups, with rounded sides rising from the recessed base, are exquisitely decorated with cockerels, hens and chicks; hence the nickname. Highly valued, such a pair that had cost a hundred thousand bronze coins in the Ming (the Wanli reign, 1573–1620) fetched HK$ 280 million at an auction in Hong Kong in 2014.

decorative styles took a turn towards the effervescent and gaudy. The underglaze red was delicate and unassuming under Xuande reign (fig. 210), which was often emulated by imperial kilns in the succeeding Qing. *Doucai*, or contending colors (Tip 36), *wucai* (famille verte), or five colors (Tip 37) and *susancai*, or the soft tri-color glaze (without the red tone produced by iron oxide) were all invented in the Ming. The *doucai* wares of Chenghua reign (fig. 211) were celebrated for their unpretentious charm at the time and beyond.

Tip 36: *Doucai*

A technique for painted porcelain produced by Jingdezhen kilns in the Ming dynasty. Parts of the design, and some outlines of the rest, were first painted in cobalt blue on the surface of the clay body, and the piece was then glazed and fired. The rest of the design was added in overglaze enamels of different colors and the piece fired again. *Doucai* wares first appeared under Xuande reign, reached the peak of its popularity under Chenghua, and continued to be produced in the Qing dynasty and beyond.

Tip 37: *Wucai* (Famille Verte)

A technique for painted porcelain in the Ming and Qing dynasties. One type is the blue-and-white *wucai* ware marked by characteristic underglaze blue and overglaze enamels, which first appeared in the Ming dynasty. The other is the overglaze *wucai* decorated with overglaze enamels only. Their origins can be traced to porcelain wares of the Song and Jin dynasties that were painted with overglaze decoration.

During and after Jiajing reign, famille verte wares gained much more popularity. While some famille verte and *doucai* wares are hardly distinguishable (both using a combination of underglaze blue and overglaze polychrome enamels), the former has a denser pattern of bold washes to complement splashes of strong colors, cheerful in effect (see fig. 17 on page 13). They were inevitably gaudy, though finer specimens could still be modest and unassuming. A number of underglaze colors were developed by the imperial kilns and highly praised for their exquisite beauty. Courtly wares of silky *tianbai* (sweet white) glaze (fig. 212), underglaze blue (sacrificial blue), underglaze red (sacrificial red) (fig. 213), peacock green, or delicate

Fig. 212 Jingdezhen *Tianbai* (Sweet White) Glazed *Jue*

Ming dynasty (Yongle reign)
Overall height 11.2 cm, rim length 15.2 cm
Jingdezhen Institute of Ceramics Archaeology, Jiangxi

Unearthed from the ruins of Zhushan imperial kiln in Jingdezhen, Jiangxi in 1982. It is molded in imitation of the bronze libation cup, *jue*, of the Shang and Zhou dynasties. Used in rituals at the Temple of the Moon and in ancestral worship, the sweet white glazed cups were produced by imperial kilns in considerable quantities during the Ming.

Fig. 213 Jingdezhen "Monk's Cap" Ewer in Ruby Red Glaze

Ming dynasty (Xuande reign)
Height 19.2 cm, rim diameter 11.2 cm, foot diameter 7.4 cm
Palace Museum, Taibei

So named because of its shape that resembles a monk's cap, such ewers became popular likely due to the spread of the Tibetan Buddhism. Not only were the Mongol rulers devout adherents, but also the Ming and Qing emperors took a fancy to liaising with the upper echelon of Tibetan Lamaist sect.

yellow showed a decorative charm in color rather than pattern; delicate and dainty or intense and majestic. Bright yellow glaze and painting on yellow ground were exclusively used for courtly wares, just as the same was designated the imperial sartorial color, replacing the brownish yellow used since the Tang dynasty. The extant *tianbai* wares, with a soft, lustrous glaze, are abundant, due to their extensive use in sacrificial rituals.

Highly refined celadon wares continued to be produced in large quantities by Longquan kilns up to the mid-Ming dynasty. Their decline began thereafter with notable deterioration evidenced by the cruder form and thinning glaze. The white porcelain from Dehua kilns gained popularity from the mid-Ming through the early Qing and its export greatly expanded, garnering a great reputation in Europe (as blanc de chine). Its glaze was ivory in tone, pure and extremely fine. Archaic shapes were often copied and many in exquisite forms were made for display. Dehua

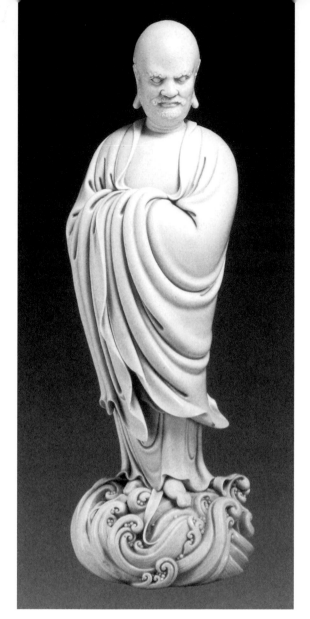

kilns were also known for their figurines, and He Chaozong was one of the finest at creating ceramic figurines (fig. 214) in the late Ming. Production of Yixing *zisha* wares (Tip 38), which were chiefly teapots and first made in the Song dynasty, picked up again around the mid-Ming. Finely molded and finished, and of a beautiful clay color, a *zisha* teapot sits particularly well in the hand. The period saw the rise of a group of outstanding *zisha* artists, including Gong Chun and Shi Dabin (fig. 215), who were renowned for their *zisha* teapots.

Fig. 214 Dehua White Ware Figure of Standing Bodhidharma with Maker Signature "He Chaozong"
Late Ming dynasty
Height 43 cm
The Palace Museum, Beijing

An elegant masterpiece of modeled porcelain figures of ancient times, it depicts the legendary monk, who is credited with establishing the Zen branch of Buddhism, crossing a river atop a reed blade amidst crested waves, as the legend holds.

Fig. 215 Yixing *Zisha* Teapot with Loop Handle Bearing Maker Signature "Shi Dabin"
Late Ming dynasty
Height 20.5 cm, rim diameter 9.5 cm
Nanjing Museum, Jiangsu

Having been handed down through centuries, it shows finer workmanship than that of unearthed teapots bearing the "Shi Dabin" signature. Well-proportioned and of charming rustic elegance, it is a fine specimen of what are called "Dabin" teapots, often emulated by *zisha* potters even today.

Tip 38: *Zisha* Pottery

Zisha pottery is made using high quality clay from Yixing, Jiangsu that has a high content of iron oxides, fine texture and good plasticity. The buff clay body, usually unglazed, is fired in an oxidation atmosphere to a high temperature ideally between 1,090 and 1,180 ℃. The Yixing kilns were most renowned for the stoneware teapots of reddish brown, yellow, green, or purple colors. They were prized for their rustic elegance and fine functional attributes.

Fig. 216　Gold Ewer with Jade Dragon Panel

Ming dynasty (Wanli reign)
Height 21.8 cm, base diameter 8.3 cm
Dingling Museum, Beijing

Unearthed from Dingling (tomb of Emperor Wanli) in Changping, Beijing in 1958. Production of decorative objects in imperial workshops was the most prolific under the Wanli reign, albeit of deteriorated taste. This ewer is such an example.

Fig. 217　Cloisonné Chinese Backgammon Board

Ming dynasty (Xuande reign)
Height 15.7 cm, top edge length 53.3 cm, width 33 cm
The Palace Museum, Beijing

Backgammon was a popular gambling game in ancient China. Extant Chinese backgammon boards of various materials are abundant, though little is known today of the rules of the game.

Gold and silverwares of the period were unimpressive and of mediocre workmanship. However, the technique for intricate wire patterns reached greater maturity, mostly applied to gold jewelry. More ornate jewelry or wares were often adorned with jade or gemstone inlays, which gave them the appearance of luxury, but rarely enhanced artistic value. Gold funerary objects excavated from the tome in present Changping, Beijing, of Emperor Wanli (1563–1620), infamous for his personal indulgences and inattention to government, were examples of such gaudy lavishness (fig. 216). Cloisonné (Tip 39) and bronze censers of Xuande reign were notable for their high level of achievement among metalwork objects of the period.

Cloisonné enameling had been a decorative tradition developed in the West and Arabic regions. Cloisonné began to be produced in large quantities in the Ming dynasty and became an important form of decorative arts since. Extant cloisonné pieces from the Ming were mostly produced by imperial workshops. Those of Xuande reign are known for their exquisite craftsmanship (fig. 217), while those from Jiajing and Wanli eras show deterioration in execution. With origins in the West, cloisonné retained the use

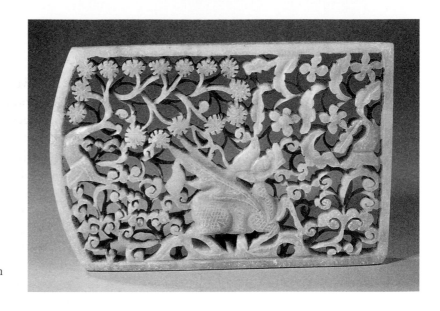

Fig. 218 Jade Plaque with Openwork Carving of *Qilin* and Flower Motif

Ming dynasty (Chongzhen reign, 1628–1644)
Length 9.3 cm, width 6.5 cm, thickness 0.7 cm
Jiangxi Provincial Museum

Unearthed from the tomb of Duke of Yiding (d. 1634) in Nancheng, Jiangxi in 1982. The dense openwork pattern is excessively ornate, but jade plaques of even denser pattern were also found.

of dense and brightly colored patterns, lavish and elaborate in effect, after being adopted in China. Commentaries in the Ming referred to it as "not befitting the literati's study and more suitable for the private use by womenfolk."

Xuande bronze censers were made for the court for display and sacrificial rituals under Emperor Xuande's reign. They were cast according to exacting standard, using high quality imported copper alloyed with minerals. Often in sophisticated and undecorated shapes, they demonstrated classic elegance, borrowing from the best of bronze sacrificial vessels of the Shang and Zhou, and porcelain of the Song dynasty. Their magnificence is to be taken in the subtle, splendid tones of their color, numbering in the dozens. As they became highly sought after, imitation was rife even during the Ming. Copies of Xuande censers could be

so well crafted that it became difficult to tell them apart.

The infatuation with jade was an inevitable subject of any connoisseur's commentary during the Ming. The Ming jade objects did not show any marked difference in style from other eras, given their similar uses. They manifested unpretentious charm, minimalistic elegance, or refined exquisiteness. A higher proportion of jade pieces were carved in openwork (fig. 218), which were more finely finished than those of the earlier age. Most extant jade pieces once belonged to the royal court. Their lavish and elaborate decoration with gemstone inlays and gold mounts, as shown in funerary objects excavated from the Ming imperial tombs, did not add to their aesthetic appeal. The jade minerals were extracted in the northwest of China, while imperial workshops were located in Beijing. In the south, Suzhou was the foremost center of private production. Lu Zigang was a jade artist under Jiajing and Wanli reigns, the only one about whom much is still known today. Because of his fame, jade carvings of his were extensively copied. Numerous pieces bearing his mark can be found today. Yet it is difficult to distinguish the originals from copies.

Ming lacquerware was highly lauded in contemporary commentaries; being described as "flourishing in myriad forms and styles,

Tip 39: Cloisonné

A technique for decorating metalwork objects. It involves first soldering metal strips (copper or gold), bent to form the grid or outlines of a design, to the surface of a metal object (usually copper), and then filling the spaces with enamel paste. The object is fired, ground and polished, and even gilded. Enamel is a silicate compound of quartz, kaolinite, feldspar, and borax melted together.

Fig. 219 "Double Lozenge" Lacquer Box with Incised and Gilt Pattern of Dragon and Phoenix

Ming dynasty (Jiajing reign)
Height 11 cm, length 28.5 cm, width 11.3 cm
The Palace Museum, Beijing

The densely incised patterns of this box were filled with gold powder, resplendent in effect; more lavish than the typical lacquerware of gold-filled incised patterns.

splendid beyond measure." Many types of lacquerware were produced; the commonest numbering fourteen in total. They could be either plain and undecorated or embellished by painting, piling, filling, carving, incising, sculpting and inlay. Elaborately decorated ones, often with a combination of techniques employed, were best suited for display, rather than serving any practical purposes.

New techniques led to new styles. Lacquer wares produced under Yongle and Xuande reigns had thick layers of lacquer, boldly carved in a smooth, fluent style of classic elegance in the Song and Yuan tradition. This was replaced by a more restrained, delicate, and often over-elaborate style in later eras (fig. 219). Lacquered wood furniture and wares were decorated in the "hundred treasure" style, i.e. inlay with gold, silver, jade, mother-of-pearl, coral, ivory, rock crystal and agate (fig. 220). They showed pictorial designs of elegant beauty and indicated a trend towards employing more valuable materials in lacquerwork.

Of many noted lacquer artists of the period, Zhang Degang of the early Ming was best known for his carved lacquer, Yang Xun of the mid-Ming gold painted lacquer, and Jiang Qianli of the late Ming lacquer with mother-of-pearl inlay. Zhou Zhu, also of the late Ming, was known for inventing the "hundred-treasure" inlay technique. He was a native of Yangzhou where lacquer cabinets and wares decorated in such a style were produced throughout the Ming and Qing. *On Lacquer Art*, the only extant monograph on the subject from ancient China, was written by Huang Cheng, well known for his carved red lacquer, and published under the reign of

Fig. 220 Black Lacquer Brush Holder with Inlaid Flowers

Late Ming dynasty
Height 15.2 cm, rim length 15.2 cm
The Palace Museum, Beijing

The "hundred treasure" inlay, with mother-of-pearl, *shoushan* stone, jade, turquoise, and ivory, produces exquisite, brilliant images in the natural colors of the materials, without needing any other colorants.

Fig. 221 *Huanghuali* **Zither Table, Stool and Plant Stand**
Late Ming dynasty
Shanghai Museum

The display of the *huanghuali* (fragrant rosewood) furniture was curated by the famed connoisseur Wang Shixiang (1914–2009), according to tradition. The combination adds to the reserved elegance that is already striking in any single piece of fine Ming furniture.

Longqing (1567–1572). The book catalogued materials, tools, and techniques for lacquer making, with references to creative principles and the history of lacquer art in China. Yang Ming, a renowned lacquer master from Xitang, Jiaxing in Zhejiang wrote an introduction and added extensive annotations for an expanded edition of the book in the late Ming.

Plain hardwood furniture of fine workmanship was produced during the Ming and early Qing dynasties, earning the famed name of the Ming-style furniture. Important centers of production included Beijing, Yangzhou, Huizhou, Guangzhou, and more notably Suzhou. Beginning from around the mid-Ming, scholars' gardens became greatly admired and desired. The rich and powerful competed to fit out their garden residences with elegant hardwood furniture of reserved simplicity that were harmonious with the ornate gardens (fig. 221), ostensibly to show off their cultured sensibility. The literati played an important role in the emergence of the Ming-style, by not only being patrons but also collaborating with cabinetmakers to design and make items appealing to their taste. Such furniture befitting a scholar's studio became so admired in lower Yangtze basin during Jiajing reign and beyond that even lowly, uneducated government servants would acquire a piece or two, to the scorn of the literati, as the legend has it.

Hardwoods used for the Ming-style furniture were primarily *huanghuali* (fragrant rosewood), purple sandalwood, Ceylon ironwood, and the so-called chicken-wing wood. Soft hardwoods such as beech and phoebe were also used. These materials, the hardwoods in particular, often only varnished for finishing, were deemed precious and prized for their toughness, fine natural grain, and magical texture that manifested the beauty of the material. Purple sandalwood furniture was loved for its smooth satin finish and fragrant rosewood its lustrous, amber-like translucence.

The furniture types included chairs (fig. 222), stools, and tables both high and low, in various designs. Made out of the choicest materials, they showed faultless workmanship. Wood that best showed the beauty of the natural grain (see fig. 27 on page 18) was used for the most prominent part of the furniture. Various kinds of Chinese joinery were most ingenious. When decoration was required, carving in relief, with smooth, fluid execution, was used, though, as a rule, Ming furniture was plain and undecorated. Carved patterns, if any, were mostly stylized or abstract, some mimicking lines and curves of antiquity. Bronze fittings were both functional and decorative. Such furniture was lauded for its simple elegance, pure form, masterful command of lines and curves (fig. 223), though redundancy and over-elaborateness existed in the worst examples. Chairs and tables also manifest a good command of proportions and functionality in keeping even with modern ergonomics.

Bamboo carving, though having a long history, did not become a standalone form of decorating art and flourished in lower Yangtze basin until after the mid-Ming. Several competing styles emerged over time. The Jiading style, represented by Zhu He, his son Zhu Ying, and grandson Zhu Zhizheng, was renowned for high-relief carving and carving in the round (fig. 224). Other well-known carvers included Pu Cheng of Jinling (present Nanjing, Jiangsu) for his technique of light incising coupled with occasional cutting, and

Zhang Zonglue his technique of "retaining the green" (with the outer skin of the bamboo being retained and carved through), both living in the late Ming and early Qing. Most of the carved bamboo objects were scholar's brush vases and wrist rests. Carving techniques were similar to those used for ornaments of valuable materials such as rhino horn or ivory. Thus, bamboo carvers could work with great prowess in several media and styles.

The flourishing of decorative arts in the Ming was to have profound and lasting influence on their equivalents in the succeeding Qing dynasty. The blue-and-white wares of Xuande reign and *doucai* of Chenghua reign were often emulated by imperial kilns of the Qing. Private artisans producing *zisha* teapots and bamboo carvings in the Qing continued the Ming tradition without any alteration. Su embroidery of the

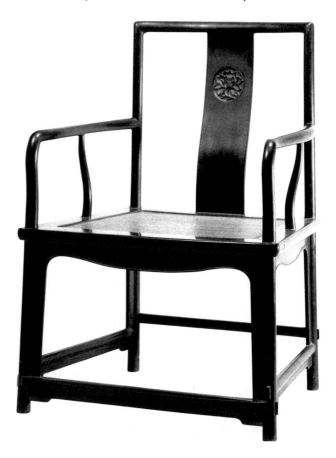

Fig. 222 Purple Sandalwood "Southern Official's Hat" Chair

Late Ming dynasty
Overall height 108.5 cm, seat height 51.8 cm, width 75.8 cm
Shanghai Museum

The "official's hat" chair is distinguished by its "exposed four corners" (arm rails extending beyond the front posts and the horizontal back crest rail the rear posts), while that with "unexposed four corners" is its southern variation—the current piece; originally owned by connoisseur Wang Shixiang.

Fig. 223 *Huanghuali* (Fragrant Rosewood) Bookshelf

Late Ming dynasty
Height 177.5 cm, width 98 cm, depth 46 cm
Shanghai Museum

The top panel and shelves are squarely supported in a rectangular frame, which is contrasted with the finely shaped aprons and curvy borders to good effect; manifesting superb workmanship.

Fig. 224 Carved Bamboo "Pine and Crane" Brush Holder with Maker Signature "Zhu He"

Ming dynasty (the 5th year of Longqing reign, 1571)
Height 17.8 cm, rim diameter 8.9–14.9 cm
Nanjing Museum, Jiangsu

The only extant bamboo carving that is reliably attributed to Zhu He, it was made by him as a birthday gift for his friend's father; hence the "pine and crane" motifs (both symbolic of longevity).

Qing showed such a striking resemblance to Gu embroidery of the current period that it is futile to attempt telling their stylistic differences. Influences of West Asia were still seen in porcelain of the early Ming. However, due to the "sea prohibition" policy against rampant Japanese piracy off the coast, Chinese influence on Western decorative arts was suspended until the late Ming. Of interest were Chinese potters working at kilns in West Asia at the invitation of Iranian royalty, and the export of Chinese porcelain in great quantities to Europe, which led to the rise of the porcelain industry in Italy and the Netherlands. The soft-bodied European porcelain wares produced at the time often copied the blue-and-white wares as well as the white wares of Dehua kilns.

THE QING DYNASTY

(1644–1911)

Decorative arts of the Qing did not show apparent nomadic influence, even though the Manchu who founded the dynasty came from the north. This was due to two factors: a) efforts by the Manchu ruling elite to be sinicized; b) the agrarian nature of the Manchu economy, formed long before their founding of the Qing.

The Qing dynasty spanned nearly three centuries. In the early Qing, decorative arts greatly flourished, adopting the best of archaic traditions and achieving an unparalleled level of technical sophistication by Emperor Qianlong's reign (1736–1795). Given myriad possibilities, the tendency for obsessive concern with technical mastery, championed by imperial workshops, began to take hold.

The emphasis on technical complexity was carried to extraordinary lengths and high-grade decorative objects manifested absurd, showy elaborateness.

Extensive Qing court documents, well-kept to this day, show personal involvement of the Qing emperors in the production of

Fig. 225 "Peach, *Foshou*, and Pomegranate" Brocade Woven with Gold Thread (detail)

Qing dynasty
Full length 178 cm, width 75 cm
The Palace Museum, Beijing

The color scheme on ground of turtle pattern harks back to the archaic Song style of classical elegance. The densely woven pattern of peach, *foshou* ("Buddha's hand") and pomegranate motifs (respectively symbolic of good fortune, longevity and prolific fertility) manifests a distinct Qing character.

imperial workshops, often giving decrees and strict requirements in the design process. Such royal involvement in and influence on decorative arts should have existed in other eras, too, though less known and not as well documented.

Jiangsu and Zhejiang, having been centers of silk production from the Southern Song onward, enjoyed an elevated status during the Qing and were unmatched by any other region of China in the quality and volume of their silk products. Jiangning (present Nanjing, Jiangsu), Suzhou and Hangzhou were the most important towns in these silk producing provinces. Private production had also grown tremendously by the late Qing, with private silk mills reaching remarkable sizes and the quality and volume of their production being no inferior to that of imperial workshops. Silk production became increasingly more pronounced in the local economies.

Most of the best-known types of silk were produced in the two provinces, showing distinct regional characteristics. The most celebrated were *Yunjin* (cloud brocade) and *Songjin* (Song brocade). *Yunjin* brocades from Jiangning had ornate, lavish patterns of scrolls in bold colors (Tip 40). They were woven thickly with a dense, colorful design, often incorporating gold threads, magnificent and stately in effect. *Songjin*, produced in Suzhou (Tip 41), earned its name by mostly emulating the fine brocades of the Song dynasty that were used in mounting Chinese painting and calligraphy (fig. 225). They were woven with exquisite, uniform patterns in harmonious

colors, displaying a classic elegance. Velvet (Tip 42) also gained popularity during the Qing, which was invented and first produced in considerable quantities in Zhangzhou, Fujian. Though still popular during the Qing, Zhangzhou velvet was overtaken by that of

Tip 40: *Yunjin*

A term referring to silk brocades produced in Jiangning (present Nanjing) in the Qing dynasty and beyond. They include *kuduan* (woven with a raised monochrome floral design, occasionally with gold threads), *kujin* (woven with gold or silver fillings in floral design), and *zhuanghua* (most resplendent and representative of *yunjin*, woven with colored silks for polychrome patterns, sometimes within outlines of gold on ground of gold).

Tip 41: *Songjin*

Songjin refers to silk brocades produced in Suzhou in the Qing dynasty and beyond, taking its name from the Song dynasty patterns that it often imitated. Variations include the heavy and fine brocades and *xiajin*. The heavy brocade was finely woven, often with gold fillings added for dazzlingly colorful effect, and used in mounting calligraphy or as spread for display. The fine brocade was loosely woven, of medium thickness and decorated with different motifs in varied composition. It was often used in mounting painting and calligraphy, or for making garments. *Xiajin* was a slightly coarse fabric, thin and soft, woven with small floral patterns in elegant, pale colors, and was used in mounting, or making pouches for, paintings and calligraphy. Fine brocade and *xiajin* showed styles more akin to that of the Song, in contrast to the heavy brocade.

Tip 42: Velvet

A silk fabric having a short pile, with a looped or tufted surface formed by supplemental yarns running in the warp direction. The technique achieved maturity during the Ming and the fabric was produced with variations in great quantities during the Qing. Fabrics were either plain or ornamented. A decorative design was first drawn or printed on the surface of the fabric before the yarns being partially clipped to create the pattern reserved on a plain ground.

Fig. 226 Velvet with Flower and Bat Motifs (detail)
Qing dynasty
Full length 220 cm, width 66 cm
Nanjing Museum, Jiangsu

The pattern consists of red flowers and golden bats surrounded by intertwined green leafy stems (all suggestive of "endless blessings"). Velvet weaving is time-consuming and costly, of which that woven with colored silks and supplementary gold threads is the most expensive and lavish.

Jiangning (fig. 226), Suzhou and Hangzhou in both volume and popularity. Woven in elegant colors and highly durable, velvet was marked out as fit fabric for making lush and lavish garments and decorative uses.

Silk was emblematic of the decorative style of the time. Floral motifs were prevalent and geometric patterns widely used. Festive, auspicious patterns, though superfluous and gaudy, became increasingly popular. Composition in the style of Chinese traditional paintings, fluent and unrestrained, was often encountered. Yet their decorative appeal could wear thin with overuse. The composite floral pattern (fig. 227), of varied sizes and density, was elegant, pleasing to the eye, and peculiar to the period. Given increased contact with the west, European patterns found their way into Chinese silk decoration, initially used in export production and not integrated with Chinese styles. It was until much later that such patterns were used in domestic production, for their exotic appeal and out of admiration for a culture deemed "superior." The introduction of automated iron looms from Europe and the U.S. brought changes to silk patterns (fig. 228). Fabrics with western patterns were called *taixi* (Far West) silk, a term beginning to be used from the late Ming onward.

A large quantity of *kesi* tapestries were produced by imperial workshops, especially under the Qianlong reign. Often of large

Fig. 227 Brocade *Magua* (Jacket) of Floral Motif, Woven with Supplementary Gold Threads

Late Qing dynasty
Length 73 cm, full yoke/ sleeve length 120 cm, hem width 80 cm
The Palace Museum, Beijing

The prominent floral roundels (symbolic of gratification and perfection), on ground of persimmons and *ruyi* (a talisman symbolic of good fortune), much favored by the Manchu, are altogether rich in auspicious meaning.

Fig. 228 *Taixi* Satin Damask with Rose Motif (detail)

Late Qing dynasty
Full length 556 cm, width 70.5 cm
The Palace Museum, Beijing

The *taixi* (Far West) pattern of roses on intertwined leafy stems is highly realistic, showing gradation and fading hues of color, the effect of which is very different from that of traditional Chinese fabric decoration.

Fig. 229 *Kesi* Tapestry in Imitation of a Peaceful New Year Painting by Emperor Qianlong

Qing dynasty (Qianlong reign)
Height 54.9 cm, width 38.4 cm
Palace Museum, Taibei

Inscribed with the characters for "peaceful and blessed new year," the silk tapestry manifests superb workmanship. However, as Emperor Qianlong is no artist par excellence, the impeccable reproduction in silk tapestry hardly makes itself a great work of art.

sizes, they featured well-known paintings, calligraphy, Buddha portraits, as well as birthday verses or paeans composed by princes and ministers in honor of the emperor. Emperor Qianlong (1711–1799), known for his cultivated taste and artistic flair, surely did not hold himself off on this, and often had his calligraphy and paintings rendered in sumptuous silk hangings (fig. 229). Yet the fine workmanship of the weavers could do little to the lack of artistic value in the originals.

A number of distinct embroidery styles emerged, each named after the place of their production: Jing (Beijing), Lu (Shandong), Bian (Henan), and Ou (Wenzhou), in addition to the four already well known: Su (Suzhou), Yue (Guangdong), Xiang (Hunan) and Shu (Sichuan). Works by private embroiderers, mostly for everyday use, displayed a rustic simplicity and joyous festivity (see fig. 24 on page 17). High-grade embroidery from the south of China adopted an artistic approach in the late Qing. Techniques of western painting such as perspective, light and shade were widely employed to depict images in a realistic manner. Embroidery was thus made an extension of and accessory to painting. The renowned Su embroidery artist Shen

Fig. 230 Embroidered Picture of Clams by Shen Shou

Late Qing dynasty
Height 28 cm, width 35 cm
Nantong Museum, Jiangsu

Various techniques were superbly executed to elicit hues of color, light, and texture of the depicted objects. The personal seal at the bottom right reads "My name sealed on an imperial screen," suggesting that a silk screen embroidered by Shen Shou was once presented to the Empress Dowager Cixi for her birthday.

Shou (1874–1921) had great influence in this development (fig. 230). Her embroidery even caught the fancy of Empress Dowager Cixi (1835–1908). Her embroidered portraits of the Italian king and Jesus fetched top prizes at world expos in the early 20th century. Later in life, she dictated the book *Shen Shou on Embroidery* that gives a complete account of various stitches and techniques. Embroidery by imperial workshops remained lavish and resplendent, often using gold and silver threads extensively. Formal robes for the aristocracy were ornamented with peacock feather (see fig. 22 on page 16) and pearls in addition to embroidery.

Cotton was cultivated and produced from the Yuan dynasty onward, gaining increasing popularity. By the Qing dynasty, the number of cotton mills and their production volume had far exceeded those of silk. In lower Yangtze basin, cotton weaving became a major cottage industry, in which many rural families were engaged alongside farming. There were also many specialized cotton mills. Printing and dyeing were the chief means of decoration. The most common patterns were printed in indigo; with regional variations in design and technique, and all of refreshing rustic simplicity and unaffected charm.

Jingdezhen, the famed capital of porcelain, was unquestionably at its most productive during this period, though the description of having "potters and helpers employed in their hundreds of thousands" might have been a little exaggerated. The imperial kilns there reached their peak in production volume and popularity, particularly under the reigns of Kangxi, Yongzheng (1722–1735), and Qianlong. Ornamentation was predominantly by painting and colored glazes. Many new glaze colors were invented by the imperial kilns, as in the preceding Ming period. The glazes had a lustrous warmth and purity, imparting a sense of serenity, clarity, delicate charm (fig. 231), or rustic simplicity. Perfectly matching and often enhancing the shape of the ware, the translucent beauty of such glazes was often compared to that of "spring orchids and autumn chrysanthemum." The traditional celadon and white wares also had a high level of achievement during the period.

Falangcai porcelain (with enamel decoration) and *fencai* (or famille rose, literally "pink color") were notable innovations during the period, both using overglaze polychrome enamels. The former was inspired by

Fig. 231　Five Peach-Bloom Glazed Wares of Jingdezhen Kilns
Qing dynasty (Kangxi reign)
Metropolitan Museum of Art, New York City, U.S.

Porcelain covered on the exterior with a peach-bloom glaze (*jiangdouhong*), speckled with minute greenish brown spots, and of smallish sizes, is highly prized under the Kangxi reign. The glaze recipe includes copper oxide as a colorant.

cloisonné enameling (Tip 43), with patterns and forms often prescribed by imperial decrees, and produced in small quantities exclusively for the court. It looked quite similar to cloisonné during the Kangxi reign, before taking on a unique character later. The enamel decorated ware was thinly potted, with bright and elegant patterns finely painted in disciplined brushwork (fig. 232). The latter, famille rose ware (Tip 44), was decorated with elegant washes of soft enamel colors, showing layered depth. Both imperial (see fig. 2 on page 2) and private kilns produced famille rose wares, with the former achieving the highest level of refinement. Made in much larger quantities than *falangcai* porcelain, famille rose became one of the three primary types of painted porcelain (the other two being famille verte and blue-and-white), and are being made to this day at Jingdezhen as its main type of painted porcelain.

Both blue-and-white and famille verte wares produced by imperial and private kilns reached their peak of perfection during the Kangxi reign. Shades of blue could be seen on different blue-and-white wares. The typical design was executed in graduated washes, allowing some diffusion of blue as in Chinese ink painting, which became a hallmark of blue-and-white wares under Kangxi reign (fig. 233). On famille verte wares (fig. 234), the underglaze blue became faint or even disappeared altogether, and

Fig. 232 *Falangcai* **Pheasant and Peony Bowl**
Qing dynasty (Yongzheng reign)
Height 6.6 cm, rim diameter 14.5 cm, foot diameter 6 cm
The Palace Museum, Beijing
Thinly-potted and extremely light, it is exquisitely painted with enamels, with flower and bird motifs, in addition to a poetic inscription and seal mark, as in a traditional painting of the meticulous style.

Tip 43: *Falangcai*

The term refers to the fine enameled courtly wares produced in the Qing dynasty. The enamels, rich in boric oxide, were painted onto the surface of high-fired white porcelain from Jingdezhen in typical styles of the palace art. The porcelain piece was then fired a second time. Called "enamel-painted porcelain" by the Qing court, it was first invented in the late Kangxi period and reached its peak in artistic quality in the Yongzheng and Qianlong eras.

Tip 44: Famille Rose (*Fencai*)

The term refers to a type of painted porcelain invented in the Kangxi period. Pictorial designs were painted on an enamel slip, a white opacifier of lead arsenic compound, which heightens the contrast between the painted colors and the plain ground. Patterns were created in fine and meticulous brushwork allowing a degree of diffusion. The finest specimens were produced by imperial kilns and the Yongzheng and Qianlong eras saw a great flourishing of this art.

Fig. 233 Jingdezhen Blue-and-White Gourd-Shaped Vase with Squirrel and Grape Motifs

Qing dynasty (Kangxi reign)
Height 12.4 cm, rim diameter 2 cm, foot diameter 5.2 cm
The Palace Museum, Beijing

A product of the imperial kilns towards the end of the Kangxi period, it is potted in a minute form, with squirrel, grape, and foliage elegantly painted on white ground under lustrous glaze; markedly different from those from private kilns.

the newly invented overglaze blue was applied in bold washes to complement other overglaze colors. The decorative motifs were varied, with legendary figures being the most favored. The spirited and exaggerated representation was much influenced by the portrait paintings of Chen Hongshou (1598–1652), a celebrated painter living in the late Ming and early Qing dynasties.

The incomparable masterpieces of the imperial kilns were produced after trials

Fig. 234 Jingdezhen Famille Verte "Phoenix-Tail" Vase, *Zun*, with Lotus Pond Motif

Qing dynasty (Kangxi reign)
Height 45.5 cm, rim diameter 22.9 cm, foot diameter 15 cm
The Palace Museum, Beijing

Famille verte or *wucai* (literally "five colors") is often referred to as "archaic colors" in modern and contemporary times. The "phoenix-tail" form (with waisted lower half spreading towards the base) is very representative of the Kangxi period. Sturdily potted and decorated in brilliant colors, this vase is a masterpiece of Qing wares.

and errors and numerous rejects. The technique of having sections fired separately and reassembled allowed combination of varied glazes and painted patterns. A vase could have a revolving inner body and neck (fig. 235). Other wares were designed in representational shapes with realistic pictorial decorations. They mimicked those of jade, gold and silverware, rhino horn cup, bronze vessel (fig. 236), lacquerware, or carved bamboo, in fruit or animal shapes, to remarkably realistic effect. The workmanship reached its peak during the Qianlong reign. Technical finesse and precision were so emphasized as to obliterate artistic spontaneity and innovativeness. Eventually, ceramics became vehicles for showing peculiar skills and technical flair. As the Qing's power began to wane after Qianlong, the imperial kilns were losing their prestige and decorative arts in the current period never regained the glory they once had.

The imperial kilns had supervisors appointed by the court, of whom Zang

Fig. 235 Jingdezhen Famille Rose Revolving Vase

Qing dynasty (Qianlong reign)
Height 41.5 cm, rim diameter 19.5 cm, foot diameter 21.2 cm
The Palace Museum, Beijing

The revolving mid-section is pierced with openwork roundels that reveal the revolving cylindrical interior. It is believed to have been designed by Tang Ying (1682–1756), et al, in 1754.

Fig. 236 Jingdezhen Archaistic Vase, *Zun*, with Animal Shaped Handles on Shoulders

Qing dynasty (Qianlong reign)
Height 22.2 cm, rim diameter 13.2 cm, foot diameter 11.7 cm
The Palace Museum, Beijing

An archaistic porcelain vase in the style of the Warring States bronze with gold and silver inlay, it is covered with a brownish glaze in imitation of an ancient bronze patina, mottled in rusty russet. However, the pleasing feel of the porcelain is altogether lost in the near perfect bronze imitation.

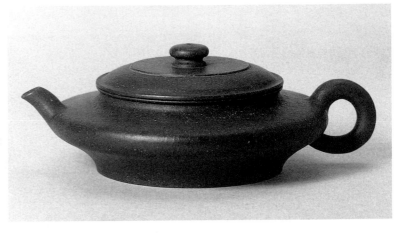

Fig. 237 Yixing Compressed-Form Teapot of Mixed Clay, with Maker Signature "Chen Mingyuan"

Qing dynasty (Qianlong reign)
Height 4.9 cm, rim diameter 8.5 cm
Yixing Ceramics Museum, Jiangsu

Zisha teapots are prized for their classical elegance, with emphasis on the color of the clay, mostly purplish brown, of varying hues.

Yingxuan, Lang Tingji, Nian Xiyao, and Tang Ying were the most well-known. Chroniclers often prefixed the names of the kilns with their inspectors'. Tang Ying (1682–1756), whose tenure was the longest of all inspectors, left a greater mark on porcelain development. Well versed in all aspects of production, he wrote several important treatises on the subject. Products of the kilns under his direction were thought to represent the best of porcelain art in ancient China.

Outside Jingdezhen, there were also numerous private kilns, among which Dehua, Yixing and Shiwan kilns were more influential. White porcelain of Dehua, though still superlative, was not as refined as it once was during the Ming. Yixing's fame for *zisha* pottery (fig. 237) persisted. The elegant simplicity of *zisha* prevailed while attempts at glazing or painting that detracted from the fine clay tone and texture were shunned. Works by Chen Mingyuan, Chen Mansheng and Shao Daheng were the most acclaimed. The superb Jun ware glaze was often imitated in the Qing. The imitation wares were produced at Jingdezhen, Yixing and Shiwan alike. The "Jun style pottery" from Yixing, first produced in the Ming dynasty, continued to be made in the Qing, albeit in improved forms. Shiwan kilns produced wares in imitation of both Jun and Ge wares, in addition to figurines for which it was most famous (fig. 238).

Europe had become an important destination for Chinese export porcelain by the late Ming, in addition to traditional markets in Asia. During the Qing dynasty, much more orders came from European traders, often topping a million pieces annually in the 17th and 18th centuries. Guangzhou was an important center for decorating export porcelain, typically with

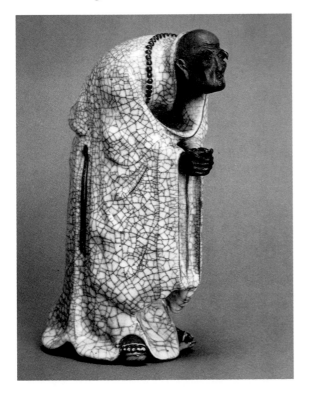

Fig. 238 Shiwan Pottery Figure of "Mi Fu Worshiping Buddha"

Qing dynasty
Height 16.6 cm
Guangdong Provincial Museum

Mi Fu (1051–1107) was a famed calligrapher and painter of the Northern Song period; a storied character. This splendid work gives expression to the "weird, esoteric" side of his personality.

coats of arms of European aristocracy (fig. 239). High-fired white porcelain wares from Jingdezhen were sent to Guangzhou to be painted and fired for the second time at a lower temperature. Called *guangcai* (Guangzhou colors), they were made in enormous quantities by the mid-18th century. The design of export porcelain often catered to the traders' requirements, which was to influence porcelain for the home market and even imperial courtly wares. With Chinese export porcelain being highly valued and much sought after in Europe, porcelain techniques were also introduced to

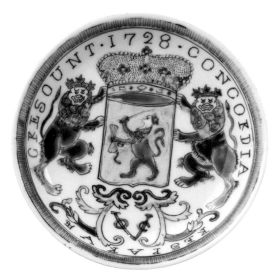

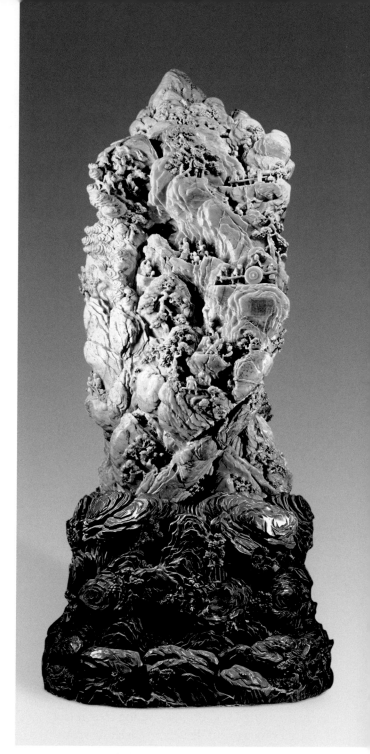

Fig. 239 *Guangcai* Bowl and Dish
Qing dynasty (Yongzheng reign)
Dish diameter 10.6 cm
Percival David Foundation of Chinese Art, London, U.K.

Bearing a mark for the year 1728, the white porcelain wares are of a superior quality quite beyond the reach of European kilns, though the painted decoration is hardly worthy praise.

Fig. 240 Jade Carving "Dayu Harnessing Floods"
Qing dynasty (53rd year of Qianlong reign, 1788)
Height 224 cm, width 96 cm, weight about 5,330 kg
The Palace Museum, Beijing

Emperor Qianlong was said to have believed that the raw jade better suited for a carving celebrating the ancient king Dayu, than being cut into sections for ritual vessels. As the Chinese legend has it, King Dayu led the people in epic undertakings to harness the floods that had ravaged the land.

Europe. Early products of European factories often copied Chinese porcelain. However, deterioration became apparent after the Qianlong reign. With the rise of porcelain production in several European states, Chinese export also began to wither.

Jade ornaments were produced in many cities during the Qing; the most notable being Beijing, Suzhou and Yangzhou. High quality ones were often associated with the imperial court. In the early Qing, courtly jade ornaments were often reworked old jade pieces and few were new, due to difficulty in sourcing jade stones from the northwest where insurgency was rife. After the unrests were quelled in 1760, high-quality jade stones were sent in large quantities as tributes to the capital, which led to flourishing production of courtly jade. In additional to small ornaments, large jade carvings were made, the most striking being "Dayu Harnessing Floods," a jade carving of more than seven feet in height (fig. 240). Jade ornaments showed exquisite elegance (fig. 241) or unassuming charm (see fig. 29 on page 20). Patterns of Islamic style were much liked. The production of courtly

jade ornaments began to taper off again, as supplies of nephrite from Xinjiang started to decline in 1811. Despite a momentary revival in the late Qing, it never regained its past level.

Jadeite began to be imported in the mid-Qing, chiefly from Burma, as a new source of high-quality jade stones. Green jadeite was the most desired among many color variations. Being harder to obtain than Hetian nephrite, it was priced higher and much favored by the ruling elite. A miniature landscape (penjing or Chinese bonsai) constructed with jade, gemstone, pearl and coral was a popular item for the desk (fig. 242) in the Qing. Such objects of

Fig. 242 Jade Miniature Landscape
Qing dynasty
Overall height 25 cm, bowl height 6 cm
The Palace Museum, Beijing

Jadeite and nephrite stones, carved in the shape of bamboo and rocks, were set in a beautiful cloisonné bowl. Well-proportioned, it has an elegant, pleasing layout; a bowlful of nature, evocative of its calming tranquility.

luxury, made by both palace jewelers and private artisans, were often presented as royal awards, tributes, or personal gifts. Except for occasionally more elegant pieces, they were mostly designed to be symbolic of good fortune, wealth, longevity and happiness.

Lacquer production largely continued the early Ming tradition, with techniques being

Below

Fig. 243 Carved Lacquer, *Ticai*, Cabinet with Archaistic Motifs

Mid-Qing dynasty
Height 74.6 cm, width 49 cm
The Palace Museum, Beijing

Carved lacquer furniture was abundant in the Qing palace, which was rather impractical, with all the uneven surfaces prone to collecting dust and extremely difficult to clean.

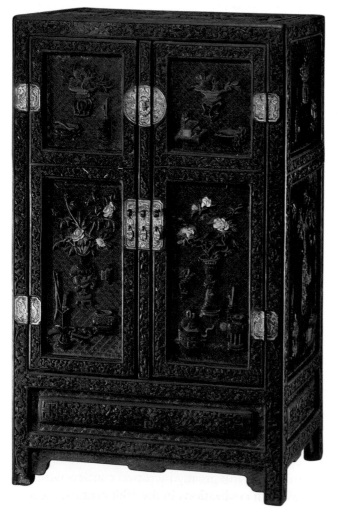

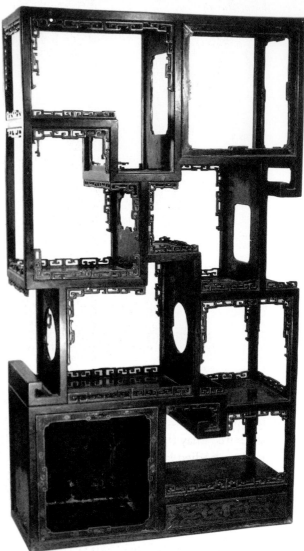

Above

Fig. 244 Purple Sandalwood Display Shelf

Qing dynasty (Qianlong reign)
Height 123.5 cm, width 70 cm, depth 30 cm
The Mountain Resort Museum, Chengde, Hebei

It is designed with ten open shelf spaces for displaying curios and objects for admiration of various sizes. Its ornate form and layered structure betray a tendency towards gaudy and superfluity.

Tip 45: *Ticai*

A technique for carved lacquer invented during the Ming dynasty, it involves cutting through layers of lacquer to reveal the desired color according to design.

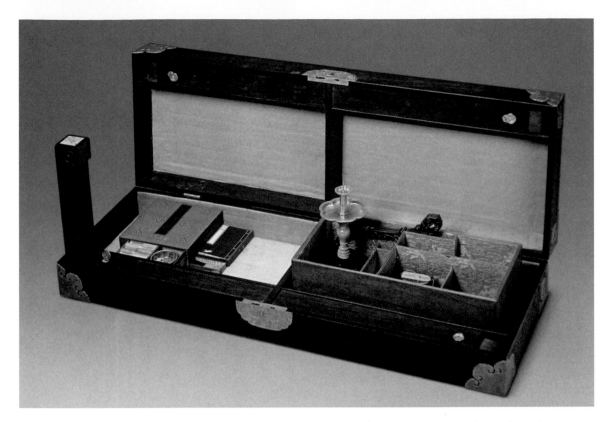

further improved upon and more refined. Carved lacquer from Beijing and Suzhou, lacquer with mother-of-pearl or "hundred-treasure" inlay from Yangzhou, and the hollow-bodied lacquer from Fuzhou were the most remarkable. Of many outstanding lacquer artists, Lu Kuisheng of Yangzhou, highly skilled in several lacquer techniques, was especially known for his mastery of "hundred-treasure" inlay and lacquer inkstones. Shen Shao'an of Fuzhou, another fine lacquer artist, was known for his finely polished and ingeniously shaped, hollow-bodied lacquerware, decorated with exquisite polychrome painting. Courtly carved lacquer reached a peak of perfection during the Qianlong period, which included carved red lacquer, marbled red and black type, and *ticai* (carved colors) (Tip 45). Not only small ornamental pieces, but also lacquered furniture (fig. 243) and models were being made. The tendency towards the exquisite, peculiar, and elaborate, in both form and decoration, led to obliteration of creative spontaneity, foreboding the eventual decline of lacquer art.

Qing furniture up to Yongzheng

Fig. 245 Purple Sandalwood Travel Stationery Cabinet

Qing dynasty
Overall height 14 cm, length 74 cm, width 29 cm
The Palace Museum, Beijing

The travel cabinet, ingeniously designed to neatly hold 64 stationary items and ornaments for the scholar's desk, can also open into a low, four-legged *kang* (platform bed) table.

reign manifested a classic elegance in the Ming tradition. Superfluity and excessive complexity began to plague furniture design. After Qianlong reign, furniture was often embellished with elaborate carved decoration, often using multiple woodwork techniques; the higher the grade, the more ornate the carvings (fig. 244). For high-grade furniture, the concern for decoration, through meaningless variation and showy ornamentation, often outweighed that for form and functionality. Yet, small portable cabinets made at the time were refreshingly innovative in design (fig. 245). They were made for the emperors known for their penchant for royal outings. With greatly increased contacts with Western civilizations in the 18th century, some

high-grade furniture used designs based on a combination of Western and Chinese styles, often in an absurd jumble.

Gold and silverwares were abundant, especially those for everyday use in the court. Some objects were enormous in size, reflecting the extravagance and wealth of the ruling house, but having little artistic value. Enameled metalwork achieved more technical sophistication, with cloisonné being the most common, in addition to metal objects decorated with painted enameling (Tip 46), enameling of incised or chased patterns, and translucent enameling (Tip 47).

Painted enameling apparently influenced *falangcai* porcelain. As enameling was introduced to China from the West, patterns of painted enameling often had an obvious European character (fig. 246). Enameling

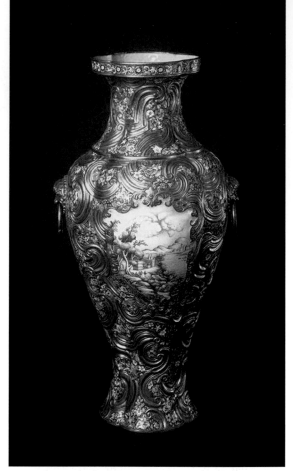

Fig. 246 Enamel Painted Vase
Qing dynasty (Qianlong reign)
Height 50.5 cm, rim diameter 16 cm, base diameter 14 cm
The Palace Museum, Beijing
An example of "Guangzhou porcelain," with rather exotic decoration. Guangzhou became a major trading port in the Qing dynasty and its decorative products were often found to have received European influences.

Tip 46: Painted Enameling

Enamels were first painted onto the surface of a bronze object, before it was fired to form colorful and intricate patterns. The technique was first introduced from the West. Production of enamel painted bronze wares began under Kangxi reign and expanded greatly under Qianlong reign. They were mainly produced in Guangdong, in addition to the Qing palace workshop in Beijing.

Tip 47: Translucent Enameling

Also known as *shaolan* (fired blue enameling), the translucent enamel glaze was applied onto the surface of the metal object, often bronze and rarely silver, with incised or chased patterns, and sometimes gold or silver appliqué strips. Overglaze gold was sometimes added for lavish and resplendent effect. Translucent enameling first appeared in Europe at the end of the 13th century and was introduced into China in the early Qing dynasty. Production reached its peak during the Qianlong period and bronze wares of translucent enameling from Guangzhou was deemed the best.

of incised or chased patterns on bronze first appeared probably in the Ming and achieved technical perfection under Qianlong reign. Bronze wares with translucent enameling (fig. 247) had a warm, lustrous glaze, embellished with exquisite, pleasing patterns. Beijing, Yangzhou, Jiujiang, and Guangzhou had long been known for their enamelware. However by the late Qing, only Beijing had some sizable production of cloisonné by private artisans, which was largely supported by foreign patrons.

Artistic glass, called *liaoqi* in the Qing

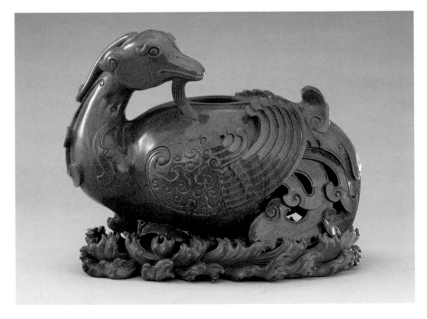

Fig. 247 Bronze Basin with Translucent Enameling

Qing dynasty
Height 12.7 cm, outer rim diameter
47 cm, base diameter 16.5 cm
The Palace Museum, Beijing

The surface of the bronze basin is chased and filled with specks of sliver, which is applied all over with an enamel glaze with no backing, allowing light to shine through for a translucent effect. It was made in Guangzhou under the Qianlong reign.

and beyond, was produced in Zibo, Beijing, Guangzhou and Suzhou. Glass factories, first set up by European missionaries under Kangxi reign, were of the highest standard at the time, and their production flourished in the Qianlong period. Aventurine glass (diffused with golden specks) (fig. 248), and glass decorated with overlaid swirls and patterns (see fig. 5 on page 4) show exquisite, elaborate designs and superb workmanship. Chinese artistic glass hence attained a reputation no inferior to Western equivalents. Glass ornaments made by private glassmakers in Beijing were mostly in animal or fruit shapes. Inside-painted glass snuff bottles became well known in the late Qing and beyond. Other small ornamental objects

from the period included those of ivory, rhino horn, gourd (molded while growing), carved bamboo, as well as "iron pictures" (forged iron strips soldered in pictorial patterns), each representing a unique tradition.

Formal sophistication, spatial complexity, and uniform floridness became increasingly pronounced in the decorative arts of the Qing. Technical prowess helped innovation and imitation of archaistic forms. Under successive reigns of Kangxi, Yongzheng and Qianlong, decorative arts attained a glorious height; marked by their ornate resplendence, the pursuit of which continued well into the late Qing, despite declining fortunes of the empire and gradual deterioration in workmanship after Qianlong reign.

Fig. 248 Aventurine Glass "Celestial Pheasant" Water Pot

Qing dynasty (Qianlong reign)
Height 15 cm, length 21.5 cm
The Palace Museum, Beijing

The making of aventurine glass is rather difficult, requiring careful control of firing temperature. After the glass has melted and cooled, the crucible is broken up and the glass ground polished to the desired form, as for jade carving.

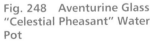

APPENDICES

Dates of the Chinese Dynasties

Xia Dynasty (夏) ..2070–1600 BC
Shang Dynasty (商) ..1600–1046 BC
Zhou Dynasty (周) ...1046–256 BC
 Western Zhou Dynasty (西周) ..1046–771 BC
 Eastern Zhou Dynasty (东周) ...770–256 BC
 The Spring and Autumn Period (春秋)770–476 BC
 The Warring States Period (战国)475–221 BC
Qin Dynasty (秦) ...221–206 BC
Western Han Dynasty (西汉) ..202 BC–AD 8
Xinmang Period (新莽) ..9–25
Eastern Han Dynasty (东汉) ...25–220
Three Kingdoms (三国) ..220–280
 Wei (魏) ...220–265
 Shu Han (蜀) ..221–263
 Wu (吴) ...221–280
Jin Dynasty (晋) ...265–420
 Western Jin (西晋) ..265–316
 Eastern Jin (东晋) ..317–420
Sixteen Kingdoms (十六国) ..304–439
Northern and Southern Dynasties (南北朝)420–589
 Southern Dynasties (南朝) ...420–589
 Northern Dynasties (北朝) ...439–581
Sui Dynasty (隋) ...581–618
Tang Dynasty (唐) ...618–907
Five Dynasties and Ten Kingdoms (五代十国)907–979
 Five Dynasties (五代) ..907–960
 Ten Kingdoms (十国) ..902–979
Song Dynasty (宋) ...960–1279
 Northern Song (北宋) ..960–1127
 Southern Song (南宋) ..1127–1279
Liao Dynasty (辽) ..916–1125
Western Xia (Tangut) (西夏) ..1038–1127
Jin Dynasty (金) ...1115–1234
Yuan Dynasty (元) ...1271–1368
Ming Dynasty (明) ...1368–1644
Qing Dynasty (清) ...1644–1911

Index